P9-CDL-751

Cubism and Abstract Art

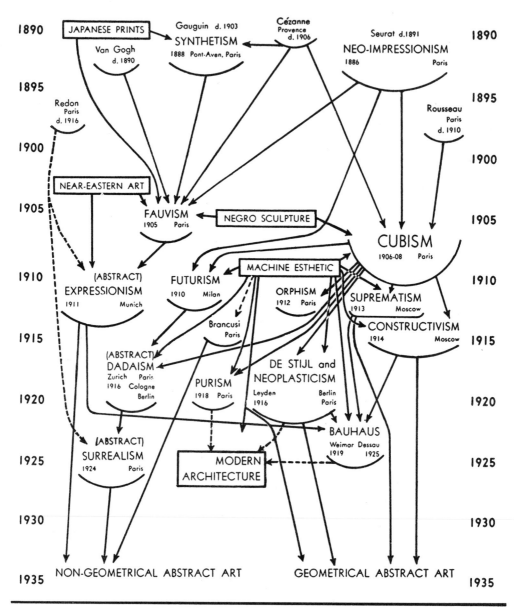

1890	JAPANESE PRINTS Gauguin d. 1903 SYNTHETISM Cézanne Provence d. 1906 Seurat d.1891 NEO-IMPRESSIONISM	1890

NON-GEOMETRICAL ABSTRACT ART GEOMETRICAL ABSTRACT ART

Cubism and Abstract Art

Painting

Sculpture

Constructions

Photography

Architecture

Industrial Art

Theatre

Films

Posters

Typography

The Museum of Modern Art, New York

Distributed by New York Graphic Society, Boston

This edition of *Cubism and Abstract Art* reproduces exactly the text of the original clothbound edition. The text and the plates of the original volume were photographed separately and the plates rescreened.

Corrections

Page 22, footnote	*For* Bible. (V) *read* Bibl. 44.
Page 58	*Fourth paragraph: for* Chahut of 1899 *read* Chahut of 1889.
Page 61	*Second line from top: for* decades *read* decade.
Page 77, date 1924	*For* Cubist *read* Cubist film.
Page 125, fig. 116	*For* Suprematist *read* Non-Objectivist.
Page 130, date 1922	*For* Ehrenberg *read* Ehrenburg.
Page 159, fig. 170	*For* Artist unknown *read* Domela-Nieuwenhuis.
Page 167	*Third paragraph: for* (fig. 184, above) *read* (fig. 184, below).
Page 186	*Third line from top: for* Illusion (fig. 206) *read* The forest (cat. no. 66).
Page 208, no. 62	*Size should read* 11 x 14½.
Page 209, no. 63	*Size should read* 13½ x 20¼.
Page 222, no. 234	*For* Suprematist *read* Non-Objectivist.
Page 231, no. 357A	*Should be credited to* Domela-Nieuwenhuis. (For biography see *Painting and Sculpture*.)
Page 234, no. 1	*For* 1933 *read* 1932.
Page 239, no. 147	*Delete* Born Kiev, 1878.
Page 246, no. 343	*For* Fernard *read* Fernand.

First Paperbound Edition 1974
Library of Congress Catalog Card Number 74-81657
ISBN 0-87070-274-2
The Museum of Modern Art
11 West 53 Street
New York, New York 10019
Printed in the United States of America

Contents

Figures in parentheses in captions beneath illustrations refer to numbers in catalog section.

Acknowledgments

The exhibition has been selected from the following collections:

Mrs. Alexander Archipenko, Hollywood, California

Mr. and Mrs. Walter C. Arensberg, Hollywood, California

Hans Arp, Meudon-val-Fleury, France

Giacomo Balla, Rome

S. N. Behrman, New York

M. Thérèse Bonney, New York

Georges Braque, Paris

André Breton, Paris

Alexander Calder, New York

Carlo Carrà, Milan

Walter P. Chrysler, Jr., New York

Le Corbusier, Paris

Mme. Cuttoli, Paris

Frank Crowninshield, New York

Robert Delaunay, Paris

Mme. Pétro van Doesburg, Meudon-val-Fleury, France

César Domela-Nieuwenhuis, Paris

Miss Katherine S. Dreier, New York

Estate of Raymond Duchamp-Villon, Paris

Nahum Gabo, Paris

A. E. Gallatin, New York

Alberto Giacometti, Paris

Julio Gonzales, Paris

A. Conger Goodyear, New York

Mme. Paul Guillaume, Paris

César M. de Hauke, New York

Hunt Henderson, New Orleans

Mrs. Patrick C. Hill, Pecos, Texas

Dr. F. H. Hirschland, New York

Mrs. Edith J. R. Isaacs, New York

Sidney Janis, New York

Philip Johnson, New London, Ohio

T. Catesby Jones, New York

Mme. Simone Kahn, Paris

Henry Kahnweiler, Paris

Frederick Kiesler, New York

Frank Kupka, Paris

Michael Larionov, Paris

Jacques Lipchitz, Paris

Piet Mondrian, Paris

Henry Moore, London

George L. K. Morris, New York

William Muschenheim, New York

Ben Nicholson, London

Antoine Pevsner, Paris

Francis Picabia, Paris

Miss Elsie Ray, New York

Albert Rothbart, New York

Mme. Helena Rubinstein, New York

Mrs. Charles H. Russell, Jr., New York

Arthur Sambon, Paris

Mr. and Mrs. Francis Steegmuller, New York

Mr. and Mrs. Michael Stein, Palo Alto, California

Alfred Stieglitz, New York

Mr. and Mrs. James Johnson Sweeney, New York

Theatre Arts Monthly, New York

Tristan Tzara, Paris

Georges Vantongerloo, Paris

Mrs. George Henry Warren, Jr., New York

Christian Zervos, Paris

The Bignou Gallery, New York

The Brummer Gallery, New York

Marie Harriman Gallery, New York

M. Knoedler and Company, New York

Julien Levy Gallery, New York

Pierre Matisse Gallery, New York

Raymond and Raymond, Inc., New York

Léonce Rosenberg, Paris

Paul Rosenberg, Paris

J. B. Neumann, New York

Jacques Seligmann and Company, New York
Galerie Simon, Paris
Valentine Gallery, New York
Weyhe Gallery, New York
Wildenstein and Company, New York
A. Zwemmer, London
The Art Institute of Chicago
The Gallery of Modern Art, Milan
The Gallery of Living Art, New York University
Société Anonyme, Museum of Modern Art, 1920, New York
Smith College Museum of Art, Northampton, Massachusetts
The Kröller-Müller Foundation, Wassenaar, The Netherlands

In addition to those who have made loans to the Exhibition, the Director, on behalf of the President and Trustees of the Museum, wishes to thank the following:

The members of the Museum's Advisory Committee, especially Mrs. Charles H. Russell, Jr., the chairman, Mr. Sidney Janis, Mr. George L. K. Morris, and Mrs. Duncan Read for their assistance and advice in planning the exhibition;

Mr. Jay Leyda and Mr. Robert M. MacGregor for special assistance in securing material for the U.S.S.R.;

Mr. John Walker III, of the Advisory Committee, for special assistance in securing the material from Italy;

Mrs. H. Kröller-Müller and Mr. S. van Deventer for assistance in securing loans from the Kröller-Müller Foundation;

For their assistance in assembling the Exhibition: Mr. A. Everett Austin, Jr., Director of the Wadsworth Atheneum, Hartford; Mr. Alexander Calder, New York; Mr. Walter P. Chrysler, Jr., New York; Mr. Marcel Duchamp, Paris; Mr. Paul Eluard, Paris; Mr. A. E. Gallatin, New York; Mr. John D. Graham, New York; Mr. Robert B. Harshe, Director of The Art Institute of Chicago; Mrs. Edith J. R. Isaacs, New York; Mr. D. H. Kahnweiler, Paris; Mr. Louis Lozowick, New York; Mrs. Grace L. McCann Morley, Curator of the San Francisco Museum of Art; Mr. George L. K. Morris, New York; Mme. Lydia Nadejena, New York; Mr. Man Ray, Paris; Mr. Daniel Catton Rich, Associate Curator of Painting and Sculpture, The Art Institute of Chicago; Mr. Alexander Rodchenko, Moscow; Mr. Léonce Rosenberg, Paris; Miss Alice Roullier, Chairman of the Exhibition Committee of The Arts Club of Chicago; Mrs. Galka Scheyer, Hollywood; Miss Varvara Stepanova, Moscow; Mr. James Johnson Sweeney, New York; Mr. Vladimir Evgrafovich Tatlin, Moscow;

Mr. Alexander Calder for making the "mobile" hung from the Museum flagpole during the Exhibition;

Mrs. Sidney Janis for preparing the analysis of Picasso's *The painter and his model*;

Miss Margaret Scolari and Mr. James Johnson Sweeney for their assistance in preparing the catalog.

The Director wishes to thank especially Miss Ernestine M. Fantl, Curator of Architecture and Industrial Art; Miss Dorothy C. Miller, Assistant Curator of Painting; Mrs. Loyd A. Collins, Jr., Head of the Publications Department; and Mr. Beaumont Newhall, Librarian, for their self-sacrificing work in preparing the catalog and installing the Exhibition.

A. H. B. Jr.

8

Preface

The exhibition is intended as an historical survey of an important movement in modern art. It is conceived in a retrospective—not in a controversial spirit.

Exigencies of time and space have made it impracticable to include the work of several artists and movements that would otherwise have merited attention. In general, movements confined in their influence to a single country have not been included. In several cases the earlier and more creative years of a movement or individual have been emphasized at the expense of later work which may be fine in quality but comparatively unimportant historically.

The exhibition is confined to abstract art in Europe because only last year a large exhibition of Abstract Art in America was held at the Whitney Museum of American Art.

The first purely abstract paintings were done as long as twenty years ago and many of the conclusions in the development of abstract art were reached before the War. Nevertheless there is today a quickening interest in the subject here, and in many countries in Europe, where ten years ago one heard on all sides that abstract art was dead. In a few years it will be time to hold an exhibition of abstract art of the 1930's to show the contemporary work done by groups in London, Barcelona, Prague, Warsaw, Milan, Madrid, Paris, New York and other centers of activity.

Except in a few of its aspects this exhibition is in no sense a pioneer effort. To the pioneers homage is rendered, especially to Mr. Alfred Stieglitz and to the late Arthur Jerome Eddy. Special acknowledgment should also be made of the work of Miss Katherine Dreier, the founder, in 1920, of the Société Anonyme, which brought to this country innumerable exhibitions of European abstract art long before the Museum of Modern Art was founded.

The writer wishes the text to be considered as a series of notes accompanying the illustrations without any pretensions to originality or inclusiveness. The plan of the exhibition is a development of a series of lectures based upon material collected in Europe during 1927-28 and given in the Spring of 1929.

The director has greatly benefited from the encouragement and advice afforded by the Advisory Committee of the Museum.

<div align="right">A. H. B., Jr.</div>

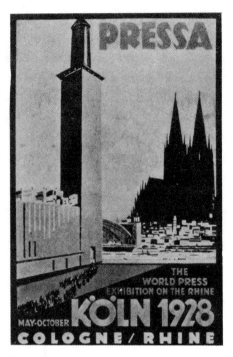 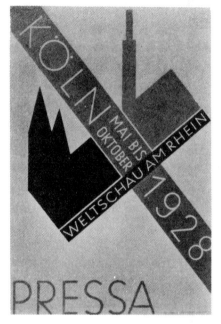

1 (347) Nöckur: Poster for the Pressa, Cologne, 1928

2 (334) Ehmcke: Poster for the Pressa, Cologne, 1928

Contrast—and Condescension

These two posters were published simultaneously to advertise, in railway stations and travel agencies, the *Pressa*, the international exhibition of printing, held at Cologne in the summer of 1928. Both posters show Cologne Cathedral and the Exposition Tower, between which flows the Rhine crossed by a bridge. The poster at the left is done in the fairly realistic poster style common to mediocre travel posters the world over. The poster at the right is by contrast highly abstract. In it the natural objects are reduced to flat, almost geometric forms arranged on a strongly diagonal axis under the influence of Russian Suprematism (fig. 4). Why were two posters published and why do they differ in style? Because one was designed for the Anglo-American public, the other for the German public. In 1928 it was thought that Americans, accustomed to an over-crowded and banally realistic style, would not appreciate the simplicity and abstraction of the right hand poster. The German public, on the contrary, through the activity of its museums and progressive commercial artists was quite used to an abstract style. Today times have changed. The style of the abstract poster, which is just beginning to interest our American advertisers, is now discouraged in Germany.

10

Introduction

The early twentieth century

Sometimes in the history of art it is possible to describe a period or a generation of artists as having been obsessed by a particular problem. The artists of the early fifteenth century for instance were moved by a passion for imitating nature. In the North the Flemings mastered appearances by the meticulous observation of external detail. In Italy the Florentines employed a profounder science to discover the laws of perspective, of foreshortening, anatomy, movement and relief.

In the early twentieth century the dominant interest was almost exactly opposite. The pictorial conquest of the external visual world had been completed and refined many times and in different ways during the previous half millennium. The more adventurous and original artists had grown bored with painting facts. By a common and powerful impulse they were driven to abandon the imitation of natural appearance.

"Abstract"

"Abstract" is the term most frequently used to describe the more extreme effects of this impulse away from "nature." It is customary to apologize for the word "abstract," but words to describe art movements or works of art are often inexact: we no longer apologize for applying the ethnological word "Gothic" to French thirteenth century art and the Portuguese word for an irregular pearl, "Baroque," to European art of the seventeenth century. Substitutes for "abstract" such as "non-objective" and "non-figurative" have been advocated as superior. But the image of a square is as much an "object" or a "figure" as the image of a face or a landscape; in fact "figure" is the very prefix used by geometers in naming A or B the abstractions with which they deal.

This is not to deny that the adjective "abstract" is confusing and even paradoxical. For an "abstract" painting is really a most positively concrete painting since it confines the attention to its immediate, sensuous, physical surface far more than does the canvas of a sunset or a portrait. The adjective is confusing, too, because it has the implications of both a verb and a noun. The verb *to abstract* means to *draw out of* or *away from*. But the noun *abstraction* is something already drawn out of or away from—so much so that like a geometrical figure or an amorphous silhouette it may have no apparent relation to concrete reality. "Abstract" is therefore an adjective which may be applied to works of art with a certain latitude, and, since no better or more generally used word

presents itself, it shall be used from now on in this essay without quotation marks.

Near-abstractions and pure-abstractions

The ambiguity of the word abstract as applied to works of art is really useful for it reveals the ambiguity and confusion which is inseparable from the subject. Perhaps keeping in mind the "verb" and "noun" meanings of *abstract* may help to clarify. For example, the Suprematist painting by Malevich is composed of a black and red square (fig. 113). This painting has absolutely no dependence upon natural forms. It is purely abstract in its genesis as well as in its final form. In it Malevich carried out his program by combining two of the elementary geometrical forms which he had set up as the fundamental vocabulary of Suprematism (figs. 111, 112). This painting is *abstract* in the "noun" sense of the word. Similar to it are Mondrian's *Composition* (fig. 157) and Gabo's *Space construction* (fig. 138). Different in character and genesis but equally abstract, at least in intention are certain paintings of Kandinsky who used non-geometrical (fig. 3, page 18) as well as geometrical forms (fig. 53). These works of Malevich, Mondrian, Gabo, Kandinsky, may be called *pure-abstractions.*

However, Mondrian's "plus and minus" composition of 1915 (fig. 142) despite its appearance is not a pure-abstraction. It is actually based upon a seascape just as van Doesburg's painting (fig. 144D) has been *abstracted* (note the verb) from the form of a cow. After 1920 Mondrian and van Doesburg abandoned the process of "abstracting," and composed pure-abstractions (figs. 146,156).

Arp's reliefs (figs. 207, 208) are also impure abstractions even though their forms are so far removed from nature that it is often difficult to tell whether a given object represents a head or a cloud or Paolo and Francesca. Similarly, a Picasso landscape of 1912 may sometimes be mistaken for a still life or a portrait. The cords which tie these works to nature are tenuous, but unbroken— nor would the artist wish them broken. In fact Arp and Picasso usually *name* their works—"Guitar," "Head," or "Fork and Plate." Because of these vestiges of subject matter, even though little more than a name, it is clear that such works should be described as quasi- or pseudo- or near-abstractions. Perhaps the last is the least objectionable.

To resume: pure-abstractions are those in which the artist makes a composition of abstract elements such as geometrical or amorphous shapes. Near-abstractions are compositions in which the artist, starting with natural forms,

12

transforms them into abstract or nearly abstract forms. He approaches an abstract goal but does not quite reach it.

There are of course several variations within these two classifications and several without, for example, the famous Kandinsky *Improvisation, no. 30* (fig. 52) in which the artist intended to paint an abstract composition but unconsciously (he says) introduced a couple of cannon in the lower right hand corner. So we have in this case a near-abstraction which the artist had intended to be a pure-abstraction.

Dialectic of abstract art

Abstract art today needs no defense. It has become one of the many ways to paint or carve or model. But it is not yet a kind of art which people like without some study and some sacrifice of prejudice. Prejudice can sometimes be met with argument, and for this purpose the dialectic of abstract painting and sculpture is superficially simple enough. It is based upon the assumption that a work of art, a painting for example, is worth looking at primarily because it presents a composition or organization of color, line, light and shade. Resemblance to natural objects, while it does not necessarily destroy these esthetic values, may easily adulterate their purity. Therefore, since resemblance to nature is at best superfluous and at worst distracting, it might as well be eliminated. Hans Arp, although he long ago abandoned pure-abstraction, has expressed this point of view with engaging humor:

"Art is a fruit growing out of a man like the fruit out of a plant, like the child out of the mother. While the fruit of the plant assumes independent forms and never strives to resemble a helicopter or a president in a cutaway, the artistic fruit of man shows, for the most part, ridiculous ambition to imitate the appearance of other things. I like nature but not its substitutes."[1]

Such an attitude of course involves a great impoverishment of painting, an elimination of a wide range of values, such as the connotations of subject matter, sentimental, documentary, political, sexual, religious; the pleasures of easy recognition; and the enjoyment of technical dexterity in the imitation of material forms and surfaces. But in his art the abstract artist prefers impoverishment to adulteration.

The painter of abstractions can and often does point to the analogy of music in which the elements of rhythmic repetition, pitch, intensity, harmony, counterpoint, are composed without reference to the natural sounds of either the "helicopter" or the "president in a cutaway." He looks upon abstract painting

[1] "Notes from a diary," *Transition* N. 21, Paris, 1932. Quoted in Sweeney, Bibl. 93, p. 30.

as independent painting, emancipated painting; as an end in itself with its own peculiar value.

To support their position defenders of abstract art during the past twenty-five years have often quoted a famous passage from the *Philebus* of Plato. Section 51c:[1]

> "Socrates: What I am saying is not indeed directly obvious. I must therefore try to make it clear. I will try to speak of the beauty of shapes, and I do not mean, as most people would think, the shapes of living figures, or their imitations in paintings, but I mean straight lines and curves and the shapes made from them, flat or solid, by the lathe, ruler and square, if you see what I mean. These are not beautiful for any particular reason or purpose, as other things are, but are always by their very nature beautiful, and give pleasure of their own quite free from the itch of desire; and colors of this kind are beautiful, too, and give a similar pleasure."

Near-abstractions and their titles

Why then do Arp and Picasso give names such as "Head" or "Still Life" to works which are so abstract that at first glance they baffle recognition of any resemblance to nature? Why do they not, like Malevich and Kandinsky, go the whole way and call their pictures simply "compositions" or "improvisations"? This naming of near-abstractions after concrete objects certainly confuses and exasperates the layman who might otherwise be ready to enjoy the beauties of form and color which the near-abstractions offer.

For this reason critics and amateurs of abstract art have sometimes considered the titles given by Arp or Picasso to their near-abstractions as stumbling-blocks which may well be ignored or forgotten. This is, however, an unwarranted simplification of which, as has been remarked, the artists themselves do not approve. For a cubist painting or an Arp relief *is* a *near*-abstraction, and offers an impure and ambiguous enjoyment to which the title is a guide. It is not merely the primary relationship of form and color *within* the picture which are enjoyable but also the secondary relationships between the picture *and* the subject matter of which the picture is an abstraction. Take for instance Picasso's *Violin* (fig. 31): starting with the idea or image of a violin Picasso makes an angular, quasi-geometrical composition which displays his power not merely of *composing* abstract forms but of breaking up and assimilating natural forms. As evidence of this abstracting and transmuting process and as a guide to our enjoyment of it he leaves certain vestiges of the violin, the spiral line of the scroll, the shape of the sound-holes, the parallel lines of the strings and the

[1]For an interesting commentary on this passage see A. Phillip McMahon: *Would Plato find artistic beauty in machines? Parnassus*, vol. VII, 6-8, February 1935. Prof. McMahon emphasizes Plato's dislike for art and esthetic delight in geometry.

14

curves of the purflings; and as further explanation he gives the name of the original object—*Violin*.

Abstract art and subject matter

Further examination of subject matter not merely as a point of departure but as something of interest in itself may seem anomalous in a discussion of abstract art; for, abstract art, in so far as it is abstract, is presumably devoid of subject interest. Nevertheless, subject matter, although it can be ignored by the purist, has played a part of some importance in several of the movements which will be considered hereafter in these pages from a primarily formal point of view.

The Cubists seem to have had little conscious interest in subject matter. They used traditional subjects for the most part, figures, portraits, landscapes, still life, all serving as material for Cubist analysis.[1] On the contrary, to the Italian Futurists subject matter was of real importance. The exaltation of the machine and of the noise and confusion of modern life was as conscious a part of their program as the abstract analysis of movements and forces. The French Purists after the War used the silhouettes of deliberately chosen familiar objects with which to make near-abstract compositions.

In Germany the Russian Kandinsky passed beyond subject matter except when it appeared without the conscious intention of the artist. But Franz Marc's poetic sentiment for animals lingered even in his most Cubistic compositions and Feininger never eliminated entirely his romantic feeling for architecture and the sea. Klee's subject matter is as ingenious and interesting as his form.

The Dadaists, who mocked all kinds of art including abstract, had no prejudice against subject matter though sometimes they eliminated it. Their successors, the Surrealists, however, would, as conscientious Freudians, maintain that even squares and circles have symbolic significance. But even in much Sur-

[1] In spite of the fact that the Cubists themselves and their most ardent admirers attached little importance to subject matter, Meyer Schapiro of Columbia University advances an interesting theory that consciously or unconsciously the Cubists through their subject matter reveal significant preoccupation with the bohemian and artistic life. It is possible of course that the things in a Cubist still-life: bottles, playing-cards, dice, violins, guitars, pipes, which Dr. Schapiro calls "private instruments of idle sensation," may be a direct rather than a symbolic inventory of objects in the cubist's studio; and the painting of letters, introduced by Braque into Cubism, may be, like his use of imitation wood and marble textures, merely a reminiscence of his early apprenticeship as a house painter, rather than a symbol of the art of literature; and the repetition of such word-fragments with artistic connotations as *Etude, Bal, Bach* and so forth may be balanced by the names of daily newspapers, *Figaro, L'Intran, Journal*—and "Hennessy" (fig. 67) by "Baker's Cocoa" (fig. 98). Nevertheless, the continual repetition of figure paintings called *Pierrot, Guitarriste, Clarinettiste, Harlequin*, in later Cubist pictures suggests a concern with the world of art instead of the world of life and may consequently be taken as a symbol of the modern artist's social maladjustment—which is, however, not limited to Cubists. In any case the iconography of Cubism should not be ignored.

realist painting subject and symbol are obscured or entirely lost in what is virtually an abstract design.

The cows and seascapes and dancers which lurk behind the earlier abstract compositions of Mondrian and Doesburg have no significance save as points of departure from the world of nature to the world of geometry. Malevich, however, who founded Suprematism by drawing a perfect square (fig. 112) discovered inspiration for some of his subsequent and more elaborate compositions in the airplane photographs of cities.

In summary it may be said that only in Futurism, Dadaism, Surrealism and Purism had subject matter any real importance, at least so far as the conscious program of the artists was concerned.

Abstract art and politics

It is its style, its abstract quality, as a general rule, and not its content or avowed program, that has from time to time involved abstract art in politics. Exceptions to this generalization were Futurism and Surrealism. The former in much of its program anticipated Fascism and the latter has been involved in Communism.

Pre-War Italian Futurism was latently Fascist in its patriotism, esthetic enjoyment of war and exhortation to the dangerous and dynamic life. Marinetti, its promotor, is now a Fascist senator, and Boccioni, its most important artist, died in military service, from the effects of a fall from his horse.

In Moscow after the Revolution, the Russian Futurists, Suprematists and Constructivists who had been artistically revolutionary under the Czar came into their own. For three years they dominated the artistic life of the larger cities, taught in the art academies, designed posters, floats in parades, statues to Marxian heroes and gigantic Cubistic facades to screen the Winter Palace during mass celebrations. Malevich's *White on white* of 1918 (fig. 115) might have counted as a *tabula rasa* upon which to build a new art for a new order, but it was as unintelligible to the proletariat as his earlier Suprematist pictures had been to the bourgeoisie. Tatlin's and Rodchenko's constructions may have been abstract exercises in technological discipline but what the land desperately needed was practical mechanics. Highly cultivated Bolsheviks, such as Trotzky and Lunacharsky, understood and supported the artists of the advance guard, but Lenin, with his broad and penetrating vision of the practical needs of the U.S.S.R., found no joy in the Suprematists, the Cubo-Futurists and Tectonic Primitivists. He summarized the left-wing art and literature of 1920 as "the infantile disorder of Leftism" and felt that movies were more useful

16

to the Soviet State. In 1921 came the New Economic Policy, the era of recon-
struction and practical materialism. An attitude of toleration towards Leftism
turned to impatience. A schism appeared in the ranks of the artists themselves.
One faction wanted to maintain art for art's sake; their opponents wanted to
put art at the service of the new order. The atelier of Pevsner and Gabo at the
Moscow Academy was closed; they and Lissitzky left for Berlin; Kandinsky
left for Germany to join the Bauhaus; Malevich took a post in less influential
Leningrad; and most of the Suprematists and Constructivists who stayed in
Moscow left art, in the narrow sense of the word, for typography, photography,
posters, movies, engineering, stage design, carpentry—anything but painting
or sculpture. Today abstraction or stylization in art is still considered a "left
deviation" in the U.S.S.R. and is discouraged.

The political atmosphere of the Dadaists, the West-European contempora-
ries of the Russian Leftists, might be described as anarchist. That of their suc-
cessors, the Surrealists, was Communist, although it would be hard to find any-
thing specifically Communist in their paintings. The schism which had divided
the Moscow Constructivists of 1920 reappeared ten years later in Surrealism.
Aragon, the Surrealist writer, insisted, as Tatlin and Rodchenko had done, that
the artist should place his talents practically and exclusively at the service of
the Revolution. The Constructivist heretics who insisted upon the indepen-
dence of art had found it advisable to leave Communist Moscow for Social
Democratic Germany; but the Surrealists, Communist or not, continue to work
in Paris without serious molestation from either the Left or the Right (except
when showing films).

Abstract art which had begun in Munich flourished in post-War Germany.
In addition, the esthetic ideals of the Dutch *Stijl* group and of the Russian
Constructivists were brought to Berlin by refugees from active Soviet philis-
tinism or its more passive Dutch equivalent. Gradually abstract art, and the
architecture which it influenced, became associated with the Social Democracy
in the minds of its bitter enemies, the National Socialists. Modern architecture
of the "International Style" had been used extensively in the housing develop-
ments authorized by Social Democratic burgomasters.

To the Nazis the cultural expression of the shameful fourteen years between
the Treaty of Versailles and the National Resurgence of 1933 was—and is—
anathema. Abstract art was considered *Kunstbolschewismus*,[1] and after the
Nazi revolution many artists were dismissed from official positions or other-
wise "discouraged." The flat roof and the white, clean lines of "Bauhaus"

[1] For example, nine of the artists represented in this exhibition have left Germany since 1933. Only
one of them is a "non-Aryan."

architecture were likewise forbidden in favor of a renascence of genuine Biedermeyer (the German version of the International style of the 1830's).

About the same time, in the early thirties, the U.S.S.R. turned against modern architecture in favor of a monumental style derived from Imperial Rome and the Czarist 18th century. But Fascist Italy and conservative England, to complete the confusion, accepted modern architecture with enthusiasm. The railroad station in Florence has been completed in the *stile razionale,* and Lubetkin, a former Russian Constructivist, has designed new buildings (fig. 139) for that British stronghold, the London Zoo.

This essay and exhibition might well be dedicated to those painters of squares and circles (and the architects influenced by them) who have suffered at the hands of philistines with political power.[1]

[1] As this volume goes to press the United States Customs has refused to permit the Museum of Modern Art to enter as works of art nineteen pieces of more or less abstract sculpture under a ruling which requires that sculpture must represent an animal or human form. Some of the nineteen pieces are illustrated by figs. 47, 49, 96, 97, 104, 105, 155, 202, 209, 210, 216, 221, 222, 223. They are all considered dutiable as plaster, bronze, stone, wood, etc., and have been entered under bond. The hand-painted canvases in the exhibition were, however, admitted free, no matter how abstract.

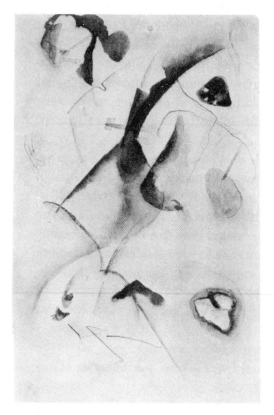

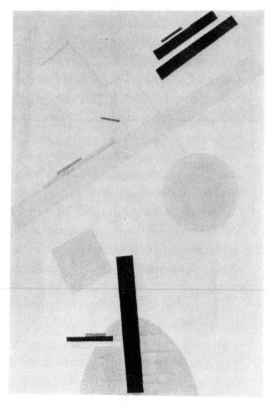

3 (104) Kandinsky: Improvisation, 1915

4 (158) Malevich: Suprematist composition

Two main traditions of Abstract Art

At the risk of grave oversimplification the impulse towards abstract art during the past fifty years may be divided historically into two main currents, both of which emerged from Impressionism. The first and more important current finds its sources in the art and theories of Cézanne and Seurat, passes through the widening stream of Cubism and finds its delta in the various geometrical and Constructivist movements which developed in Russia and Holland during the War and have since spread throughout the World. This current may be described as intellectual, structural, architectonic, geometrical, rectilinear and classical in its austerity and dependence upon logic and calculation. The second—and, until recently, secondary—current has its principal source in the art and theories of Gauguin and his circle, flows through the *Fauvisme* of Matisse to the Abstract Expressionism of the pre-War paintings of Kandinsky. After running under ground for a few years it reappears vigorously among the masters of abstract art associated with Surrealism. This tradition, by contrast with the first, is intuitional and emotional rather than intellectual; organic or biomorphic rather than geometrical in its forms; curvilinear rather than rectilinear, decorative rather than structural, and romantic rather than classical in its exaltation of the mystical, the spontaneous and the irrational. Apollo, Pythagoras and Descartes watch over the Cézanne-Cubist-geometrical tradition; Dionysus (an Asiatic god), Plotinus and Rousseau over the Gauguin-Expressionist-non-geometrical line.

Often, of course, these two currents intermingle and they may both appear in one man. At their purest the two tendencies may be illustrated by paintings of twenty years ago: a Suprematist composition by Malevich (fig. 4) and an *Improvisation* by Kandinsky (fig. 3). The geometrical strain is represented today by the painter Mondrian (fig. 158) and the Constructivists Pevsner and Gabo (figs. 137, 138); the non-geometrical by the painter Miro (fig. 204) and the sculptor Arp (fig. 209). The shape of the square confronts the silhouette of the amoeba.

From Impressionism to Fauvism, 1875-1905

Chronology

1874 First Impressionist Exhibition, Paris.
c. **1885** Neo-Impressionism; Seurat at work on the *Grande-Jatte*.
1888 Synthetism; Gauguin at Pont-Aven. Van Gogh to Provence.
1905 Matisse the leader of the *Fauve* group at the Autumn Salon.

Impressionism and its disintegration

Impressionism was both the culmination of nineteenth century effort to paint truthful imitations of natural appearances and the first step toward abstraction. It was the abstract quality of Impressionist pictures that at first made them unintelligible, just as it was the abstract quality of Whistler's nocturnal impressionism that caused the outraged Ruskin to speak of a paint pot flung in the face of the public. By its abstract quality, even though the result of presumably scientific imitation of light effects, Impressionism had begun to break down popular prejudice against all art that was *not* an obvious imitation of nature.

Impressionism was, however, too boneless and too casual in its method to serve as more than a technical basis for the artists who transformed or abandoned its tradition. Yet in spite of the conscious reaction against Impressionism, something of its attitude and technique persisted; not only among those such as Renoir, Gauguin, and van Gogh who turned from it and those who like Cézanne and Seurat tried to reform it, but even among the much younger generation of Cubists and Futurists. They continued Impressionism's analytical approach even though they analyzed or disintegrated not the light and color of natural objects but rather their forms and, in the case of the Futurists, their movements.

Twenty-five years before Cubism, in the early 1880s, Impressionism had already lost prestige among the vanguard although it had just begun to achieve wide influence and even some popularity. Renoir was leaving Impressionism for the discipline of his dry period. Cézanne had retired to Provence to make of Impressionism "something solid like the art of the museums." Only the central group, Monet, Pissarro, Sisley, remained orthodox. Even Pissarro deserted the ranks for awhile when he found a leader to follow, a leader who could regulate the amorphous technique of Impressionism without sacrificing its discoveries.

20

5 (528) Seurat: The quay, 1883 (?)

6 (260) Seurat: Study for *Side-show*, 1888-89

Neo-Impressionism: Seurat

This man was Seurat, the founder of Neo-Impressionism. Seurat's theory of art was as abstract as that of the later Cubists, Suprematists or Neo-plasticists. He believed that the art of painting depended upon the relations between colors and lines. The maximum contrast between tones is extreme light and extreme dark; between lines, the right angle; between colors, the complementaries of red and green, orange and blue, yellow and violet. Color, line and tone can be used to give a sad, or a calm or a gay effect. In carrying out his color theories Seurat systematized the fine broken color and spotty brushstrokes of the Impressionists by painting with "pointillist" technique, using small, methodically even dots of the six primary colors in light or dark tones. The sketch (fig. 6) for the *Side show*, one of his great compositions,[1] shows an early stage in the systematic building up of his forms through dots of color. The *Quai* (fig. 5) reveals his equally abstract handling of tone and line.

Seurat died in 1891, having painted a half dozen masterpieces. His theories, with their scientific basis, were popularized through his collaborator Signac and influenced a large school during the twenty years after his death.

About 1910 a more important aspect of Seurat's art, his mastery of formal design, began to be appreciated. The Cubists, many of whom had rebelled against Signac five years before, began to study Seurat's composition, adopting with it in many cases his pointillist technique (*cf.* Picasso, fig. 75, Braque, figs. 74, 77). Seurat's method was an essential part of Futurist theory and technique (Severini, fig. 45); his scientific approach to color profoundly influenced the Orphists of 1912 (figs. 58, 60); and his spirit more than that of any other lay back of the Purist effort to reform Cubism in 1918.

Synthetism: Gauguin

Seurat's Neo-Impressionist reformation of Impressionism was followed and opposed a few years later, about 1888, by Gauguin's Synthetism. The Synthetist group formed about Gauguin in Brittany turned from the superficial vision and surface agitation of Impressionism to broad, simple, flat tones of color often with definite edges emphasized by black lines. In their experiments they sought sanction and encouragement in a variety of archaic, primitive, or exotic traditions: Egyptian art, Italian primitives, the crude peasant sculpture of Brittany and, above all, Japanese prints. In all these arts they found distortions of "nature" which lent authority to their own "deformations."

[1] Illustrated Bible. (V) pl. 29.

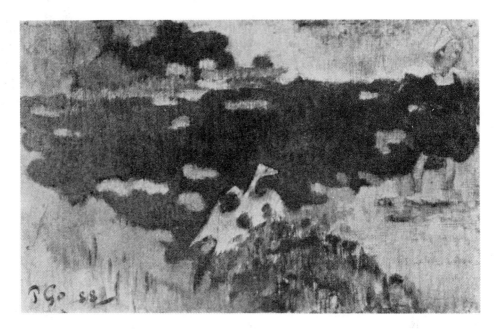

7 (80) Gauguin: Goose girl, Brittany, 1888

8 (166) Matisse: Joy of Life (study), 1905

With their synthetic method they challenged the analytic procedure of the Impressionists and the Neo-Impressionists. They supported an intuitive, conceptual or expressionist attitude against the scientific, rational esthetic of their opponents. A follower of Gauguin, Maurice Denis, who wrote in 1890 a kind of manifesto of Synthetism (also called Neo-traditionism and Symbolism), asserted[1] that "a painting—before being a battle horse, or a nude woman, or some anecdote—was essentially a flat surface covered with colors arranged in a certain order." To the public and the academies this was a revolutionary idea and to art it brought revolutionary consequences. Gauguin, having established this premise, encouraged his followers to go further, to change for the sake of greater expression the colors of nature and distort its forms. Van Gogh and, to a less extent, Cézanne, and Renoir and the Impressionists had already done this but not as a part of a formal program. Gauguin's paintings like the *Goose girl* (fig. 7) and the *Garden at Arles* (fig. 50), both done before 1890, embody Synthetist principles. In his theories and in his art, Gauguin cleared the path which led to Matisse and *Fauvisme* and beyond Matisse to Kandinsky and Abstract Expressionism.

van Gogh; Redon

Van Gogh added to this emerging expressionist tradition a violence of color and a surging, twisting arabesque of line which far surpassed that of Gauguin and his immediate followers. And Redon, allied with Gauguin's followers, contributed not only an iridescent amorphous shimmer of color which was to affect Matisse and Kandinsky, but also an introspective, visionary, subjective attitude which anticipated both Kandinsky and the Surrealists.

Fauvisme: Matisse

At the end of the century the Synthetists and the Neo-Impressionists were disputing the allegiance of the younger generation. At first Signac and Cross, the leaders of dot-painting (Seurat had been temporarily eclipsed), interested Matisse, Friesz, Derain and Braque, but about 1905 their influence began to give ground to that of van Gogh and Gauguin. At the *"Fauve"* Salon of that year, and again in 1906, Matisse and the others exhibited paintings in a mixed style. The study for the *Joie de vivre* (fig. 8), for instance, is painted partly with Signac spots, partly with the flowing lines and flat tones of Gauguin.

Matisse, in his work of 1906, had gone further towards an abstract art of line and color than any of his own generation. But in Munich, within five years, Kandinsky, who had been in Paris in 1906, was to carry the Gauguin-

[1] In *Art et Critique*, August 23 and 30, 1890, republished in *Théories*, Paris, 1913, pp. 1-13.

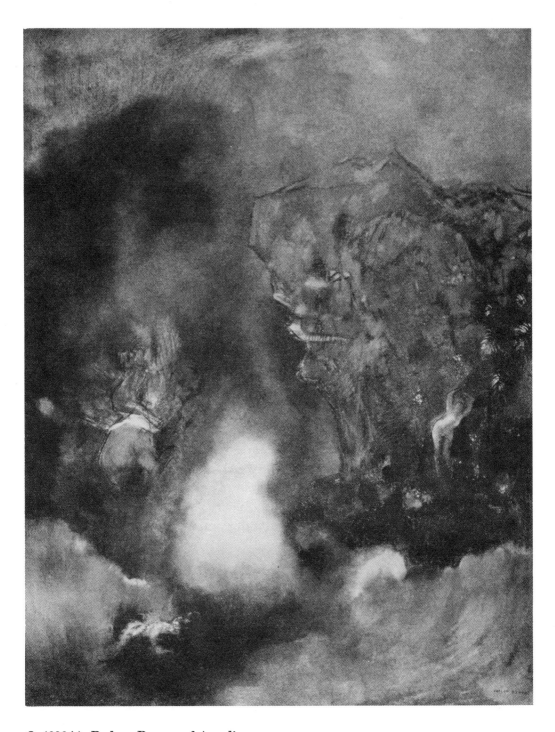

9 (232A) Redon: Roger and Angelica

Matisse tradition to the point of pure-abstraction. And in Paris, within two years, Matisse himself was to shake his head over some landscapes of Braque (fig. 19) with a disparaging remark about *"les petits cubes."* Braque and Picasso, the young Cubists of 1908, had, in fact, repudiated the *Fauves* and their precursors as a tradition of undisciplined decoration. They spurned the linear arabesque and the flat tones of Gauguin, van Gogh and Matisse and looked instead to an almost obscure older master, Cézanne, who had died in 1906 before he had begun to assume his position as the greatest artist of the late nineteenth century.

Cézanne; Rousseau

Cézanne influenced the pioneers of Cubism both through his art and his theory. But so complex and subtle was his style that they were able only gradually to assimilate its meaning. They developed more literally and much further than his perception of the geometrical forms underlying the confusion of nature. They admired, too, Cézanne's frequent choice of angular forms in his subject matter as in the *Town of Gardanne* (fig. 29), but above all they studied Cézanne's late work (figs. 18 and 24) in which he abandons the perspective of deep space and the emphatic modeling of solid forms for a compact composition in which the planes of foreground and background are fused into an angular active curtain of color.

Another painter of Cézanne's generation, Henri Rousseau, originally a naïve, self-taught amateur, encouraged Picasso and his friends to invent or conceive forms in their paintings rather than to imitate natural appearances. Rousseau, born before van Gogh, Seurat or Gauguin, lived until 1910. The primitive directness and integrity of his art (fig. 10) made a deep impression on Picasso, Léger, Delaunay, Apollinaire and others of the Cubist circle.

26

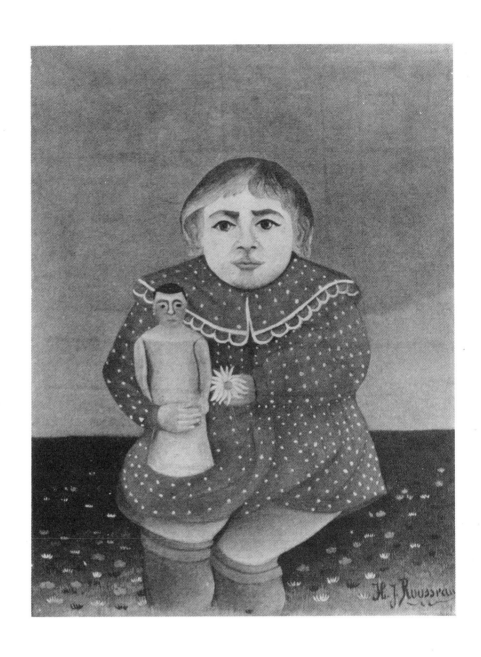

10 (248) Rousseau: Child with a doll

Analytical Cubism

Chronology in relation to this exhibition

1906 First influence of Negro sculpture upon Picasso, who begins large composition *The young ladies of Avignon.*

1907 Picasso finishes *The young ladies of Avignon* (figs. 11, 12).
Strongly under Negro influence (figs. 12, 13, 14).
Cézanne influence in landscapes of Braque, who had previously painted in manner of Matisse (fig. 8), and in *Bowls and jug* of Picasso (fig. 15). Braque meets Picasso. Kahnweiler buys from Picasso.

1908 Picasso and Braque under influence of both Cézanne and Negro sculpture (figs. 16, 17). Beginning of "facet" Cubism (fig. 20). The word "cube" associated with Braque's landscapes such as the *Seaport* (fig. 19). Braque exhibits at Kahnweiler's. Léger develops independently under influence of Rousseau.

1909 Picasso and Braque proceed with disintegration of natural object by dislocating facets or merging them with background (figs. 21, 25). They paint in sober greys, greens and browns. First Cubist sculpture (fig. 90). Gleizes, Metzinger, Picabia, Delaunay drawn to movement.

1910 Work of Picasso (fig. 27) and Braque more abstract. Suggestion of depth and distinction between foreground objects and background almost disappears. Léger (fig. 32), Gris, Marcoussis, la Fresnaye, Marcel Duchamp allied with movement.

1911 Picasso (fig. 30) and Braque paint increasingly abstract compositions with straight lines predominating. Braque introduces letters and textures of imitation wood and marble (*cf.* fig. 63 of 1913).
First group exhibition at *Indépendants* includes Gleizes, Léger, Delaunay. Guillaume Apollinaire, champion of the movement, accepts the term Cubism.

1912 Apogee of Analytical Cubism in such works of Picasso as the *Violin* (fig. 31). Picasso and Braque further develop imitation textures which lead to *collage*, the pasting of strips of paper, cloth, etc., in combination with painting or drawing (figs. 64, 65). Gris' *Picasso* (fig. 33). *Du cubisme* by Gleizes and Metzinger published. Delaunay (fig. 58) begins to use brilliant color in contrast to sobriety of Picasso and Braque. Gleizes, Metzinger, Jacques Villon and others create Cubist group, *Section d'Or*, which exhibits in this and the following year. Duchamp's *Nude descending a staircase* (fig. 40) and *Bride* (fig. 41).

1913 Picasso, Braque, Gris continue *collage*; transition to Synthetic Cubism.

The beginnings of Cubism, 1906-08

The beginnings of Cubism followed close upon the *Fauve* revolt of 1905. Braque was at first a member of the *Fauve* group and worked under the influence of Matisse and Friesz until 1907. Picasso too, though outside the *Fauve* movement, was certainly *Fauve* in the barbaric spirit and color of much of his work of 1906 to 1908.

Cubism in the early years developed under the mixed influence of Negro sculpture and Cézanne. African figures had been admired by the *Fauves*, Vlaminck, Derain and Matisse, who passed on the enthusiasm to Braque and Picasso.

Cézanne had sent ten paintings to the Salon d'Automne in 1905 and another ten in 1906, the year in which he died. In 1907, fifty-six of his paintings were shown in a memorial exhibition; they made a deep impression on Picasso and Braque but no deeper than the publication, in the same year, of a letter written by Cézanne to Emile Bernard. In this was the famous sentence: "You must see in nature the cylinder, the sphere, the cone." The influence of this maxim upon Braque and Picasso has perhaps been exaggerated but undoubtedly it led them to geometrize, to reduce to fundamental geometric forms the disorder of nature.

The young ladies of Avignon (fig. 11), which Picasso began in 1906 and finished in 1907, is often called the first Cubist picture. The figures at the left are the earlier and are still reminiscent of the robust sculpturesque classical nudes which in 1906 followed the delicacy and sentiment of the artist's "rose" period. But the angularity of the figures at the right, their grotesque masks with concave profiles and staring eyes, are already of the Negro period at its most barbaric. The half length figure (fig. 12) is a study for the upper right hand figure.

Similar in style but more consistent and more mature is the *Dancer* (fig. 14). The silhouette of the body as well as its mask are definitely derived from BaKota metal-covered fetishes from the Gabun (fig. 13). The magnificent color and violent movement were soon to give way to a sober monochrome already evident in the *Bowls and jug* (fig. 15).

In the *Nude* (fig. 17), a major work of 1908, Braque had turned from the flat, linear, decorative, *Fauve* style to a severe, almost sculpturesque study of form. The powerful drawing is perhaps from Matisse, the squat proportions from Congo figures.

In these three large pictures, *The young ladies of Avignon*, the *Dancer* of Picasso and the *Nude* of Braque, Cézanne's influence is apparent in the way in which the angular drawing is carried consistently through the composition, uniting both figures and background; and in the reduction of spatial depth to a kind of relief. These are comparatively crude adaptations of Cézanne's method. Gradually the young painters' understanding grew. A comparison[1] of the *Seaport* (fig. 19) done by Braque in 1908 with the *Pines and rocks* (fig.

[1] *Cf.* Jerome Klein in *The Lillie P. Bliss Collection*, Museum of Modern Art, 1934, pp. 12 and 30.

18) of Cézanne painted only about a decade before, shows how Braque had studied Cézanne's late style. In both paintings the surfaces of the natural forms are reduced to angular planes or facets, depth is almost eliminated and frequently the foreground and background forms are fused by means of *passages*—the breaking of a contour so that the form seems to merge with space. Cézanne painted outdoors before the landscape itself; Braque's painting is more detached from reality, more conceptual, more obviously cones, spheres and cubes. Braque's still life *Guitar* (fig. 16), also of 1908, reveals the same dependence upon Cézanne. Even the brushwork of the *Seaport* and the *Guitar* resembles the short, parallel hatching stroke which Cézanne used.

Development of Analytical Cubism, 1908-1913: Picasso, Braque

Picasso and Braque had met during the winter of 1907-08 and had, within a year, established the collaboration which was to carry them through the formative years of Cubism. These years of development can be summarized by examining a series of five heads by Picasso. The *Head of a woman* (fig. 20) of 1908-09, done at the same time as Braque's *Seaport*, is systematically broken into facets like a cut diamond, but the form is still sculptural and in fact bears a close resemblance to Picasso's bronze *Head* (fig. 90) of the same time. Both the painting and the bronze are closely related to Negro sculpture such as the Cameroon mask (fig. 91). Somewhat later, in 1909, in the *Portrait of Braque* (fig. 21) Picasso begins to break up the "crystallized" form; the facets begin to slip, causing further deformation. The head of the *Poet* (fig. 30) of 1911 marks a third stage of disintegration leading to the *Arlésienne* (fig. 22) of 1912 in which the head is made up of flat, overlapping, transparent planes, almost rectangular in shape. The profile of the face is superimposed upon a frontal view illustrating the principle of "simultaneity"—the simultaneous presentation of different views of an object in the same picture. The fifth stage, represented by the *Head of a young woman* (fig. 23) of 1913, marks the end of "Analytical" Cubism and the beginning of "Synthetic" Cubism. Only vestiges of an eye, chin, shoulder remain in an arrangement of rectangles and circles, nearly but not exactly geometrical. The progression moves from three-dimensional, modelled, recognizable images to two-dimensional, flat, linear form, so abstract as to seem nearer geometry than representation.

Other pictures illustrate variations in subject and handling. In the *Tube of paint* (fig. 25), done in 1909 about the same time as the *Head of a woman* (fig. 20), all the forms, the cock, the tube, the bottle, the glass and the drapery are merged into a continuous play of facets, so that they become almost indis-

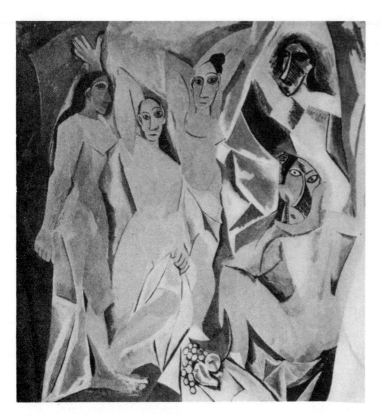

11 (205) Picasso: The young ladies of Avignon, 1906-07 (*not in exhibition*)

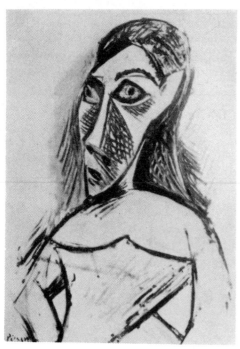

12 (203) Picasso: Study for *The young ladies of Avignon*, 1907

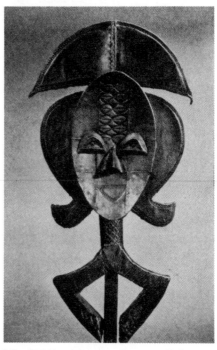

13 (276) African figure. Gabun, Bakota; *cf.* Picasso, figs. 12 and 14

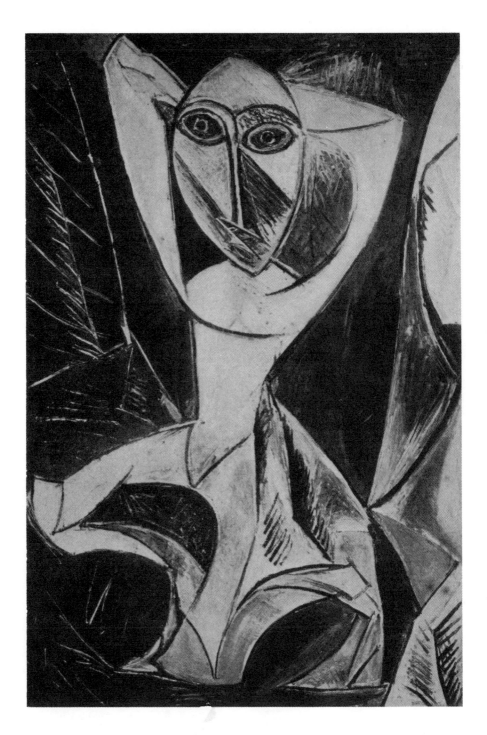

14 (207) Picasso: Dancer, 1907-08

15 (206) Picasso: Bowls and jug, 1907

16 (22A) Braque: Guitar, 1908

17 (22) **Braque: Nude, 1908**

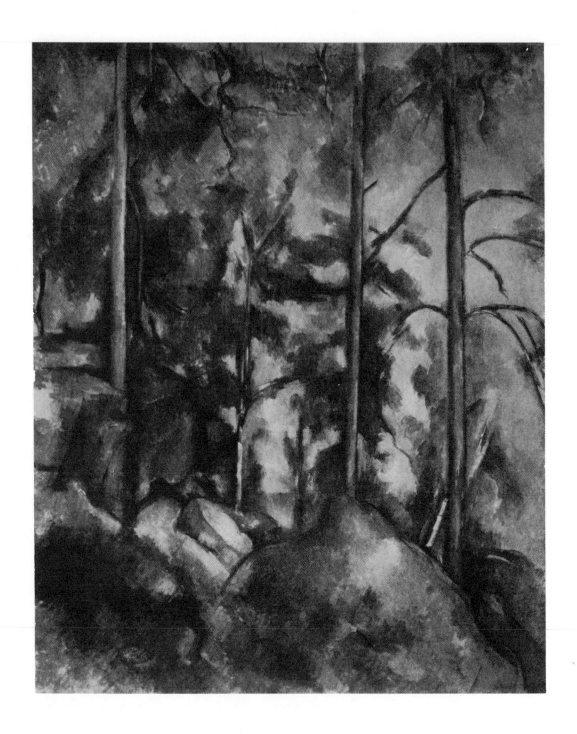

18 (35) Cézanne: Pines and rocks, *c.* 1895-1900

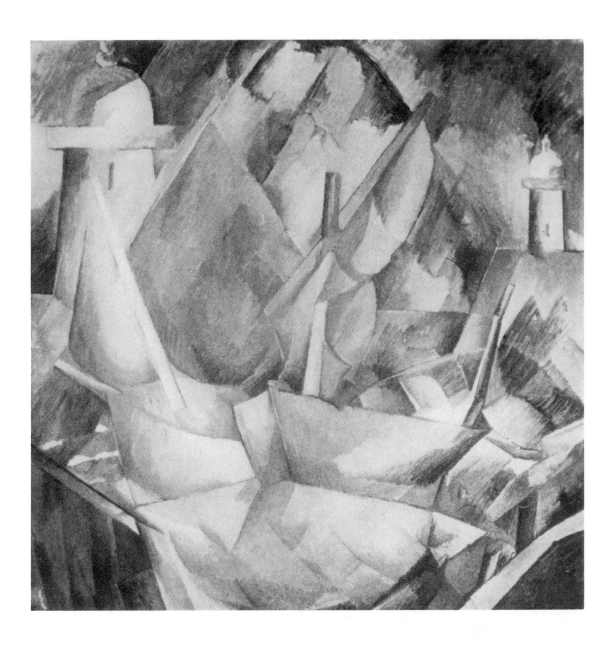

19 (23) Braque: Seaport, 1908 (*not in exhibition*)

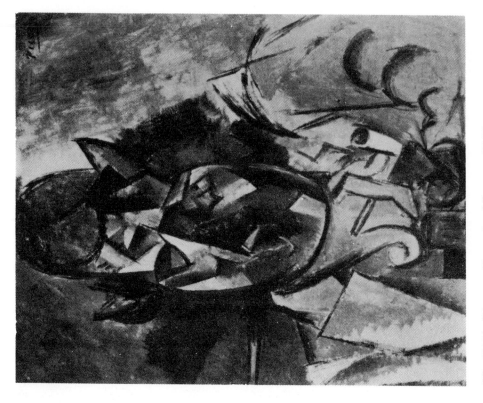

21 (209) Picasso: Portrait of Braque, 1909

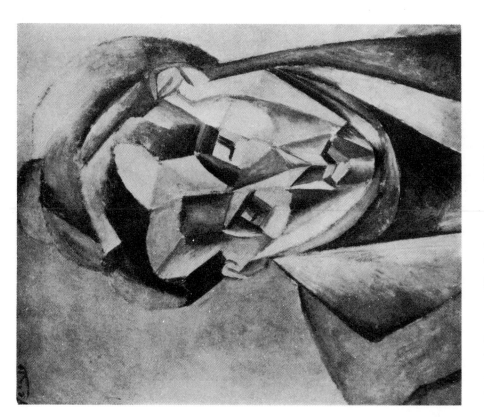

20 (208) Picasso: Head of a woman, 1908-09

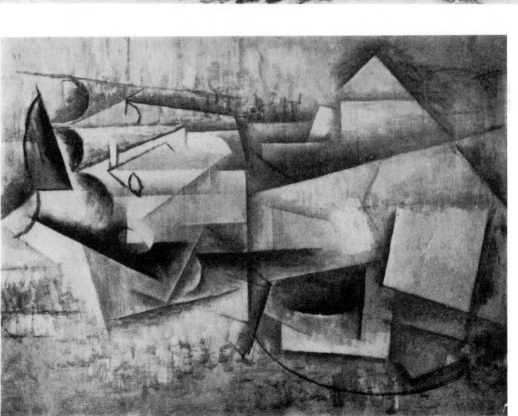

22 (215) Picasso: Arlésienne, 1911-12 (*not in exhibition*)

23 (216) Picasso: Head of a young woman, 1913

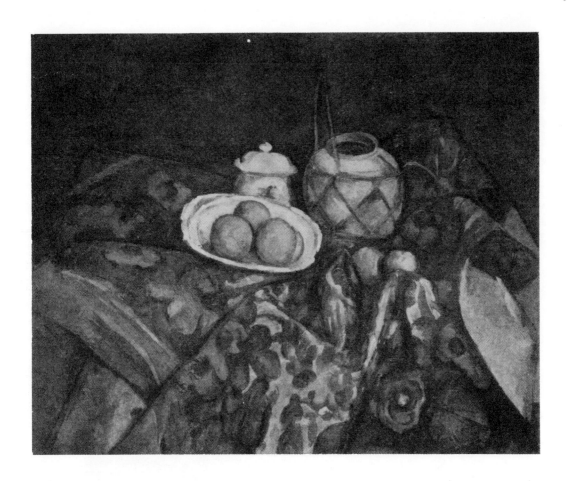

24 (37) Cézanne: Oranges, *c.* 1896

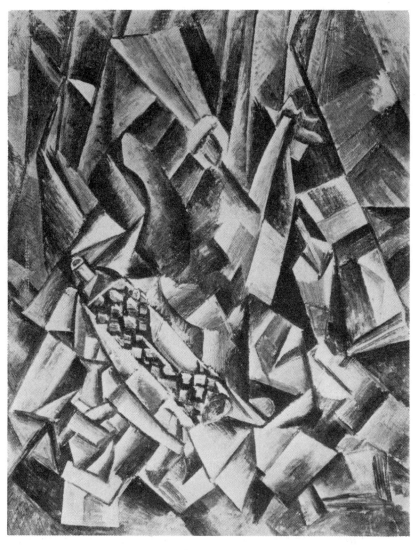

25 (210) Picasso: The tube of paint, 1909

26 (211) Picasso: Drawing, 1913, to explain *The tube of paint*, 1909

tinguishable from one another. Cézanne, in his late still life, *Oranges* (fig. 24), shows a similar tendency to build up angular planes and to eliminate the feeling of depth, though not of course to the same degree.

In spite of the abstract character of Analytical Cubism it remained throughout closely linked to the modified Impressionism of Cézanne. There is a superficial resemblance between the *Town of Gardanne* (fig. 29) of Cézanne and the *Poet* (fig. 30) of Picasso because the shapes of the houses resemble Picasso's geometrizing technique; but there is also a fundamental resemblance in the relations between line and tone, betwen light and dark, and between the *passages*, the merging of planes with space by leaving one edge unpainted or light in tone. This is seen again in a simplified version in the magnificent figure drawing (fig. 27). In it, too, may be seen the counterpoint of straight line edges, vertical and horizontal, with the curved contours of cross-sections—architecturally speaking, a combination of plan and elevation in one drawing.[1] The deformations in Cézanne's drawing (fig. 28) are more curvilinear but anticipate Picasso's to some extent.

Picasso's oval *Violin* (fig. 31) of 1912 is a masterpiece of rectangular surfaces subtly tilted forward or back from the plane of the canvas and varied by sparse souvenirs of the instrument.

Other Cubists

Picasso and Braque were of course not alone in their exploration but throughout they were pioneers in technical audacity, followed a year or two afterwards by other members of the group. The *Seamstress* (fig. 32) of Léger, two years later than Picasso's *Head of a woman* (fig. 20), is still in the facet or block stage of Cubism. Juan Gris' *Portrait of Picasso* (fig. 33) illustrates the systematic, almost academic use of *passage* in deformations of about the same stage as Picasso's *Portrait of Braque* (fig. 21) of three years before. Villon's *The dinner table* (fig. 35) is cursive and sensitive. Marcoussis' *Matches* (fig. 34) is a gentle, personal variant of the tradition; it is especially interesting here because it is the earliest painting in the exhibition to illustrate the use of letters introduced by Braque in 1911.

Delaunay, Duchamp

Picasso and Braque and the other Cubists kept at first to conventional subjects, figures, still life, landscapes, but Delaunay broke a new path by a series

[1] Alfred Stieglitz, the owner of this drawing, has nicknamed it *The Fire-escape*. It so happens that this kind of Cubist analysis was to have a definite influence on architecture as one may see by studying the following sequence: Mondrian (fig. 141), Mondrian (fig. 142), Doesburg (fig. 162), Miës van der Rohe (fig. 163) and Gropius (fig. 164).

27 (213) Picasso: Figure, 1910

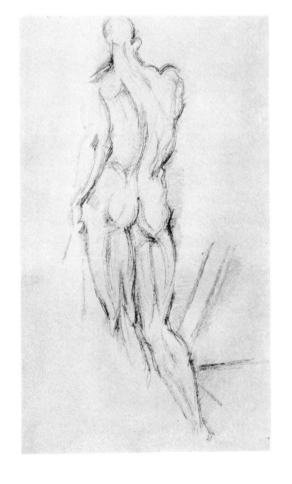

28 (39) Cézanne: Anatomical figure, *c.* 1900

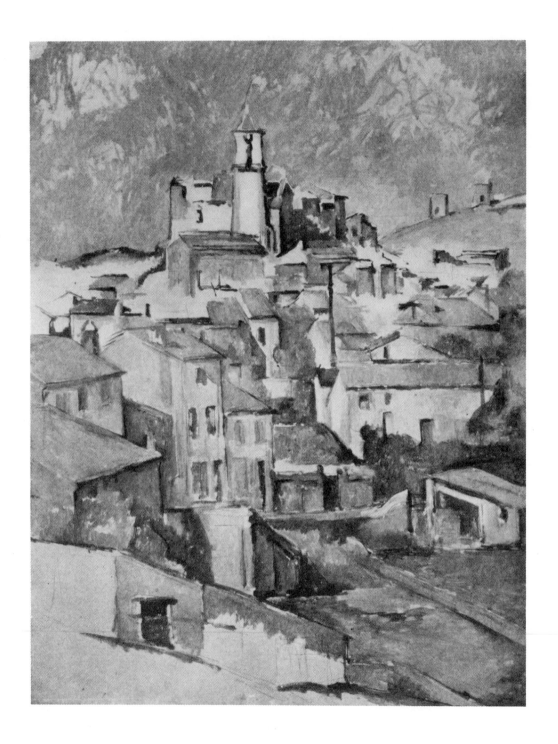

29 (33) Cézanne: Town of Gardanne, *c.* 1885-86

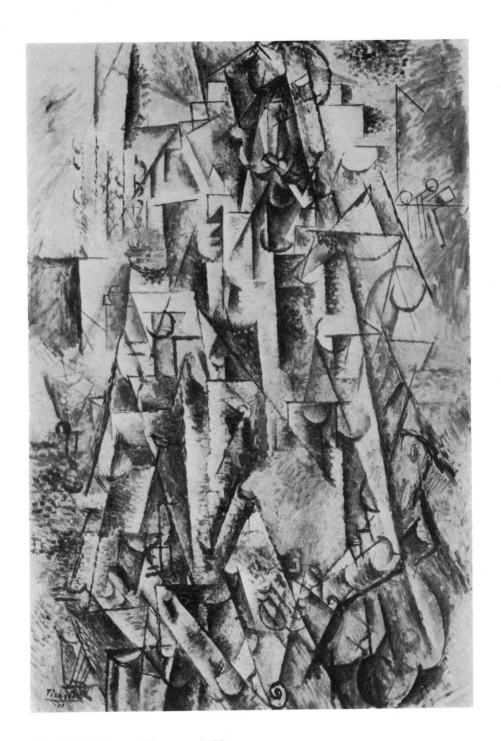

30 (214) Picasso: The poet, 1911

of dynamic, dramatic studies of architecture of which the most famous are *St. Séverin* of 1909 (fig. 36) and the *Eiffel Tower* of 1911 (fig. 37). A series of drawings for *The tower and the wheel* (fig. 38) anticipate Futurist experiment and at the same time suggest the magnificent proto-Cubist interiors of Piranesi's *Prison* etchings (fig. 39).

Of all Cubist paintings the most famous in America is Marcel Duchamp's *Nude descending a staircase* of 1912 (fig. 40). In the *Arlésienne* (fig. 22) of about the same year Picasso had juxtaposed a profile and full face of the head of a static figure. Duchamp draws a whole series of twenty or thirty aspects of the figure in motion, a problem which the Futurists had already attacked the year before but which they were never to solve more successfully. Less celebrated but of greater importance is Duchamp's *Bride* (fig. 41), also of 1912. A work of amazing originality, it can scarcely be called Cubist, but is rather the first of a kind of organic, anatomical abstraction anticipating the explorations of the Surrealists.

During the years 1912-14 the Cubists turned gradually from an analytical to a synthetic technique. This transformation will be described in a later section. In between the two major periods of Cubism, three other movements will be considered: Futurism in Italy, Abstract Expressionism in Germany, and Orphism in Paris.

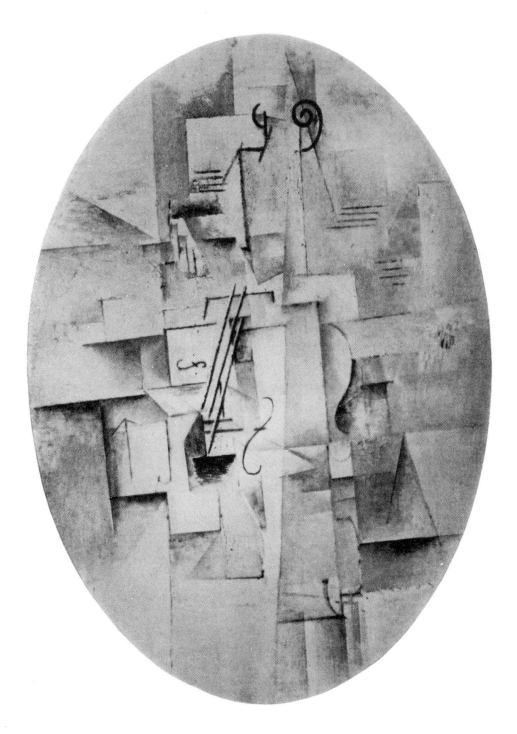

31 (217) Picasso: Violin, *c.* 1912

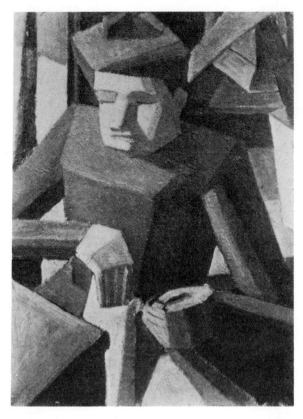

32 (130) Léger: Seamstress, 1910

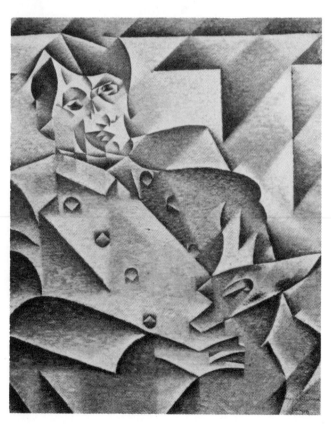

33 (94) Gris: Portrait of Picasso, 1912

34 (162) Marcoussis: Matches, 1912

35 (272) Villon: The dinner table, 1912

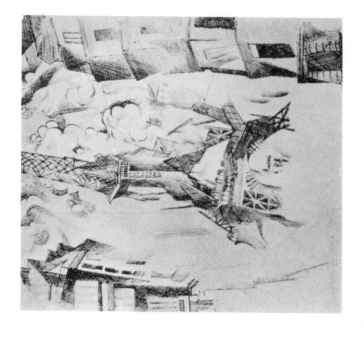

37 (44) Delaunay: Eiffel Tower, 1910

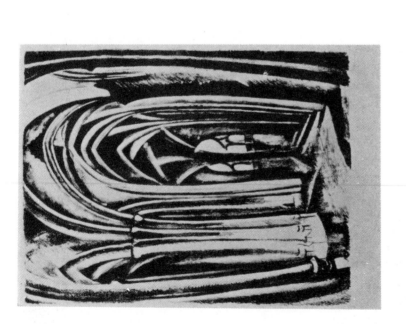

36 (42) Delaunay: St. Séverin, 1909

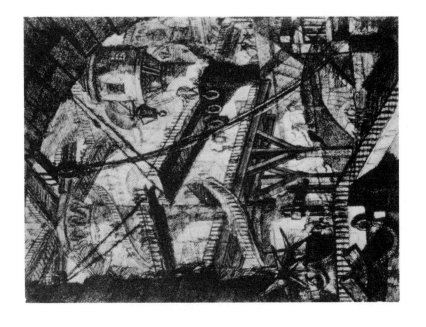

39 (232) Piranesi: Prison, c. 1745

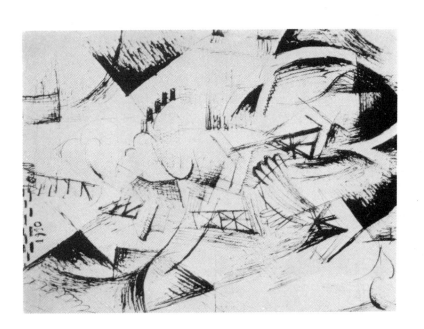

38 (43) Delaunay: Tower with a ferris wheel, 1909-10

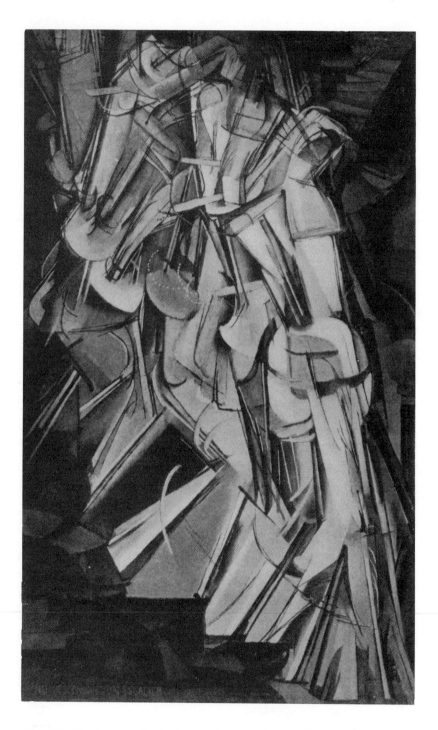

40 (57) Duchamp: Nude descending a staircase, 1912

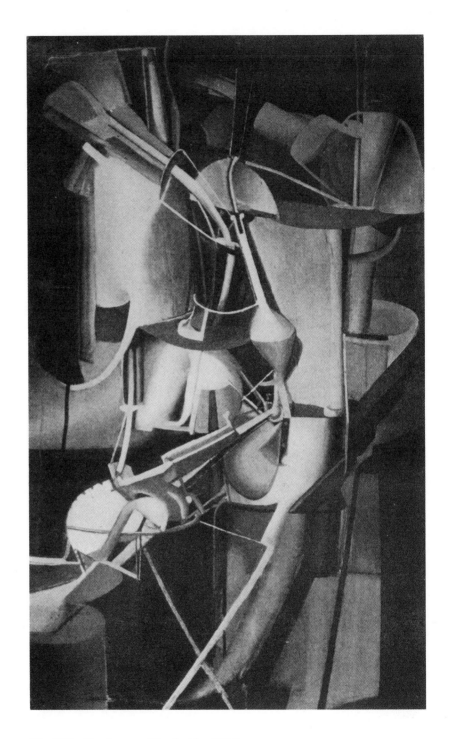

41 (58) Duchamp: The bride, 1912

Futurism

Chronology

1909 Paris, February 20: Marinetti's *Manifesto of Futurism* published in *Figaro*.
1910 Milan, February 11: Signing of the first manifesto of the five Futurist painters: Boccioni (Milan), Carra (Milan), Russolo (Milan), Balla (Rome), Severini (Paris).
1910 Turin, March 8: Proclamation in the presence of Marinetti of the above manifesto at the Chiarella Playhouse.
1910 Milan, April 11: *Technical Manifesto of Futurist Painting*.
1911 First important Futurist painting and sculpture.
1912 Paris, February: First exhibition of Futurist painting at Bernheim Jeune. Followed by exhibitions in London, Berlin, Amsterdam, Vienna, and a dozen other European and many American cities.
1912 Milan, April 11: Manifesto of Futurist sculpture signed by Boccioni.
1913 Paris, June-July: First exhibition of Boccioni's Futurist sculpture at the Galerie la Boëtie.
1914 Milan: Publication of Boccioni's comprehensive summary of Futurism, *Pittura Scultura Futuriste (dinamismo plastico)*.

The Futurist spirit

From Marinetti's first *Manifesto of Futurism*, 1909

"Let's go, say I! Let's go, friends! Let's go! . . .

"A speeding automobile . . . is more beautiful than the Victory of Samothrace . . .

"It is from Italy that we launch . . . our manifesto of revolutionary and incendiary violence with which we found today *il 'Futurismo'* . . . because we want to free our country from the fetid gangrene of professors, archaeologists, guides, and antique dealers.

"Museums: cemeteries . . . Museums: public dormitories . . ."

From the first *Manifesto of Futurist Painting*, 1910

"Destroy the cult of the past, the obsession of the antique . . .

"Exalt every kind of originality, of boldness, of extreme violence . . .

"Consider art critics as useless and noxious . . .

"Rebel against the tyranny of the words 'Harmony' and 'good taste' . . .

"Take and glorify the life of today, incessantly and tumultuously transformed by the triumphs of science."

The quotations suggest the Futurist program and the atmosphere in which it was launched.

Positively, Futurism upheld violence as good in itself, the value of war as a hygienic purge, the beauty of machinery, the glories of the "dangerous life," blind patriotism, and the enthusiastic acceptance of modern civilization. Polit-

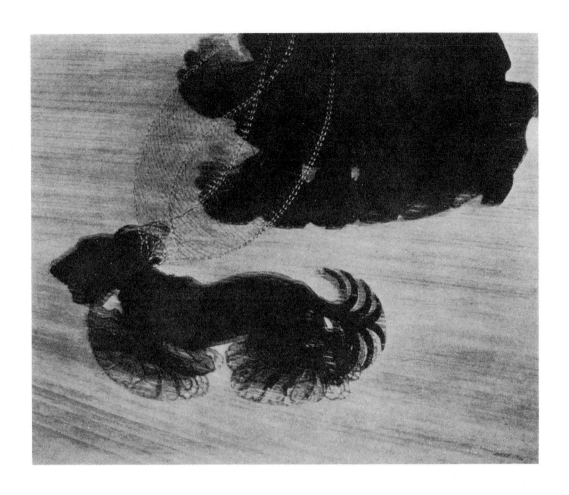

42 (11) Balla: Dog on leash, 1912

ically it was proto-Fascist; philosophically Bergsonian; ethically Nietzschean. Negatively Futurism attacked as a matter of principle the *status quo;* it tried to blast the weight of the past which, in Italy especially, seemed to smother artistic enterprise.

Futurist painting

The technical program of Futurist painting was elaborate but logical. The Impressionists and Neo-Impressionists (1886) had dissolved—analyzed—visual reality into light and color. The Cubists of 1910 had analyzed natural forms into fragments. Both Impressionism and Cubism denied the importance and the integrity of the object. Boccioni wrote, "We must combine the analysis of color (divisionism of Seurat, Signac and Cross) and the analysis of forms (divisionism of Picasso and Braque)."

But this combination was but a first step, for the primary technical problem of the Futurist artists was to express movement, force, and the passage of time. To the Impressionist the light might move and change but the object remained static. The Cubist himself might move about the object but, again, the object itself remained essentially static—a *posed* model or *still* life. Nevertheless, from the Impressionists and Neo-Impressionists, the Futurists learned how to "Destroy the materiality of objects" by means of brilliant color applied in small strokes of the brush; and from the Cubists they learned the technique of disintegration and the principle of "simultaneity"—the simultaneous presentation of different aspects of the same object in a single work of art.

The Futurists applied the device of *simultaneity* not to static but to kinetic and dynamic analysis. They announced that a running horse has not four but twenty legs—and proceeded to paint twenty-legged horses. Balla's *Dog on a leash* (fig. 42) is a lucid and entertaining illustration. A similar effect might be obtained if twenty photographs of a running dog were to be superimposed. It represents Futurism at its simplest.

Russolo's *Dynamism (automobile)* (fig. 43) makes clear a second Futurist device—*lines of force.*[1] The dynamism of an automobile is diagrammed by a series of increasingly acute resisting chevrons through which drives the half-dissolved silhouette of the car.

[1] The Futurist theory of *linee-forze,* the invisible lines which extend the forms of objects into space, was anticipated by Leonardo da Vinci: "The air is filled with an infinite number of lines, straight and radiating, intercrossing and weaving together without ever coinciding; and they *represent* for every object the true FORM of their reason (of their explanation) (*la vera forma della lor cagione*)." Manuscript A, Folio 2; quoted by Paul Valéry in *Variety,* New York, 1927, p. 275, translated by Malcolm Cowley.

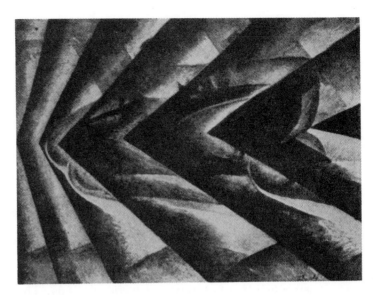

43 (250) Russolo: Automobile (Dynamism), 1913 (*not in exhibition*)

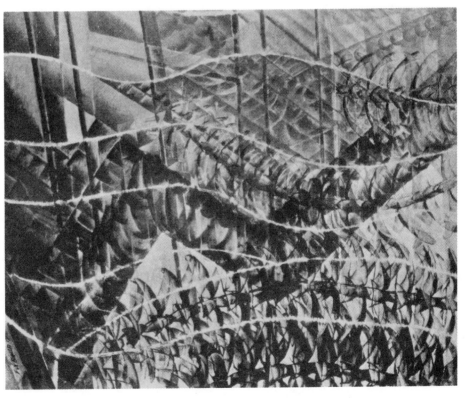

44 (12) Balla: Progressive lines + dynamic sequences (The swifts), 1913

Balla's *The swifts* (fig. 44) combines the technique of kinetic simultaneity (the silhouette of the birds multiplied into a flickering series) with *lines of movement* (the paths of flight charted by wavelike lines).

Still a third device is illustrated: the *compenetration of planes*, an extension of the principle of simultaneity. By this Boccioni, who invented much of the Futurist vocabulary, meant the fusion of the object with its surroundings. The swifts, their paths of motion, and the space in which they fly are fused into one pictorial pattern. In addition, indoors is fused with outdoors; for one sees the swifts through the wall just as well as through the window.

The subject matter of the Cubists, Picasso and Braque, was thoroughly, narrowly traditional—figures, landscape, still life. That of the Futurists was often as courageously experimental as their technique. Balla's *Swifts* even when called by its full title, *Lines of movement + dynamic successions,* is less characteristic of the movement than Russolo's *Dynamism of an automobile* or Severini's sinister *Armored train* (fig. 46). The Futurists were the first group of painters to embrace the modern world of machinery as an essential part of their program.

The night life of cabarets and dance halls was also an orthodox Futurist subject because it represented city life at its brightest and most "kinetic." Severini painted a long series of cabaret scenes and dancers (fig. 45). It is perhaps no accident that he, the only Parisian member of the Futurist group, should also be the most influenced by Seurat's Neo-Impressionism. Certainly Seurat's *Chahut* of 1899 with its reduplication of kicking legs[1] anticipates Severini's "simultaneity" and his frequent use of "pointillism" as well as his subject matter.

Futurist sculpture

Of the first group of Futurists Boccioni was not only the theorist and one of the best painters: he was the only sculptor. Sculpture, one of the most limited and concrete of the arts, was a singularly inappropriate vehicle for the elaborately abstract problems of Futurism. The dauntless Boccioni often attempted the impossible but his failures and the theories which inspired them anticipated many of the most original experiments of the ensuing quarter century.

Boccioni's manifesto of April 1912 on Futurist sculpture is of extraordinary interest. After expressing profound contempt for the sculpture of his time with its inane repetition of nude figures, he lays down these principles which may be paraphrased and abbreviated as follows:

[1] The writer owes this comparison to J. J. Sweeney, Bibl. 93, p. 72, note 1.

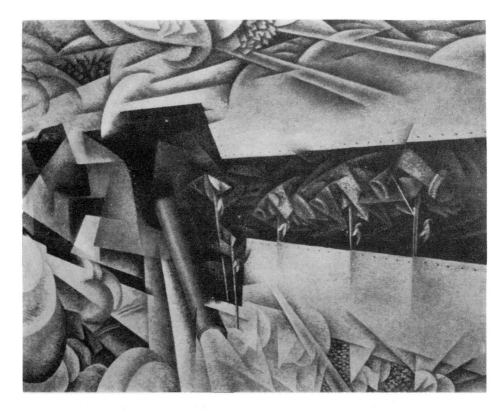

46 (261A) Severini: Armored train, 1915

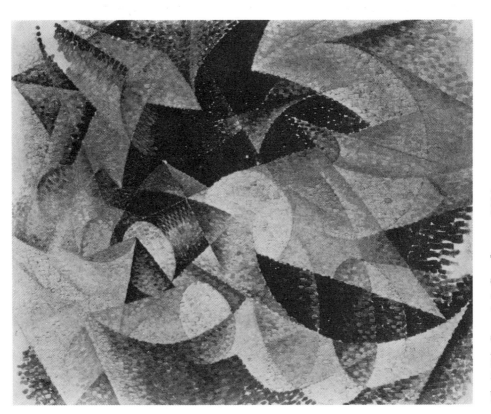

45 (261) Severini: Sea-dancer, 1914

"Sculpture should be the translation into material form of the spatial planes which enclose and intersect an object."

"Sculpture should bring life to the object by making visible its prolongation into space. The circumscribed lines of the ordinary enclosed statue should be abolished. The figure must be opened up and fused in space" (anticipating the first constructions of Pevsner and Gabo, 1915, and the first "pierced" sculpture of Archipenko, 1912).

"There is more truth in the intersection of the planes of a book with the corners of a table in the rays of a lamp than in all the twisting of muscles in all the breasts and thighs of the heroes and venuses which inspire the idiotic sculpture of our time."

". . . we shall have, in a Futurist sculptural composition, planes of wood or of metal, stationary or mechanically mobile" (anticipating the projects for mobile constructions of Gabo, 1922, and the "mobiles" of Calder, 1930).

"We must destroy the traditional and literary nobility of bronze and marble, and the convention that only one material may be used in a single work. Instead one may use in a single work twenty different materials: glass, wood, cardboard, iron, cement, horsehair, leather, cloth, mirrors, electric lights, etc." (anticipating the importance attached to the combination of non-traditional materials in the counter-reliefs of Tatlin [figs. 126, 127] and the Russian Constructivists, 1913-20, and the *collage* reliefs of Picasso, 1913-14 [fig. 98]).

A year later, June 1913, in the catalog of his Paris exhibition, Boccioni developed the idea of dynamic sculpture which he called "architectonic constructions," based upon the spiral as opposed to the static pyramid, anticipating by several years "constructivism" and Tatlin's tower of 1920 (fig. 128).

In his earliest Futurist sculpture Boccioni essayed such sculpturally improbable "fusions" as *Head + house + light.* In the next year, 1912, came the first of his bottle compositions and the first of his striding figures. The "compenetration of planes" and the "fusion of the object with its surrounding atmosphere" are both illustrated by the sculpture called *Development of a bottle in space* (fig. 47). This still life was done two years before Picasso's *Glass of absinthe* (fig. 99). Picasso's Cubist head of 1909, however, may well have influenced Boccioni's figures, such as the series which began with the *Synthesis of human dynamism,* was carried further in 1913 with the *Spiral expansion of muscles in movement,* and culminated in the *Unique forms of continuity in space,* Boccioni's masterpiece (fig. 49). In this striding figure Boccioni tried to show not the "construction of the body" but the "construction of the actions of the body" using, as he described it, a kind of spiral, centrifugal architecture which would serve as a plastic equivalent for the dynamics of organic action. The *lines of force* are visualized as a cloak of swirling streamline shapes which have much the same effect as the drapery of the *Winged victory of Samothrace* (fig. 48).

60

Although the artistic value of the Futurist movement is debatable, its influence upon European art of the following decades was second only to that of Cubism. Futurist methods of propaganda were imitated all over Europe. The Futurist cult of machinery and, often, the Futurist technique reappeared in the work of some of the French Cubists: notably Léger, Duchamp and their disciples; in English Vorticism, 1913-14; in Franco-German Dadaism, 1916-25; in Russian Constructivism and Cubo-Futurism, 1913-22; in the academic methods of Cizek in Vienna (*kinetismus*), 1912; and in French Purism, 1918. Futurism itself was conspicuous in Russia during and just after the War. In Italy under Fascism it has flourished among the younger generation. Marinetti is now a Senator, but the old guard of Futurist artists is dispersed. Boccioni was killed in the War; Severini paints clever still life; and Carrà became, with de Chirico, the leader of the "*pittura metafisica*," 1915.

The *Winged victory of Samothrace*, which Marinetti found less beautiful than a speeding automobile, still holds its own against Boccioni's *Forme uniche della continuità nello spazio*, and the speeding automobile itself is perhaps a finer Futurist work of art than Russolo's *Dinamismo (automobile)*.

Left **47** (14) Boccioni: Development of a bottle in space, 1912

Right **48** Victory of Samothrace, Greek, 4th Century B. C.; *cf.* Boccioni, fig. 49 (*plaster cast in exhibition*)

49 (15) Boccioni: Unique forms of continuity in space, 1913

Abstract Expressionism in Germany

Chronology

1909 Kandinsky first president of the New Artist's Federation, Munich; Marc a member.

1910 Braque, Picasso, Derain send paintings to the Federation's exhibition.

1911 Kandinsky paints first purely abstract composition.

1912 Kandinsky publishes *Upon the Spiritual in Art*, written in 1910 (Bibl. 136). Kandinsky, Marc and others found The Blue Rider group and publish a yearbook (Bibl. 137). Klee and Arp associated with the group.

1913 Feininger joins the group in their Berlin exhibition.

1914 The War. Kandinsky returns to Russia.

1916 Marc killed at Verdun.
Arp a Dadaist in Zurich.

1919 Feininger appointed professor at the Bauhaus, Weimar.
Kandinsky appointed professor at Moscow Academy; active in other official capacities.

1920 Klee appointed professor at Bauhaus.

1921 Kandinsky leaves Moscow for Berlin and, 1922, appointed professor at Bauhaus.

1926 Kandinsky, Klee, Feininger, Jawlensky form The Blue Four.

1933 Bauhaus closed. Feininger to Halle; Kandinsky to Paris; Klee, professor at Düsseldorf since 1930, to Switzerland.

The Blue Rider group of Munich Expressionists was second only to the Cubists of Paris in importance among pre-War abstract movements. Kandinsky, the leader, Marc and Klee were the nucleus of the group. Feininger did not come in contact with it until the Berlin exhibition of 1913.

Kandinsky

Kandinsky, originally a student of law and political economy, had painted under Franz Stuck in Munich. He exhibited in Berlin and Paris in 1902 and, before settling again in Munich, lived for a time near Paris in 1906 when *Fauvisme* was triumphant. Doubtless he saw the work of Matisse, who was then at work on his *Fauve* masterpiece, the *Joie de vivre* (*cf.* fig. 8). At any rate Kandinsky's art between 1906 and 1910 was *Fauve* in character and under the strong influence of Gauguin and van Gogh, but with an arbitrariness of color and a deformation of "nature" which surpassed even Matisse. After 1910 his painting grew more and more abstract although recognizable objects did not disappear entirely from all his paintings until about 1914.

Kandinsky's *Landscape with two poplars* (fig. 51) of 1912 shows him at his least abstract and at his closest to Gauguin. In fact, the *Landscape with two poplars* resembles, to a remarkable degree, Gauguin's *Hospital garden at Arles*

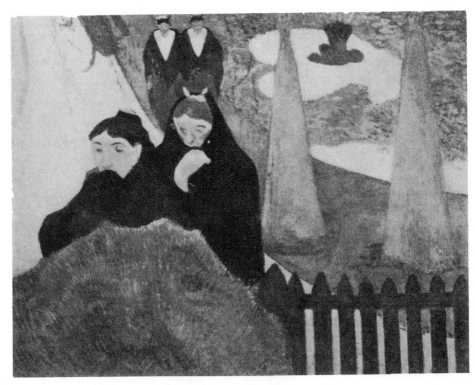

50 (79) Gauguin: Hospital garden at Arles, 1888

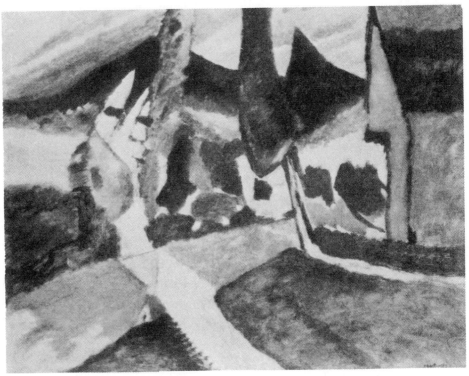

51 (102) Kandinsky: Landscape with two poplars, 1912

(fig. 50) of 25 years before. Both paintings depend on bold flat patterns and brilliant color, and both take radical liberties with perspective and drawing. But Kandinsky's *Improvisation no. 30* (fig. 52) of the following year, is incomparably more abstract and illustrates a radically new way of painting which in the previous generation only Redon (fig. 9) had in any way anticipated. Kandinsky has given his own explanation[1] of *Improvisation no. 30* which he had himself called *Cannons* for purposes of identification:

"The designation 'Cannons' is not to be conceived as indicating the 'contents' of the picture.

"These contents are indeed what the spectator *lives,* or *feels* while under the effect of the *form and color combinations* of the picture. This picture is nearly in the shape of a cross. The center—somewhat below the middle—is formed by a large, irregular blue plane. (The blue color itself counteracts the impression caused by the cannons!) Below this center there is a muddy-gray, ragged second center almost equal in importance to the first one . . .

"The presence of the cannons in the picture could probably be explained by the constant war talk that had been going on throughout the year. But I did not intend to give a representation of war; to do so would have required different pictorial means; besides, such tasks do not interest me—at least not just now.

"This entire description is chiefly an analysis of the picture which I have painted rather subconsciously in a state of strong inner tension. So intensively do I feel the necessity of some of the forms, that I remember having given loud-voiced directions to myself, as for instance: 'But the corners must be heavy!' "

His explanation is resumed in this generalization:

"Whatever I might say about myself or my pictures can touch the *pure artistic meaning* only *superficially.* The observer must learn to look at the picture as a graphic representation of a *mood* and not as a representation of *objects.*"

Broadly speaking, Kandinsky's theory of art[2] was mystical, depending upon an awareness of the spiritual in the material, and an expression of this feeling through the material medium of paint. He often thought of painting in terms of music just as his contemporary and compatriot Scriabine frequently thought of music in terms of painting. Kandinsky, following musical terminology, called his more spontaneous and casual paintings *Improvisations* and his more calculated works *Compositions* (*cf.* figs 52 and 53).

Kandinsky's method was the logical expression of his theory. Canvases like the *Improvisation no. 30* seem to have been done almost in a trance "rather subconsciously" and "in a state of strong inner tension." As an expression of lyrical, spontaneous excitement they anticipated the more abstract, Surrealist work of Masson and Miro (figs. 200, 204) both in method and form.

During and after the War, Kandinsky lived in Russia where he participated

[1] Published in Eddy, Bibl. 156, pp. 125-26.
[2] *Cf.* Bibl. 136 and Bibl. 137, 2nd ed., pp. 74-32.

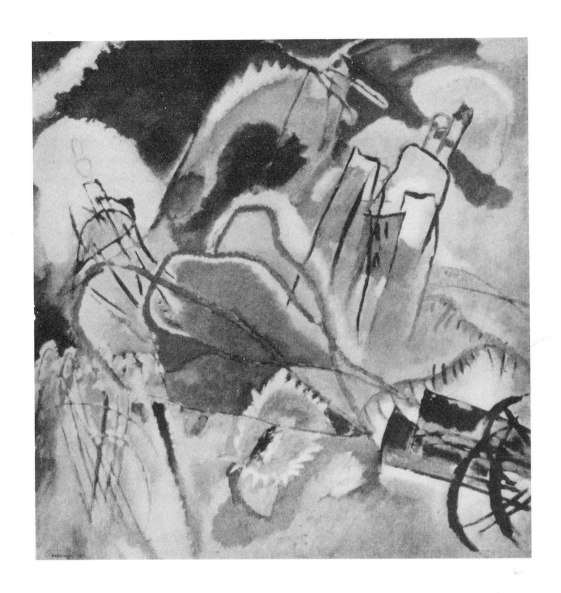

52 (103) Kandinsky: Improvisation no. 30, 1913

in vanguard exhibitions and played an important official role throughout the heyday of the Leftist movements after the Revolution. During these years his style changed, apparently under the influence of the Suprematists. In the *Composition no. 1* (fig. 53) of 1921 he combined the free, improvised, irregular forms of his earlier work (figs. 3, 52,) with the circles and straight lines of Malevich (fig. 4) and Rodchenko (fig. 118). Subsequently his work became more drily geometrical but in the last few years he has turned to more organic forms, perhaps under the influence of the younger Parisians, Miro and Arp, to whom he pointed the way twenty years before.

Klee, Marc, Feininger, Arp

Paul Klee is extremely interesting in his subject-matter but his form is equally original and of an incredible variety. Far more than Kandinsky, Klee assimilated influences from the art of children (*cf.* fig. 199) and the insane and from the great variety of primitive, medieval and exotic traditions represented in the pages of *Der Blaue Reiter* (Bibl. 137). Matisse's art was also an important factor in his development and Picasso's *collage* Cubism certainly influenced his watercolor, *Opus 32* of 1915 (fig. 56, *cf.* fig. 67). But with his sensitive color he is primarily a graphic artist, a master of line. His drawing (fig. 199), in its indication of fantastic or abstract forms, is comparable in a way to Kandinsky's painting: both have often used an almost subconscious or automatic method of composition. Klee's influence on the later Surrealists, Ernst, Miro and Masson, was considerable both in his spontaneous linear technique and in his invention of subjective Surrealist images.

About 1912 both Marc and the German-American Feininger came under the influence of Cubism. While both were excellent designers and original colorists neither invented radically new forms as did Kandinsky and Klee. In a broader treatment of German abstract painting their handling of subject matter— Marc's animals (fig. 54) and Feininger's seascapes and townscapes (fig. 55)— would deserve special examination. Few other painters were able to fuse Cubist technique with romantic or lyrical sentiment.

Hans Arp, an Alsatian who studied in Weimar, was one of the lesser members of The Blue Rider before the War. His frequent visits to Paris, as well as the exhibition of paintings by Picasso and Braque in Munich, kept him in contact with Cubism, which must have suggested the paper-pasting technique of his *Composition* (fig. 57) done in 1915. Composed entirely of nearly perfect rectangles, it is more purely abstract than anything of the Parisian Cubists or the Munich Expressionists. It is purer, too, than Kupka's *Vertical planes* of

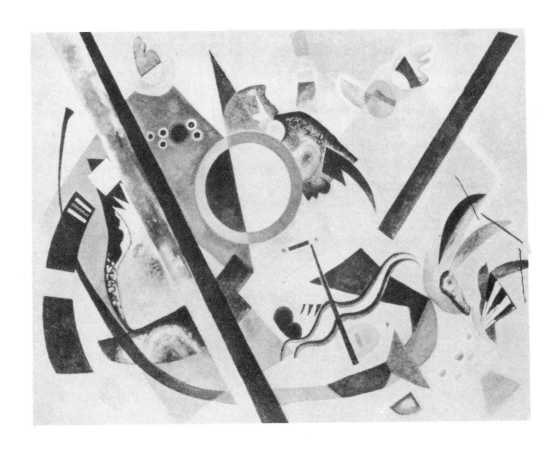

53 (105) Kandinsky: Composition no. 1, 1921

1912-13 (fig. 62) though not so simple, and anticipates by a year or two the Neo-Plasticist passion for squares. Only Malevich in Moscow in 1913 had gone further in the direction of pure geometry. In the following year, 1916, Arp became one of the leaders of the Zurich Dadaists. His later work (figs. 207-209) is generally biomorphic and, except in purity of feeling, shows little resemblance to his squares of 1915.

After the War, Kandinsky, Klee and Feininger were re-united at the Bauhaus school in Weimar. There they provided what Gropius, the director, called "spiritual counterpoint" to the machinism, technolatry, and rationalism which characterized the Bauhaus' educational policy.

54 (161) Marc: Landscape with animals, 1912-14

55 (70) Feininger: Tall buildings no. II, 1913

56 (107) Klee: Opus 32, 1915

57 (7) Arp: Composition, 1915

Abstract painting in Paris

Orphism: Delaunay

Pure-abstract painting had no such important position in Paris in the decade 1910-1920 as it held in Russia, Germany and Holland. Its practitioners were of two kinds, heretic Cubists like Delaunay, Gleizes and Villon, or independent figures such as Kupka and Arp.

Picasso and Braque approached very near geometrical abstract design in their Cubist heads and still life of 1911-13 (figs. 23, 31), but during these years two other painters, Delaunay and Kupka, went still further, painting the first pure abstractions in Western Europe, if we except the contemporary work of Kandinsky in Munich. Delaunay's rainbow-colored *Windows* of 1912 (fig. 58) has been mentioned as leading the sober Cubists toward more brilliant color. He gradually eliminated every vestige of natural appearances until he had achieved the *Disks* (fig. 59). Delaunay called his art of this time *Simultanéisme*—simultaneous color-contrasts.[1] Apollinaire called it Orphism—an art of pure "musical" lyricism of color.

Orphism: Kupka

In connection with Orphism, Apollinaire mentioned Frank Kupka, one of the least known but earliest pioneers of abstract painting. Kupka had never been a Cubist but had worked during 1911 in simplified, nearly abstract Neo-Impressionist technique. Seurat's theories of color-contrast induced him to study the use of prismatic colors. This led to the *Disks of Newton* of 1912 (fig. 60) which seems to have anticipated Delaunay's *Disks* (fig. 59). At the Salon d'Automne of 1912, moved by a desire for further simplification, he exhibited the *Fugue in red and blue* (fig. 61), which was an arabesque of circular and eliptical lines enclosing areas of red and blue. This was a clarification of the *Disks of Newton.*

At the end of the year Kupka began the final version of *Vertical planes* (fig. 62) the first studies of which had been done in 1911. Its cold grey rectangles sharpened by a single violet plane anticipate the geometric compositions of Malevich (fig. 112), Arp (fig. 57), and Mondrian (fig. 145). *Vertical planes* was exhibited at the Indépendants in the spring of 1913. Within a year's time Kupka had painted what are probably the first geometrical curvilinear and the first rectilinear pure-abstractions in modern art. In comparison with these

[1] Evidently derived from the title of Chevreul's *De la loi du contraste simultané des couleurs*, Paris, 1839.

conclusive and carefully considered achievements the slightly earlier abstractions of Kandinsky and Larionov seem tentative.

Synchromism

Synchromism, the name given to their paintings by two Paris-Americans, MacDonald-Wright and Morgan Russell, was a movement closely related to Orphism. The first large Synchromist exhibition was held in Munich in June 1913 but the first purely abstract "Synchromy" was not shown until the exhibition in Paris in the autumn of that year. In spite of their elaborate theory,[1] noisy propaganda, and aggressive attacks upon the Orphists, their paintings were obviously not very different from such works of Kupka as the *Disks of Newton* painted in 1912.

Other abstract tendencies

A few years later, about 1920, Gleizes and Villon turned from a highly abstract version of Cubism (fig. 80) to a kind of systematic composition of flat, superimposed, straight-edged planes of color (fig. 81) similar in pattern to the Picasso *Guitar* of 1920 (fig. 79) but constructed without reference to a natural object.

The nearly abstract biomorphic and machine paintings of Duchamp and Picabia done between 1912 and 1918 (figs. 41, 191, 193) are better considered in relation to Dada and Surrealist abstractions which they anticipate. Arp's pre-Dada abstract *collage* (fig. 57) should also be mentioned here. It was done in 1915, possibly before Arp settled in Zurich, and is a work of remarkable originality with no close analogies to contemporary work in either Munich or Paris in both of which centers Arp was at home.

[1] Expounded by W. H. Wright, Bibl. 95. Wright upheld Synchromism as the culmination of European art.

59 (46) Delaunay: Disks, *c.* 1913

58 (45) Delaunay: The windows, 1912

60 (114) Kupka: Disks of Newton, 1912

62 (116) Kupka: Vertical planes, 1912-13

61 (115) Kupka: Fugue in red and blue,
1912 (*not in exhibition*)

Synthetic Cubism

Chronology

1910-
1911 Braque complicates Analytical Cubism by adding imitation textures and letters.

1912 Braque and Picasso add pasted paper (*collage*) to drawings and paintings. Delaunay moves toward brightly colored "Orphism."

1913 Transition from Analytical to Synthetic Cubism as in Braque (fig. 63), which shows influence of such *collages* as fig. 64. Transitional works of Picasso (figs. 23 and 65). *Collages* by Gris (fig. 66) and Picasso (fig. 67) mark return to color.

1914 Synthetic Cubism, at first quasi-geometrical, Braque (fig. 73), Gris (fig. 68). La Fresnaye (fig. 69), begins to go soft and decorative with frequent use of pointillist technique borrowed from Seurat: Braque (fig. 74), Picasso (fig. 75).

1915 The War. Picasso continues decorative Synthetic Cubism but also begins series of realistic "neo-classic" portraits. Gleizes in New York (fig. 72); Braque wounded and discharged.

1916-
1920 Picasso, Braque, Gris further develop Synthetic Cubism (figs. 70, 76, 77, 78). Picasso in Italy 1917; designs for Russian Ballet. Picasso arrives at a simple, flat, brightly colored geometric Cubism (fig. 79). Léger's Cubism strongly influenced by machinery (fig. 84). Ozenfant and Jeanneret (Le Corbusier) start Purism (fig. 178). Léonce Rosenberg supplants Kahnweiler (a German citizen) as principal agent for Cubists. Apollinaire dies (1918).

1921 Picasso's *Three musicians*, Legér's *Le grand déjeuner* (fig. 85) masterpieces of Cubism. The movement which had begun to disintegrate in 1914 now loses all sense of continuity and homogeneity. Most of the artists, however, continue to experiment in a Cubist or abstract direction along with more realistic work.

1923 Picasso begins to use frequent curved lines instead of straight in Cubist compositions (fig. 87).

1924 Léger to Italy. Léger's Cubist *Ballet mécanique* (fig. 184).

1925 Picasso begins to introduce Surrealist elements into his work in Cubist tradition. Léger begins series of large architectonic compositions (fig. 86).

1928 Picasso reverts to straight line Cubism in such works as *The painter and his model* and *The studio* (figs. 88, 89). Begins serious experiments in sculpture and constructions. Braque, Gleizes and Marcoussis continue to work in the Cubist tradition.

Texture: *collage* (paper-pasting)

The development of Cubism during its first six years from 1906 to 1912 has been called analytical because of the progressive tearing apart or disintegrating of natural forms. Throughout this progression color had been gradually eliminated, especially in the work of Braque and Picasso; and the method of applying paint had been generally in the Cézanne-Impressionist tradition of hatching or flecking combined with frequent plain or unpainted surfaces as in Cézanne watercolors or oils (fig. 29). But in the midst of this tradition of technical modesty, heresies began to appear, mostly through the inventiveness of Braque. Braque had been in his youth apprenticed to his father, a housepainter, and was as a result thoroughly trained in the illusionistic technique of simulating the grains of wood and marble by means of paint. As early as 1910 in a still life he had introduced a foreshortened nail with an illusionistic shadow, a trick, a *trompe-l'oeil*. In the following year he began to paint imitation textures and letters as in the somewhat later *Still life with playing cards* (fig. 63) of 1913. Sometimes the letters were associated with a newspaper or a sheet of music but as often they formed fragmentary independent words. These textures and letters contributed not merely to the variety of forms and surfaces but also to what might be called Cubist realism—that is, an emphasis not upon the reality of the represented objects but upon the reality of the painted surface.

In the development of Analytical Cubism from the head (fig. 20) to the head (fig. 23) the disintegrated image of the natural object gradually took on a more and more abstract geometrical shape. In the *Still life with playing cards* (fig. 63) the geometrical shapes are so remotely related to the original form of the object that they seem almost to have been invented rather than derived. Their texture further adds to their independent reality so they may be considered not a breaking down or analysis, but a building up or synthesis. The difference in point of view is made clear by the addition in 1912 of *collage*, the pasting of strips of paper, bus tickets, newspapers, playing cards etc. upon the canvas as part of the composition. This was a logical culmination of the interest in simulating textures and a further and complete repudiation of the convention that a painter was honor-bound to achieve the reproduction of a texture by means of paint rather than by the short cut of applying the texture itself to his canvas. In this way, paradoxically, the Cubists, having destroyed in their paintings the image of the natural world, began to apply to their paintings actual fragments of the natural world. True, these fragments were at first

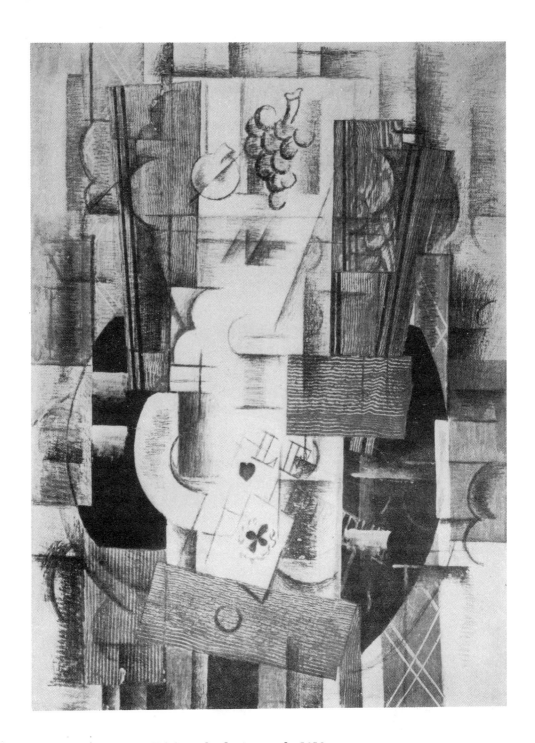

63 (25) Braque: Still life with playing cards, 1913

65 (219) Picasso: Still life, 1913

64 (24) Braque: Composition, 1913

67 (220) Picasso: **Still life with guitar, 1913**

66 (96) Gris: **Still life, 1914**

little more than surfaces but only a year or so after his first pasted paper Picasso had begun to make "reliefs" of glued spools, lathes, moldings and other solid objects (fig. 98).

In the years 1912-14 Picasso, Braque, Gris and the others rivalled each other in the variety and originality of their *collages*, combining the pasted materials with drawing and painting (figs. 64 to 67). *Collage* encouraged a still greater variety of surface handling as in Braque's *Music* of 1914 (fig. 74) in which areas of sawdust texture are applied to the canvas. In this canvas and in the *Green still life* of Picasso of 1914 (fig. 75) and the later oval *Still life* of Braque of 1918 (fig. 77), stippling and pointillism borrowed from Seurat and the Neo-Impressionists added to the vibration and variety of the surface. Before the end of 1914 a decided softness affects for a brief period not only the surface but the design of Picasso and Braque; this may be clearly seen by comparing Braque's *Oval still life* (fig. 73) with the slightly later *Music* (fig. 74) or Picasso's *collage, Still life* (fig. 67), with the *Green still life* (fig. 75). Decorative color reappears in the work of the leading Cubists, possibly through its use in such *collages* as Picasso's *Still life* of 1913 (fig. 67). In any case the days of dry, ascetic Analytical Cubism were definitely done before the end of 1914.

The renaissance of color

The renaissance of brilliant color among the Cubists was not initiated however by Braque and Picasso but by Delaunay and Picabia. In 1912 Delaunay exhibited the *Windows* (fig. 58) which was painted entirely in gay, sparkling rainbow colors. The *Windows* was extremely abstract in concept and was followed within a year by a type of entirely abstract composition (fig. 59) which Apollinaire called Orphism—a movement in which the non-Cubist painter Kupka was also a pioneer.

Léger, who had been working in sober blues and greys, began to use vibrant "stained glass" reds, blues, and greens in paintings reminiscent of facet Cubism in form but more loosely knit (fig. 71). Gleizes, too, deserted monochrome for vigorously colored, severely designed compositions like the *Brooklyn Bridge* of 1915 (fig. 72). La Fresnaye along with his large semi-Cubist figure compositions made a series of still life paintings combining brilliant color with a sensitive perfection of design (fig. 69). During the years of Synthetic Cubism, Gris held his own even against Picasso and Braque, achieving a series of *collages* and painted compositions unsurpassed in precision and refinement (figs. 70, 76).

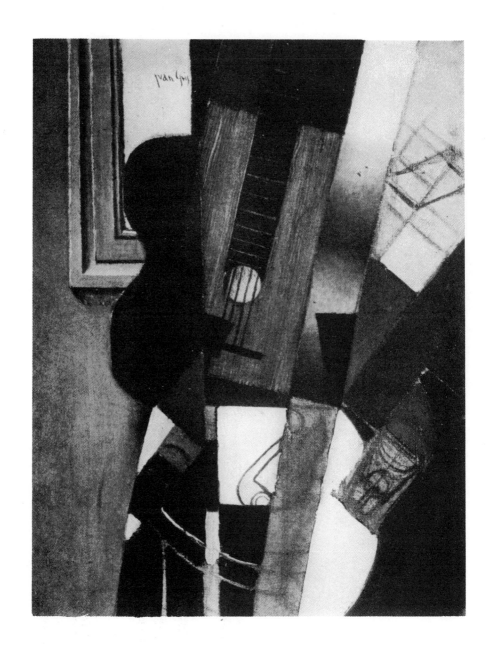

68 (95) Gris: Composition, *c.* 1914

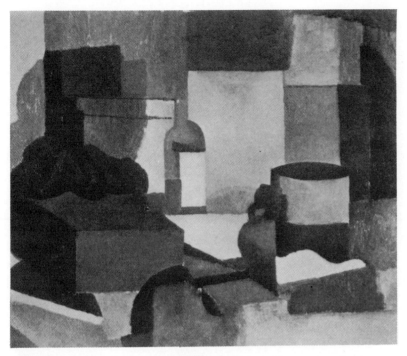

69 (118) La Fresnaye: The bottle of port, 1914

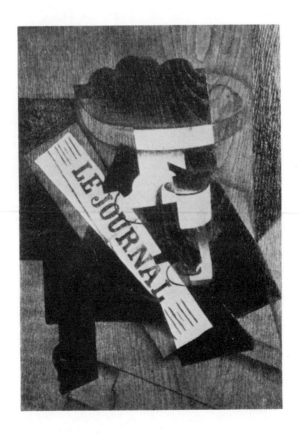

70 (97) Gris: Still life, 1916

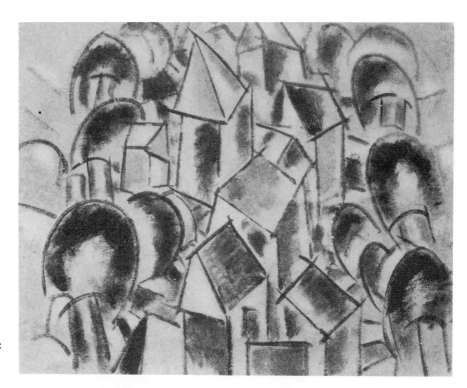

71 (131) Léger:
Village in the
forest, 1914

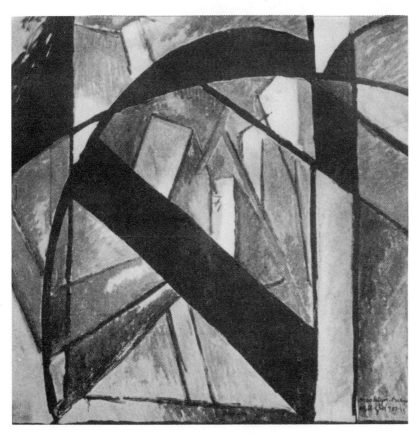

72 (88) Gleizes: Brook-
lyn Bridge, 1915

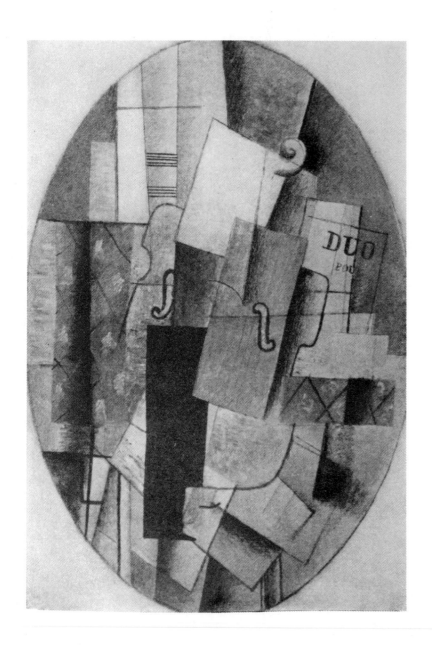

73 (26) Braque: Oval still life, 1914

74 (27) **Braque: Music, 1914**

75 (221) Picasso: Green still life, 1914

76 (98) Gris: Still life, 1917

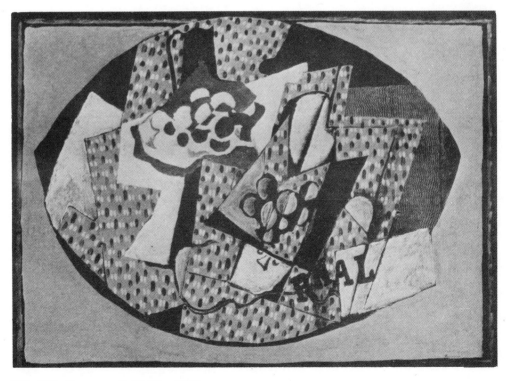

77 (28) Braque: Still life, 1918

78 (224) Picasso: The table, *c.* 1919-20

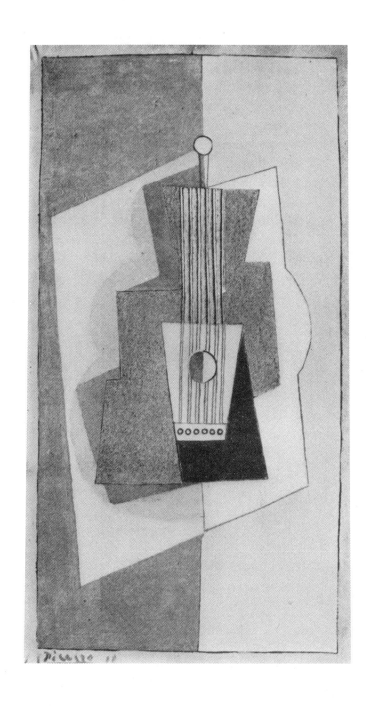

79 (225) Picasso: Guitar, 1919

The tendency toward flat, rectangular shapes in Cubism reasserted itself in Picasso's work of 1916-20. The complex pattern of *The table* (fig. 78) is reduced in the *Guitar* (fig. 79) to an extreme, almost geometrical severity relieved by brilliant color and sawdust textures. Picasso was not to pass far beyond the *Guitar* in the direction of pure-geometrical abstraction which had already been reached by Kupka in Paris, Malevich in Russia, and Mondrian in Holland.

As a movement Cubism had consistently stopped short of complete abstraction. Heretics such as Delaunay (fig. 59) had painted pure abstractions but in so doing had deserted Cubism. About 1920 Gleizes and Villon, possibly under Picasso's influence (fig. 79), developed a system of flat quasi-geometric design (fig. 80) which at times they turned to pure abstraction (fig. 81). Their influence is seen in McKnight-Kauffer's poster for the London subway (fig. 82).

 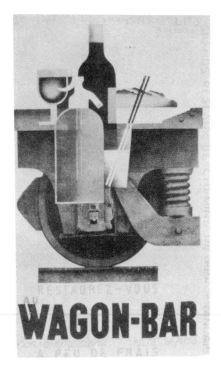

82 (342) McKnight-Kauffer: Poster for London Underground, 1927

83 (331) Cassandre: Poster for dining cars, 1932

92

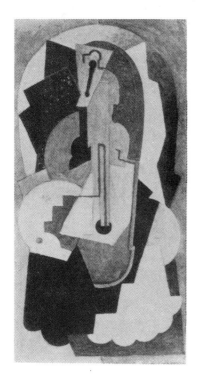

80 (89) Gleizes: Composition, 1920

81 (273) Villon: Color perspective, 1922

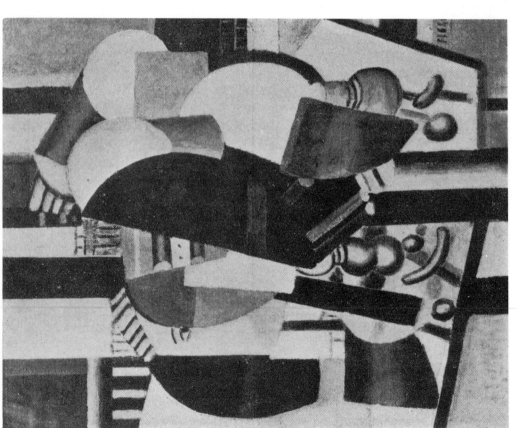

84 (132) Léger: Breakfast, c. 1920

85 (133) Léger: Luncheon, 1921

Later Cubism

From 1918 to 1920 Léger painted a long series of vigorous and often highly abstract compositions strongly under the influence of machine esthetic. Clangorous reds, blues, greens, steel greys, stencil letters, wheels, tubes were mingled in a restless tumult. The *Breakfast* of 1920 (fig. 84) is a characteristic work of the end of this machine period. It serves as a transition to Léger's masterpiece *Le grand déjeuner* of 1921 (fig. 85). In this magnificent decoration Léger painted more easily recognizable forms in a more intelligible perspective but the intention and the effect is essentially abstract. The monumental stability is, however, a new development in Léger's work. This architectonic quality and the machine-like rigidity of his composition suggest a relation to the contemporary painting of the Purists, Ozenfant and Le Corbusier (fig. 178), then at the height of their activity. In fact Léger seems to have been influenced somewhat by the Purists in such work as the *Composition no. 7* (fig. 86) with its careful profiles and silhouettes. But Léger escaped the dryness and prettiness of most Purist paintings and at times achieved a hieratic splendor suggestive of the mosaics he had admired during a visit to Italy in 1924.

The later development of Cubism in Picasso's work is of extreme variety even though it has formed only one part of his activity during the past fifteen years. In 1921 he painted two versions of the *Three musicians*[1] which are often considered his masterpieces in the Cubist style. They continued the angular decorative style of *The table* (fig. 78) and the *Guitar* (fig. 79) of the previous year. In 1923 he painted a series of Cubist still lifes in which he abandoned predominantly straight lines and angles for the use of soft curved forms often against a somber background (fig. 87).

After passing through many mutations Picasso painted in 1928 a series of large compositions of extreme angularity. Although done the same year and in approximately the same style both the large compositions, *The painter and his model* and *The studio*, have been included because they provide an interesting contrast. On the page opposite *The painter and his model* (fig. 88) is an analysis of its composition. *The studio* (fig. 89) is sparser and more geometric in style. In relation between lines and areas of tone it seems definitely comparable to Picasso's work of 1913 such as the *Head of a young woman* and especially the *collage Still life* (figs. 23 and 65). In the center of the picture is a table with still life and at the right, apparently, a white bust

[1] Bibl. 44, plate 128.

86 (134) Léger: Composition no. 7, 1925

in the position corresponding to that of the artist in *The painter and his model*. Above the table are the same rectangles of paintings or mirrors, motives which Léger had often used before (*cf.* fig. 85). While the method of composition is superficially Cubist there is, in the masks of the figures, an element of disquieting Surrealism very different from the more reticent sentiment of Cubism in its earlier years.

87 (226) Picasso: Still life, 1923

88 (228) Picasso: The painter and his model, 1928

The painter and his model

A self-portrait of Picasso characterizes the artist seated on the right at his easel. With palette in one hand and palette knife in the other, he is engaged in working from a model who is posing at the other side of the room. On the canvas before him is the profile painted from the model. In the center background is a red-topped table with a green apple, above which hangs a framed mirror. One of the two apples resting on the window sill reappears near the profile-portrait of the model.

The picture contains one of the rare flashes of Picasso humor, which grows to the proportions of a commentary by the manner and force with which it is integrated as an idea into the structure of the composition. The artist and his model are abstracted to an advanced degree while the concept in the canvas on the easel is in terms of realism. By this reversal in the scheme of reality the extraordinary artist and model are declared ordinary and the natural profile becomes the astonishing product of the artist's invention.

The impulse from which this concept emerges is visualized as a shaft of light projected literally from the artist's brain. The light converges to a point where it forms a contact with the palette knife, after which it opens up in hour-glass fashion as crystallization, releasing upon the canvas a visible image—the natural profile. The concentration of this white light is most intense on the small canvas, where the pigment is built up stratum upon stratum, embedding the black line in a deep rut down which the profile flows like a river. The action of the surrounding white triangles produces a prismatic reflection of the light, and this encases the whole area of the easel in a rapture of visionary excitement.

A large oblique area is thus suddenly and surprisingly interjected in the composition as the center of dynamics.

By a constant recession of front planes and equally forceful advance of rear planes, Picasso achieves a counter-balance of spatial weights producing two-dimensional equilibrium. This activity is assisted by the directional drive of the heavy black lines, through the open construction of which it may be observed.

The various color values are employed in similar action, by which means the widely different gradations of tone and quantities of saturation are brought into a common level on the surface plane.

Picasso has avoided the deflated vitality of decorative flat pattern by transforming the three dimensions of nature into plastic elements of a new two-dimensional integration.

HARRIET JANIS

89 (229) Picasso: The studio, 1928

Cubist sculpture—Paris, 1909-1920

Chronology

Material in parenthesis is not directly in the Cubist tradition

*c.*1904 (Discovery of Negro sculpture by Vlaminck [?]).

1907 (Derain's *Crouching figure; cf.* Bibl. 26, 2nd edition, p. 225).

1908 (Brancusi's *Kiss*).

1909 Picasso's *Head* (fig. 90).

1910 Archipenko's *Hero* (fig. 92).

1911 (Milan, Boccioni's first Futurist sculpture).

1912 Archipenko's construction *Médrano* and *Walking woman* (fig. 93).
Laurens' first Cubist sculpture.
(Milan, Boccioni's bottles and striding figures—figs. 47, 49).
Duchamp-Villon's design for house with cubistic ornament.

1913 Archipenko's *Boxing* (fig. 94).
Picasso's *collage* reliefs (fig. 98).
Moscow, Tatlin's relief constructions (*cf.* fig. 126).
(London, Epstein's *Rock drill*).
(Paris exhibition of Boccioni's Futurist sculpture).

1914 Duchamp-Villon's *Horse* (fig. 97).
Lipchitz' first Cubist sculpture.

1915 Lipchitz' *Bather* (fig. 100).
Archipenko's sculpto-paintings (fig. 95).
Laurens' constructions in wood (*cf.* fig. 104).
(Moscow, Tatlin's counter-reliefs; *cf.* fig. 127).
(Oslo, Gabo's first construction).

1916 Lipchitz' *Sculpture* (fig. 102).

1917 Gris' *Toreador* (fig. 103).
Picasso's costumes for the Managers in the ballet *Parade.*
(Leyden, Vantongerloo's *Construction within a sphere*, fig. 210).

1918 Duchamp-Villon dies of fever contracted during the War.

*c.*1918 Lipchitz' and Laurens' polychrome reliefs.
(Leyden, Vantongerloo's *Volume construction*, fig. 143).

Cubist sculpture throughout its course was secondary to Cubist painting and often closely dependent upon it.

The first Cubist sculpture, Picasso's *Head* of 1909 (fig. 90), is approximately his painted *Head* of the same period (fig. 20) put into three dimensions: both are dependent to some extent on Negro sculpture of the Congo and the Cameroon (fig. 91) and the painting of Cézanne. Thereafter until 1928 Picasso's occasional sculpture was to be merely a commentary upon, or an extension of, his painting.

103

Two years before, in 1907, Derain had done a crudely blocked out stone figure composition and in 1908 Brancusi in his *Kiss* had reduced two figures to brick shaped oblongs with rudimentary features. Both pieces were far more abstract than Picasso's *Head* but both were isolated experiments without direct relation to Cubism.

Archipenko

Archipenko, who had studied Egyptian and archaic Greek figures in the Louvre after his arrival in Paris in 1908, was the first to work seriously and consistently at the problem of Cubist sculpture. His torso called *Hero* (fig. 92) seems related in style to Picasso's paintings of his Negro period such as the study of 1907 for *The young ladies of Avignon* (fig. 12), but in its energetic three-dimensional torsion it is entirely independent of Cubist painting.

After a series of solid Cubistic figures Archipenko modelled in 1912 the radically original *Walking woman* (fig. 93) in which the Cubist search for far-fetched analogies in the deformation of "nature" is applied to sculpture by substituting voids for solids in the face and torso and concavities for convexities in the left leg and the skirt. This figure was tinted in two tones, perhaps the first departure towards the polychrome which became so conspicuous in Cubist sculpture and construction of 1915-20.

In 1912 Archipenko also made the first of his famous Médrano series of figure constructions in polychrome glass, wood and metal which put into practice that defiance of traditional materials recommended by Boccioni in his *Futurist Sculpture Manifesto* of April 1912.

Archipenko's *Boxing* of 1917 (fig. 94) is his most abstract work and his most powerful. It embodies the dynamic vigor of his earlier *Hero* without a trace of the mannered prettiness which characterizes much of his later work.

Duchamp-Villon

Duchamp-Villon had worked under Rodin's influence, then in a style suggesting Maillol but more severely simplified. His earliest Cubist sculpture like the *Lovers* (fig. 96) was related to a series of architectural decorations. In 1913 he exhibited the model for a house with Cubistic ornament, the first of its kind, but applied to an essentially conventional Louis XIV facade. In the following year he completed his *Horse*, perhaps the most important work in the entire tradition of Cubist sculpture. It is a fusion of organic and mechanical forms intended to suggest the dynamism of the animal. In 1912, two years

104

90 (212) Picasso: Head, 1909

91 (274) African mask.
Cameroon, Bangwa; *cf.*
Picasso, figs. 20 and 90

93 (2) Archipenko: Walking Woman, 1912

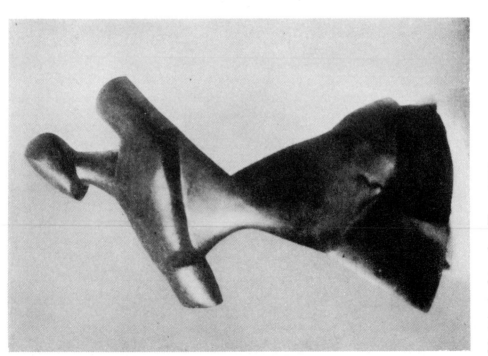

92 (1) Archipenko: Hero, 1910

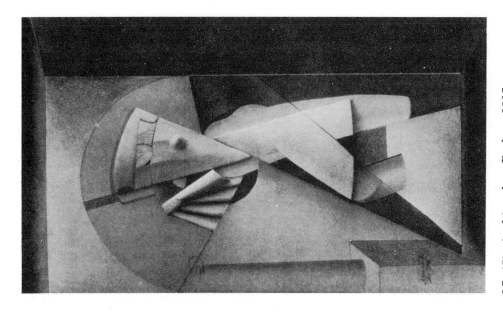

95 (5) Archipenko: Bather, 1915.

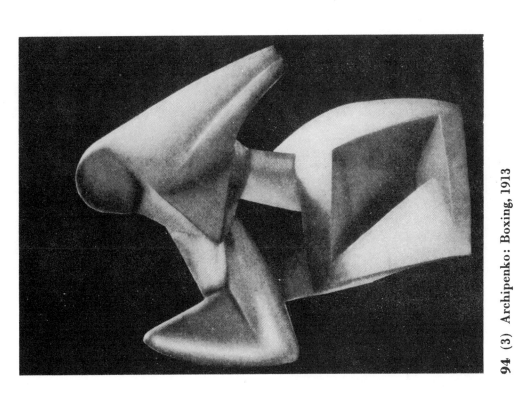

94 (3) Archipenko: Boxing, 1913

96 (63) Duchamp-Villon: The lovers (final version), 1913

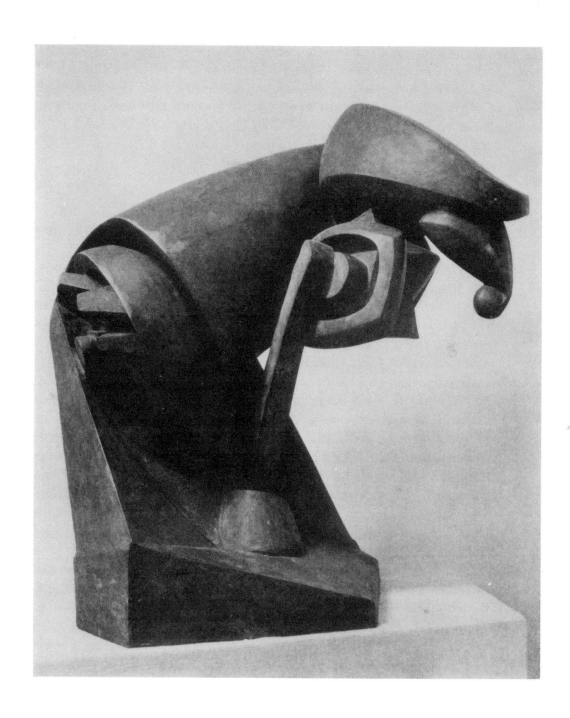

97 (64) Duchamp-Villon: The horse, 1914

before, the Italian Futurist painters had exhibited in Paris and Marcel Duchamp, the brother of Duchamp-Villon, had painted in emulation his *Nude descending a staircase* (fig. 40), a study in kinetics finer in quality than any of the Futurist paintings. In April 1913 Boccioni, the Futurist sculptor, exhibited in Paris such works as the striding figure (fig. 49), which in turn Duchamp-Villon surpassed not perhaps in kinetic illusion but certainly in formidable dynamic power.

Picasso, Lipchitz, Laurens

Archipenko, Duchamp-Villon and the Futurist Boccioni frequently concerned themselves with problems of dynamics which lay outside the essentially static conception of Cubism upheld by the painters Picasso and Braque[1] and followed more or less by the sculptors Laurens and Lipchitz. Picasso's "Baker's Cocoa" *Relief* is an extension into three dimensions of his *collage* Cubism, 1912-14. Such reliefs were to exert an important influence upon the Dadaist, Schwitters (fig. 197), and perhaps upon the Constructivist, Tatlin (fig. 126). Picasso's bronze *Glass of absinthe* of 1914 (fig. 99) is identical in style with such paintings as the *Green still life* (fig. 75) of the same year, in the center of which may be seen a similarly distorted cup, dotted in pointillist manner.

Lipchitz gradually turned to Cubism in 1914 but with frequent reference to Negro sculpture. His *Bather* (fig. 100) of 1915 may be compared to the Gabun figure (fig. 101). In 1916 he did a series of "figures" like the *Sculpture* (fig. 102) which were more abstract than any previous sculpture in the Cubist tradition (though not more so than some of Brancusi's work of 1912-15).

Gris and Braque[2] each did a single piece of Cubist sculpture. Gris' *Toreador* (fig. 103) though dependent on his painting makes one regret that he did not again try his hand at sculpture.

Picasso's *collage* reliefs and his *Absinthe* are doubtless the direct ancestors of Laurens' brilliant series of polychrome constructions in wood and metal done between 1915 and 1918. Laurens' *Head*[3] (fig. 104) is far bolder in conception and may be compared with Archipenko's *Bather* (fig. 95), a "sculptopainting" relief of 1915. Laurens' stone *Guitar* (fig. 105) of 1920 is obviously related to Picasso's *Guitar* (fig. 79) of the same period.

[1] Other Cubist painters, less at the center of the movement, especially Duchamp and Delaunay, had not ignored dynamic problems.

[2] A figure in plaster, 1919, now in the collection of A. E. Gallatin, New York; illustrated in Einstein, Bibl. 26, 2nd edit., p. 305.

[3] Dated by Kahnweiler, 1918; by Zervos, Bibl. 338, 1915. Laurens' early work 1912-16 (*cf.* Bibl. 165, pl. 84-88) is little known and the dating of his constructions disputed.

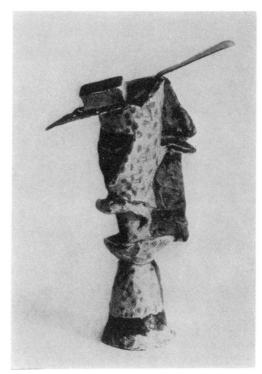

99 (223) Picasso: Glass of absinthe, 1914

98 (222) Picasso: Relief construction: guitar, 1913 (*not in exhibition*)

101 (275) African figure, Gabun

100 (136) Lipchitz: Bather, 1915

103 (99) Gris: Toreador, 1917

102 (137) Lipchitz: Sculpture, 1916

Cubist sculpture continued to develop both in Paris and in the work of many artists in other countries such as Belling in Germany (fig. 161) but after 1925 most of the Cubist sculptors moved in other directions, sometimes equally abstract as in the case of Lipchitz (figs. 213, 215), sometimes more traditional as in the case of Laurens or Archipenko or Belling.

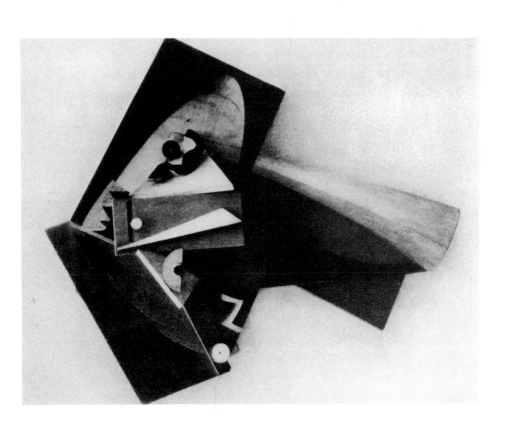

Above, **104** (127) Laurens: Head, 1918 (also dated 1915)

Right, **105** (128) Laurens: Guitar, 1920

Brancusi

Brancusi stands apart. He is the most original and the most important of the near-abstract sculptors but he has never belonged to any group.[1]

Of Roumanian birth and early training he came to Paris in 1904 where he worked for a time in Rodin's studio. In 1908 Brancusi carved *The kiss*, a composition of two primitive block-like figures, the most abstract sculpture of its period although Derain had[2] made a similar experiment the year before. As late as the *Sleeping muse* of 1910, Rodin's influence still lingered in the veiled modelling but already Brancusi's preference for egg-like forms was evident. Negro sculpture encouraged him to further experiment. *The new-born* of 1915 (fig. 106), an egg-shaped head, is a simplification of the *Sleeping muse*. It has the high polish which Brancusi from then on applied to his work in bronze and marble, and which has plausibly suggested to some critics the influence of the machine esthetic at that time on the increase in Paris. Brancusi is, however, never mechanical in his feeling. He is the master of the subtlest modulations of surface and is sensitive in the extreme to the various materials, bronze, stone and wood, which he handles with a variety of techniques.

Although his forms sometimes suggest the purity of geometry they are never actually geometrical but usually organic both in name and in shape. It is no accident that much of his sculpture approaches the shape of the egg which is, sculpturally speaking, organic form at its simplest. Not only *The new-born* but the *Chief* and the elegant *Bird in space* (fig. 107) are essentially variations upon the egg.

The courage and simplicity of Brancusi's forms and the honesty of his patient, subtle craftsmanship have influenced a host of younger sculptors, among them such men as Arp (fig. 209) and Moore (fig. 223).

[1] About 1926 the *Stijl* group enrolled him among its members but he can scarcely be said to have participated in the Dutch movement.
[2] See Bibl. 26, 2nd edition, p. 225.

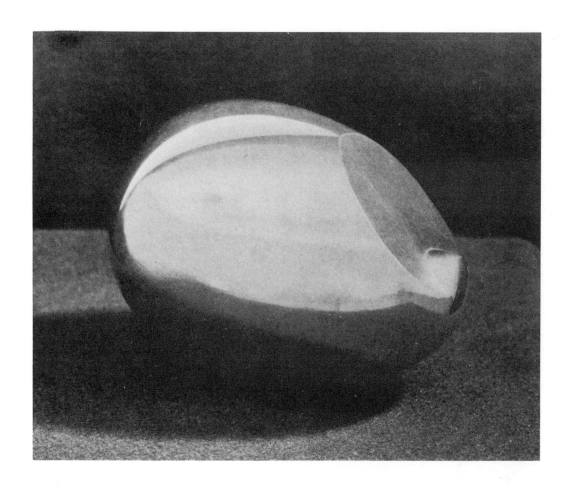

106 (17) Brancusi: The new-born, 1915

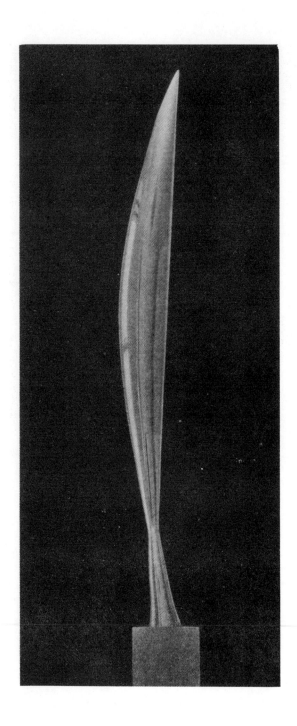

107 (21·A) Brancusi: Bird in space, *c.* 1925

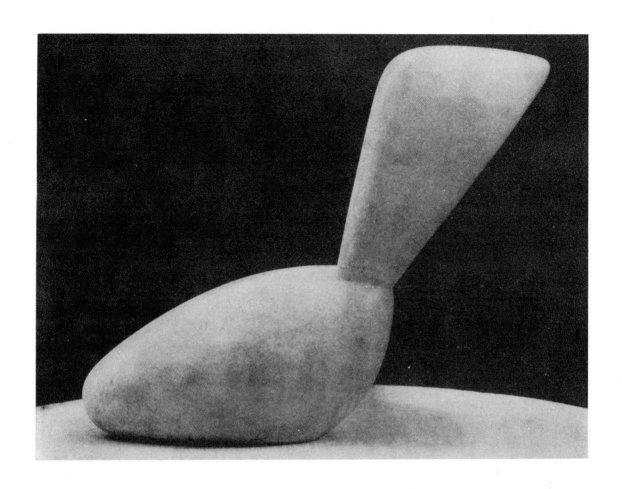

108 (19) Brancusi: Leda, 1920

Abstract painting in Russia

Chronology

1911 Rayonism of Larionov (fig. 109) and Goncharova.

1912 Malevich a Cubist (fig. 110).

1913 Suprematism founded by Malevich: he exhibits a perfect square in pencil as a work of art (*cf.* fig. 112).

1914 Malevich's Suprematist paintings (figs. 113, 114). Rodchenko's first compass and ruler abstractions. Kandinsky to Moscow.

1915 Malevich's first three dimensional Suprematist drawings.

1917 The Revolution. Rodchenko leader of Non-Objectivists.

1919 Malevich sends *White on white* (fig. 115), Rodchenko *Black on black* (fig. 116) to Tenth State Exhibition, Moscow. They and their followers become professors at Moscow State Art School. Lissitzky's first paintings in Suprematist tradition.

1920 Rodchenko and followers turn to Constructivism.

1921 Exhibition 5 x 5 = 25, Rodchenko and others. Abstract art discouraged by official attitude. Kandinsky to Berlin; Malevich to Leningrad.

1922 Berlin exhibition of Russian abstract art. Suprematist tradition spread through Germany by Lissitzky and the Hungarian, Moholy-Nagy. Rodchenko and followers abandon "art" for more utilitarian activities.

Moscow, 1910-1920

During the second decade of our century Moscow supplanted St. Petersburg not only as the political center of Russia but as one of the great artistic centers of Europe. Although fifteen hundred miles from Paris, Moscow was kept in continuous contact with the art of the French capital by means of exhibitions, periodicals such as the alert *Apollon*, and above all by the dozens of paintings of the School of Paris bought each year by the extraordinary Muscovite collectors Stchukine and Morosov who, for example, had assembled before August 1914 over one hundred paintings by Picasso and Matisse. Many Russian artists also spent much of their time in Paris.

Abstract art in Russia began long before the Revolution of 1917. The succession of artistic movements of the years 1917-22 was merely a continuation of the previous five years' excitement in which Cubism, Rayonism, Suprematism, Non-Objectivism, Cubo-Futurism, Constructivism had been born and, in some cases, had died.

Rayonism

Rayonism (*Lutchism* in Russian), the invention of Michael Larionov, was, with the Russian Kandinsky's Abstract Expressionism in Munich, the most purely abstract movement in Europe during the years 1911-12. Rayonism

120

109 (121) Larionov: Rayonist composition, 1911 (*not in exhibition*)

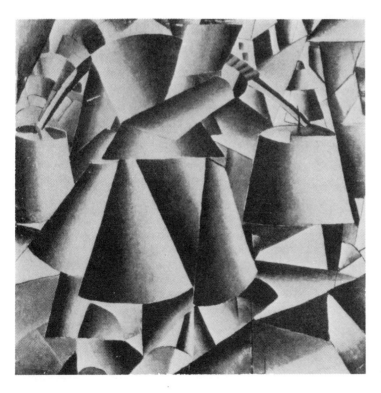

110 (147) Malevich: Woman with water-pails, 1912

started with the disintegration of forms—figures or landscapes—into radiating rays of light,[1] not far different from the Italian Futurist *forze-linee*—but carried in some paintings all the way to pure-abstraction. Rayonism was short-lived but vestiges of its splintery effects may be seen in many of the designs done by Larionov and his wife, the talented Natalia Goncharova, for the Diaghileff Ballets.

Suprematism: Malevich

The Suprematist-Non-Objectivist movement was by far the most important development in Russian abstract painting.

It was inevitable that the impulse towards pure-abstraction should have been carried to an absolute conclusion sooner or later. In Munich, Kandinsky is held to have painted a pure-abstraction as early as 1911. But as may be seen in the 1914 *Improvisation no. 30* (fig. 52), Kandinsky's spontaneous rather than amorphous forms frequently if unintentionally assumed the shapes of recognizable objects such as houses and cannons. In other words his method was not proof against impurity. In 1912 in Paris Kupka had painted his curvilinear *Fugue in red and blue* (fig. 61), probably the first pure-abstraction in Western Europe. Early in 1913 he exhibited *Vertical planes* (fig. 62), probably the first rectilinear abstraction. But *Vertical planes* had been derived from *Nocturne*, a near-abstraction of 1911, so that in its genesis its purity was not quite absolute.

The first artist to establish a system of absolutely pure geometrical abstract composition was the Russo-Polish painter Kasimir Malevich of Moscow. Malevich had painted *Fauve* compositions like those of the Jack of Diamonds group in Moscow. In 1911-1912 he developed a Cubist formula related to, but apparently independent of the work of Léger and Duchamp during those years. His *Woman with water-pails* of 1912 (fig. 110) is definitely more advanced than Léger's, along the same line of development.

Malevich suddenly foresaw the logical and inevitable conclusion towards which European art was moving:

"In the year 1913 in my desperate struggle to free art from the ballast of the objective world I fled to the form of the Square and exhibited a picture which was nothing more or less than a black square upon a white background. The critics moaned and with them the public: 'Everything we loved is lost: We are in a desert. . . . Before us stands a black square on a white ground.'" (Bibl. 210, p. 66)

[1] Rayonist theory was exactly anticipated by Leonardo da Vinci, see page 56, note 1.

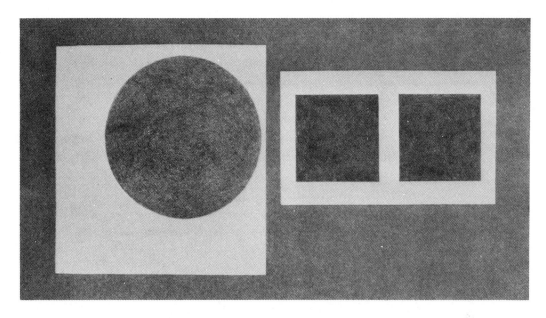

111 (148) Malevich: Fundamental suprematist element, 1913. **112** (149) Malevich: Fundamental suprematist elements, 1913

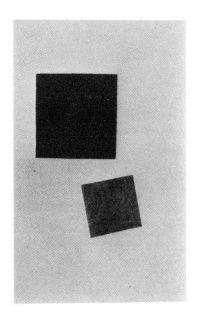

113 (155) Malevich: Suprematist composition

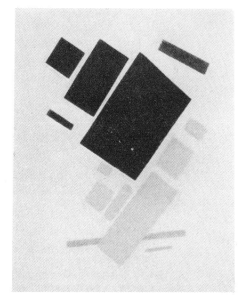

114 (152) Malevich: Suprematist composition, 1914

The black square done in lead pencil was the first Suprematist picture. "By Suprematism," Malevich wrote (Bibl. 210, p. 65), "I mean the supremacy of pure feeling or perception (*Empfindung*) in the pictorial arts." "It was no 'empty square' which I had exhibited but rather the experience of non-objectivity (*Gegenstandslösigkeit*)."

The second Suprematist picture was the Circle (fig. 111) followed by the Two Squares (fig. 112) and a series of simple geometrical forms in simple compositions. In the same year he began more complicated compositions. The *Composition of suprematist elements* of 1914 (fig. 114) is a painted version of a drawing of 1913 (Bibl. 210, p. 77). It is one of the first compositions in which Malevich began to distort the geometrical forms—the parallelogram into the trapezoid—and one of the first in which he composed on the bias or diagonal axis, which the Cubists had used tentatively and which was to become within the next twenty years a characteristic not merely of Suprematism but of much geometrical abstract painting in Russia and Germany and modern typography and advertising art all over the world. Other paintings show the range of Malevich's art during the years 1914-18. The *Suprematist composition* (fig. 113) is a study in equivalents: the red square, smaller but more intense in color and more active on its diagonal axis, holds its own against the black square which is larger but negative in color and static in position. A typical Malevich is the *Suprematist composition* (fig. 4) with its circle, square and ellipse varied by diagonal rectangular bars.

Some of Malevich's paintings of these years are not entirely free of remote references to the world of reality. As he explained in an elaborate series of charts, he drew inspiration for some of his compositions from airplane views of cities with their interesting patterns of rectangles and curves. Sometimes, too, he would qualify the bleak title *Suprematist composition* by adding a suggestive subtitle *Sensation of metallic sounds—dynamic* or *Feeling of flight* or *Feeling of infinite space*.

Though none of his oils surpassed in purity his first penciled *Quadrat*, or square, of 1913, he painted in 1918 a renowned series of compositions called *White on white*, one of which is the white square (fig. 115). A *White on white* sent to the famous Tenth State Exhibition, 1919, in Moscow marked the high point of Suprematist painting.

As early as 1915 Malevich had begun a series of perspective drawings of three-dimensional shapes which by 1917 had taken on the character of abstract architectural forms parallel to, but far more removed from actuality than, the contemporary projects of the *Stijl* group in Holland.

124

115 (157) Malevich: Suprematist composition: white on white, 1918

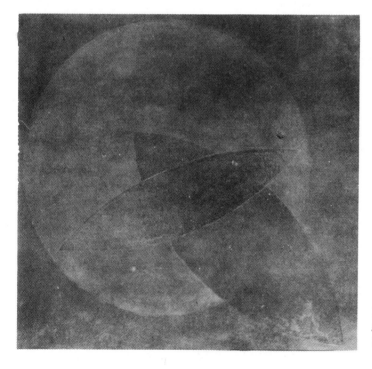

116 (234) Rodchenko: Suprematist composition: black on black, 1918 (*not in exhibition*)

In the history of abstract art Malevich is a figure of fundamental importance. As a pioneer, a theorist and an artist he influenced not only a large following in Russia but also, through Lissitzky and Moholy-Nagy, the course of abstract art in Central Europe. He stands at the heart of the movement which swept westward from Russia after the War and, mingling with the eastward moving influence of the Dutch *Stijl* group, transformed the architecture, furniture, typography and commercial art of Germany and much of the rest of Europe.

Non-Objectivism: Rodchenko

Malevich grew to be the center of a large circle of younger artists some of whom, under the leadership of Alexander Rodchenko, formed a schismatic group calling themselves the Non-Objectivists. As early as 1914 Rodchenko had made geometrical compositions using exclusively a compass and ruler. His style (figs. 117, 118) is less pure in color and form and more dynamic than Malevich's and entirely removed from the vaguely mystical atmosphere of the older man's work. To the Suprematist-Non-Objectivist Exhibition of 1919 Rodchenko sent a painting, *Black on black* (fig. 116), which his group upheld as an answer to Malevich's *White on white*. In that year Rodchenko turned to Constructivism, but his 1920 series of line-constructions (fig. 119), the first of their kind, belong in spite of their name, to the Non-Objectivist category.

In 1922 Rodchenko gave up painting and constructions entirely and, having emphatically announced the "death of art," turned with his wife, Stepanova, to photography, typography, theatre art and furniture design. The cover of the magazine *Lyef* (fig. 123) is his work and the poster (fig. 176) is under his influence.

Influence of Suprematism: Lissitzky

Lissitzky, who spent much time in Germany between 1922 and 1926, is by far the best known of the Russian abstract painters in Western Europe. He was, however, an intelligent eclectic who joined the movement as late as 1919 and based his forms upon Malevich's perspective drawings of 1915 and later. Lissitzky considered his compositions, which he called Prouns, to be a kind of transition between painting and architecture. His *Proun 99* (fig. 125) in addition to its Russian ingredients is obviously influenced by the French Duchamp's Dadaist glass painting of 1918 (fig. 193). His catalog cover (fig. 124) and his famous gallery in the Hanover Museum (fig. 177) are clever fusions of Dutch *Stijl* (figs. 145, 146, 152) with Russian textural elements.

126

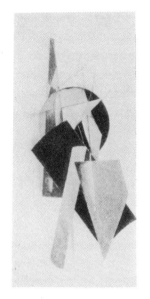 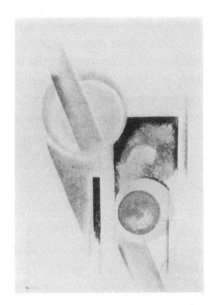

117 (235) Rodchenko: Composition, 1918. **118** (236) Rodchenko: Composition, 1919. **119** (243) Rodchenko: Line construction, 1920

Soviet jacket designs influenced by abstract painting.

Left to right: **120** (351) Sterenberg, Petersburg, 1919; **121** (338) Klusis, Moscow, 1928; **122** (335) Gan, Moscow, 1927; **123** (348) Rodchenko, Moscow, 1927; **124** (341) Lissitzky, 1928

The cover of the Soviet architectural magazine (fig. 122) by the former Constructivist, Alexei Gan, is also under *Stijl* influence. The diagonal composition of Klusis' cover for a book on Soviet films (fig. 121) is, however, in the direct tradition of Suprematism (fig. 114) of which Klusis himself was an important adherent. Sterenberg's magazine cover of 1919 (fig. 120) is also affected by Suprematism but is technically a Cubist *collage*. Suprematist influence in German posters and layout is obvious in figs. 2, 174, 175.

Russian Suprematism and Constructivism played an important role in Germany after 1922 principally through the work of Lissitzky, the Hungarian Moholy-Nagy and the Constructivist, Gabo.

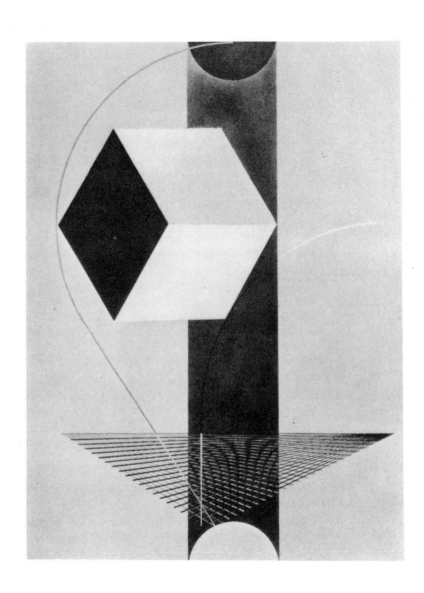

125 (146) Lissitzky: Construction 99, 1924-25

Constructivism

Chronology

1913 Moscow, Tatlin's first relief constructions.

1915 Gabo and Pevsner in Norway. Gabo's first construction, a *Head* in cardboard. Moscow, Tatlin's first counter-relief construction (fig. 127).

1917 Gabo and Pevsner return to Moscow after Revolution.
Rodchenko's first constructions.
Tatlin, Pevsner, Gabo, Rodchenko teach at the First State Art School in which Malevich also teaches.

1919 Tatlin's project for the *Monument to the Third International*, huge model constructed in Petersburg 1920 (figs. 128, 129).
First *Proun* (Constructivist painting) of Lissitzky.

1920 Moscow, great Constructivist exhibition.
Publication of Gabo and Pevsner's Constructivist *Realistic Manifesto*.
Rodchenko's hanging constructions (fig. 130).
Split among Constructivists. Tatlin, Rodchenko place Constructivism at service of Revolution; Pevsner and Gabo affirm artistic independence of Constructivism. Studio of Pevsner and Gabo closed.
Obmoku and *Unovis* groups.

1921 Moscow, 5 x 5 = 25 exhibition: Rodchenko, Popova, Stepanova, Exter, A. Vesnin.
Gabo in Berlin.
Berlin, first constructions by the Hungarian, Moholy-Nagy.

1922 Berlin, Exhibition of Soviet Art, including all important Constructivists. Pevsner to Berlin.
Gabo designs for kinetic (moving) constructions.
Berlin, Lissitzky and Ehrenberg publish Constructivist magazine *Gegenstand* (*Object*).
Moscow, Meyerhold Theatre, Constructivist settings by Popova for *The Magnificent Cuckold* (fig. 132), by Stepanova for *The Death of Tarelkin* (fig. 133).

1922 Weimar, Bauhaus, principles of Russian Constructivism as a pedagogic method introduced by Moholy-Nagy.

1923 Pevsner to Paris.

1925 Paris, Pevsner and Gabo exhibition, Galerie Percier.
Rodchenko exhibits furniture for a workers' club at the Paris Exposition of Decorative Arts.

1926 (?) Pevsner and Gabo exhibition, New York, *Société Anonyme*.

1927 Ballet for Diaghileff, *La Chatte*, settings designed by Pevsner and Gabo.

1929–1931 Gabo exhibitions in Germany.

1932 Paris, Pevsner and Gabo leaders of Constructivist element in *Abstraction-Création* group.

126 (265) Tatlin: Relief construction, 1914 (*not in exhibition*)

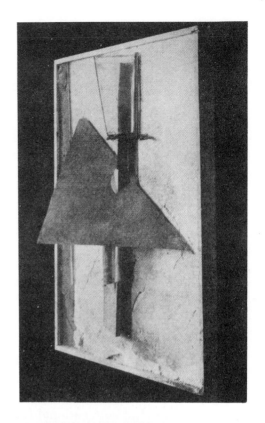

127 (266) Tatlin: Corner counter-relief construction, 1914-15 (*not in exhibition*)

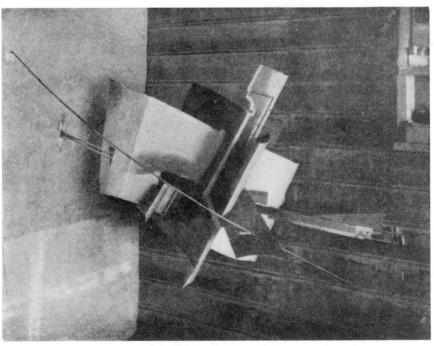

Tatlin

The history of Russian Constructivism is complex and controversial. But its sources lay without question in the Cubism of Picasso. It developed along two channels, the work of Tatlin, 1913-17, and of the brothers Gabo and Pevsner, 1915-17. The two currents converged in Moscow in 1917.

As early as 1912 Picasso and Braque began to make pictures by pasting fragments of newspapers, tickets and other odd bits of paper, completing the composition with paint or pencil (figs. 64, 65). This *collage* not only provided interesting new surfaces but proved the artist's emancipation from the exclusive use of traditional media. In 1913 Picasso carried this *collage* technique further by pasting on cardboard various more solid objects such as pieces of glass, wooden spools, sections of lathe and other odds and ends, framing the whole as a kind of relief (fig. 98) which he called, as usual, *Still life* or *Guitar*.

In 1913, the same year, Vladimir Tatlin in Moscow began a series of similar reliefs but with a far bolder variety of materials and a more abstract conception. The relief construction of 1914 (fig. 126) in glass, metal and wood on plaster is entirely free from the trivial surface agitation of *collage* Cubism. In the next year, 1915, came counter-reliefs like that in fig. 127, a three-dimensional construction to be suspended by wires strung across the corner of a room, eliminating not merely the framed background but also the solid base or pedestal of conventional free-standing sculpture. At the time of the Revolution Tatlin's counter-reliefs took on added significance for they were works of art composed not of traditional media such as bronze or marble but of industrial materials such as glass, wire, sheet metal or concrete.

Tatlin left to his numerous followers the development of *factura* (variety of surface treatment) and counter-relief and himself turned more and more toward engineering and architecture, a move culminating in 1919 in the project of the *Monument to the Third International,* the most ambitious of all Constructivist works. It was designed as a leaning spiral tower in structural steel about 1300 feet high. In the core of the tower were to be three stories of varying geometrical shape each of which was to rotate steadily at a different speed.[1] Tatlin's tower was carried as far as a huge timber model constructed in Petersburg in 1920 (figs. 128, 129).

[1] See Bibl. 439.

Rodchenko

Rodchenko, who had been a companion and rival of Malevich in abstract paint-
ing (figs. 116-119), contributed to Constructivism a series of cardboard or
wood constructions such as the hanging nest of circles (fig. 130) and the study
in cantileverage (fig. 131).

In 1920-21 during the reaction against Leftism in art[1] Tatlin and Rodchenko
turned gradually to more practical activities such as furniture or stage design
or photography. The period of pure Constructivism in Russia was over.

Constructivism in the theatre

But in 1922, the very year of its death as a "fine art," Constructivism was
reborn in the theatre. As early as 1920 the Tairov and Vakhtangov theatres in
Moscow had used settings of a Cubist-Constructivist style (cat. nos. 363, 358,
371) and Tatlin, before the War, in 1912, had designed a Cubist setting remi-
niscent of Delaunay's *St. Séverin* (fig. 36). But the first and perhaps the finest
purely Constructivist setting was designed by Popova, formerly the most bril-
liant of Malevich's followers, for *The Magnificent Cuckold*, produced at Meyer-
hold's Theatre in April, 1922 (fig. 132). Like Tatlin's tower (fig. 128), it had
movable parts so that in moments of crisis in the drama the wheels and wind-
mill would whirl and spin. In this way the setting itself participated in the
action. A few months later Rodchenko's wife, Stepanova, under the influence
of her husband's constructions, designed the cages and machinery for *The
Death of Tarelkin* (fig. 133). In subsequent years Constructivism in the theatre
spread throughout Europe and America. In Germany especially Constructiv-
ism was influential not only in the theatre but in other ways which will be indi-
cated in the paragraphs on the Bauhaus at Dessau.

Pevsner and Gabo

The Constructivist movement in Moscow was strengthened by the return in
1917 of the expatriate Russians, Pevsner and Gabo. Pevsner had studied paint-
ing in Paris where he had known his fellow countryman Archipenko. Even
before the War he had done extremely abstract designs in encaustic (cat. no.
190). His younger brother, Gabo, had been studying mathematics in Munich
and had made mathematical models. Pevsner and Gabo spent the early part of
the War in Norway where, in 1915, Gabo made his first construction, a head in
cardboard, built up of intersecting planes in the manner of Pevsner's much
later *Portrait* (fig. 134). The head was followed by a torso in iron and other

[1] See pages 16, 17.

133

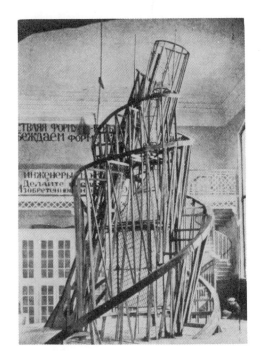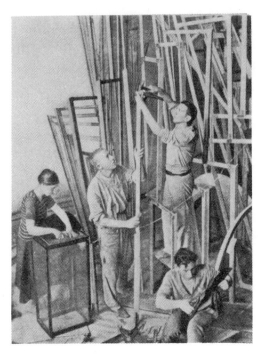

128, 129 (312) Tatlin: Model for monument to the Third International, 1920

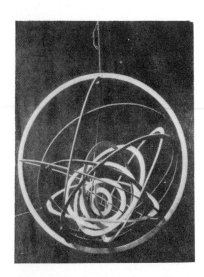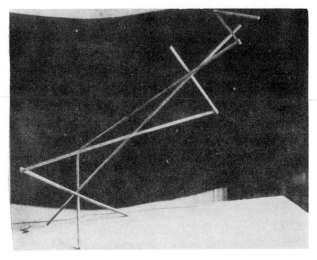

130 (240) Rodchenko: Hanging construction, 1920 (*not in exhibition*)

131 (244) Rodchenko: Construction, 1921 (*not in exhibition*)

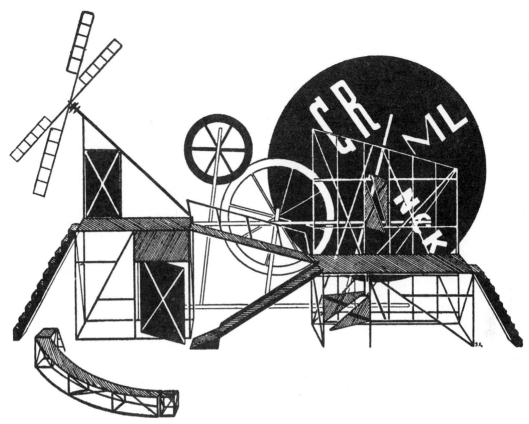

132 (374) Popova: Setting, *The Magnificent Cuckold*, Meyerhold Theatre, Moscow, 1922

133 (378) Stepanova: Setting, *The Death of Tarelkin*, Meyerhold Theatre, Moscow, 1922

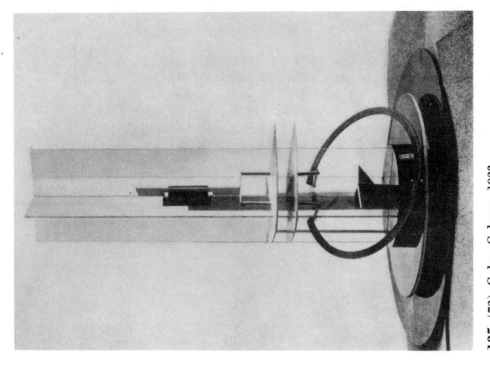

135 (72) Gabo: Column, 1923

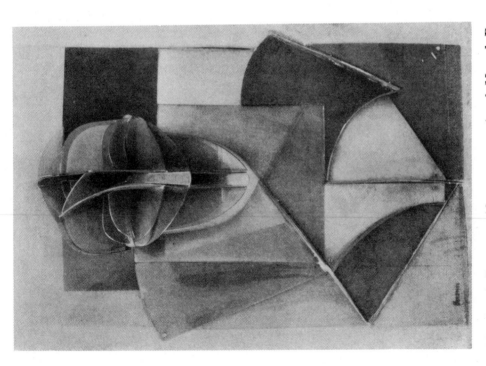

134 (197) Pevsner: Abstract portrait of Marcel Duchamp, 1926 (?)

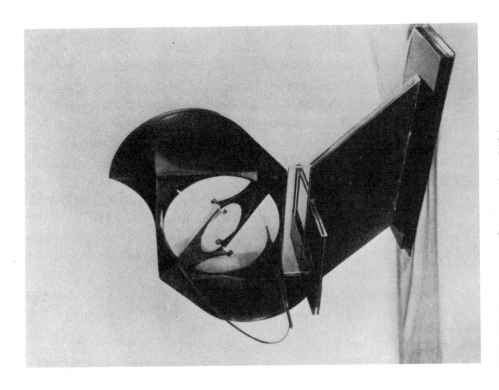

137 (199) Pevsner: Construction, 1934

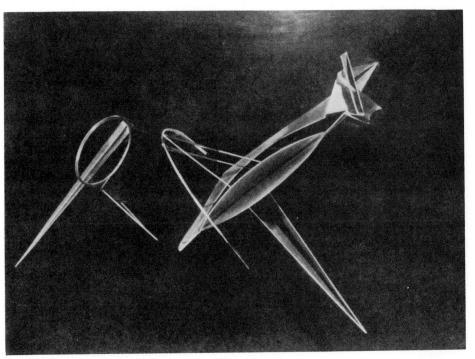

136 (198) Pevsner: Relief construction, 1930

figure constructions. Comparatively few of their constructions were abstract until after they had joined the Moscow group in 1917.

Pevsner and Gabo took an active part in the Russian movement, exhibiting with the others in the great Constructivist exhibition of 1920. In the same year they published their *Realistic Manifesto*[1] in which they insisted that depth alone is the proper measure of space and that volume and mass should be abandoned as a plastic element in art. Similar ideas had been voiced years before by Archipenko and Boccioni[2] but the Constructivists put their theories into practice.

After the split in the ranks of the Constructivists in 1920 Pevsner and Gabo, unable to adjust themselves or their art to the service of the Revolution, found one day that their studio had been closed and their students dispersed. A year or so later they left for Berlin, Gabo to work for the most part in Germany until the Nazi Revolution of 1933, Pevsner to live in Paris. The two brothers had developed their art together, they continued to exhibit together and their best known work, the designs for the ballet *La Chatte*, were the result of their joint effort.

After leaving Russia they continued to make occasional celluloid and metal constructions in the shape of masks or figures (fig. 134) but most of their constructions in the past fifteen years have been abstract. Of the two brothers, Gabo has the lighter touch, the more lyrical spirit and the surest sense of his materials, whether glass, metal or celluloid. Pevsner is more powerful, more intellectual in his approach and more inclined to force his materials so that his constructions (figs. 134, 136, 137) take on superficially something of the character of sculpture while Gabo's are more in the spirit of architecture.

Some of Gabo's constructions (fig. 135, 138) have in fact been projects for semi-architectural monuments, but it is his pupil Lubetkin and not himself who has had the privilege of designing the Constructivist Penguin Pond for the London Zoo (fig. 139).

[1] Reprinted in part in *Abstraction-Création*, Paris, 1932, p. 27.
[2] See page 60.

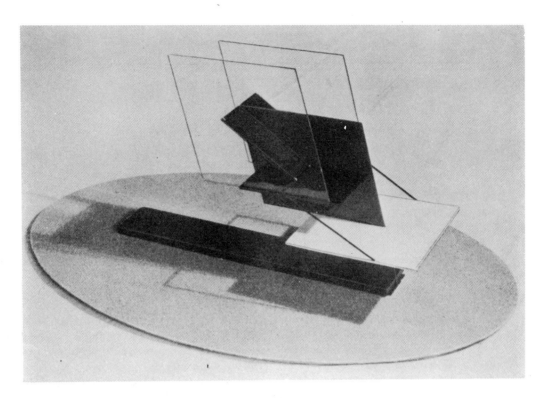

138 (73) Gabo: Monument for an airport, 1925-26

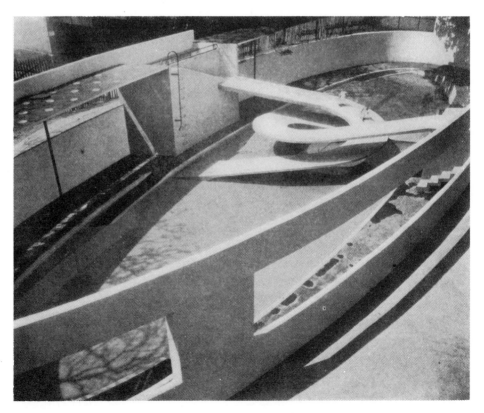

139 (303) Lubetkin: Penguin Pond, Zoological Gardens, London, 1935

Abstract art in Holland: *de Stijl* and Neo-Plasticism

Chronology of *de Stijl*

1910 Mondrian from Holland to Paris.

1911 Mondrian under influence of Picasso (fig. 140).

1913 Mondrian begins to geometrize Analytical Cubism (fig. 141).

1914 Mondrian's "plus and minus" period begins (fig. 142).
Doesburg paints abstract Expressionist pictures.

1916 Doesburg reduces natural forms to geometrical patterns under influence of Mondrian and van der Leck; first composition in rectangular planes (*cf.* fig. 144 D).
Doesburg associated with architects Oud and Wils.

1917 Formation of *de Stijl* group, Leyden; members: Doesburg, van der Leck, Mondrian, Huszar, all painters; Vantongerloo, sculptor; Oud, Wils, van't Hoff, architects; Kok, poet.
Magazine, *de Stijl*, launched in October.
Oud and Doesburg collaborate in House at Nordwijkerhout (fig. 147). Mondrian, influenced by Doesburg and van der Leck, paints squares and rectangles in primary colors (fig. 145); first pure-abstractions without reference to nature.
Vantongerloo's compositions within a sphere.

1918 Mondrian's compact rectangular compositions in pale tints divided by black lines. Doesburg continues isolated vertical and horizontal rectangles (fig. 162).
Vantongerloo's volume constructions (fig. 143).
Oud appointed housing architect of Rotterdam.
November, manifesto of *de Stijl* signed by original members, excepting van der Leck, who had resigned. Rietveld, architect, joins *de Stijl* and designs *Stijl* furniture (fig. 150).
Relations of group with other countries begin.

1919 Doesburg, followed by Mondrian, divides canvases into mathematically exact squares.

1920 Mondrian in Paris publishes *Néo-plasticisme*.
Doesburg makes grand propaganda tour, meets architects Gropius, Mendelssohn, Miës van der Rohe, Le Corbusier.

1921 Doesburg at Weimar, profoundly influences Gropius and Bauhaus.
Mondrian, in Paris, develops his own style of heavy black lines defining rectangles (fig. 146). Richter, German maker of abstract films, joins *de Stijl* (fig. 183).

1922–1923 Doesburg at Weimar and Berlin. *Stijl* (fig. 148) influences Berlin architects, Taut and Miës van der Rohe. Kiesler (scenic designer), van Eesteren (architect), Antheil (American musician) join group.

1923 Doesburg in Paris. *De Stijl* exhibition at Léonce Rosenberg's; influence on architects Mallet-Stevens and Le Corbusier.

1924 Rietveld's house at Utrecht (fig. 149). Doesburg lectures in Prague, Vienna.

1925 Oud's Café de Unie, Rotterdam (fig. 152). Kiesler's *Space construction*, Paris Exposition of Decorative Arts. Mondrian leaves *de Stijl*.

1926–1928 Doesburg collaborates with Hans Arp and Mme. Tauber-Arp in designing cabaret L'Aubette, Strasburg. Vordemberge-Gildewart (Hanover) and Domela join group. Doesburg's manifesto of Elementarism. *Société Anonyme* exhibits Mondrian and other *Stijl* artists in New York.

1931 Doesburg, after two years in Paris, dies at Davos. Last number of *de Stijl*, January 1932.

1932 Paris, *Abstraction-Création* group dominated by *de Stijl* tradition; Mondrian (fig. 158), Doesburg (posthumously) (fig. 156), Vantongerloo (fig. 155) and their followers Buchheister, Einstein, Gorin, Hélion (fig. 220), Mass, Vordemberge-Gildewart, Domela (fig. 217), etc. all participate.

de Stijl

De Stijl, one of the longest lived and most influential groups of modern artists, was formed in Holland during the War. From the very beginning it was marked by extraordinary collaboration on the part of painters and sculptors on the one hand and architects and practical designers on the other. It included among its leaders two of the finest artists of our time, the painter Piet Mondrian and the architect J. J. P. Oud; but its wide influence was exerted principally through the propaganda and theory of its founder, Théo van Doesburg, painter, sculptor, architect, typographer, poet, novelist, critic, lecturer and theorist—a man as versatile as any figure of the Renaissance. Two elements formed the fundamental basis of the work of *de Stijl*, whether in painting, architecture or sculpture, furniture or typography: in form the rectangle; in color the "primary" hues, red, blue and yellow.

Mondrian and Doesburg, 1910-20; Neo-Plasticism

These severely simplified elements were not, however, developed in a moment but as the result of years of trial and error on the part of the painters Mondrian, Doesburg, and van der Leck. Mondrian first studied with his uncle, a follower of Willem Maris, then, after three years at the Amsterdam Academy, he passed through a period of van Gogh-like landscapes and gloomy figures to a mannered, mystical style resembling the work of Thorn-Prikker and Toorop.

In 1910 he went to Paris and almost over night fell completely under the influence of Picasso. His *Composition* of 1911 (fig. 140), evidently based upon a seaport with masts and rigging, was as abstract as any Braque or Picasso (fig. 30) of that time. In the *Composition* of 1913 (fig. 141) the disorderly diagonals of two years before are regimented into irregular rectangles of pale yellow and grey varied by occasional curved lines reminiscent of such Picassos as the drawing, fig. 27. Two years later, in 1915, in the *Composition* (fig. 142) color is eliminated and the horizontal black lines are broken into subtly syn-

141

copated and varied progressions. This apparently abstract "plus-and-minus" pattern is based upon memories of the beach at Scheveningen;[1] the graduated lines of the waves move toward the shore at the bottom of the picture and break about the predominantly vertical lines of the pier in the center. By 1917 Mondrian had made pure-abstract paintings using heavy plus and minus lines.

Between 1911 and 1917 Mondrian's development had been gradual, consistent and independent, but from 1917 to 1921 his growth was tentative and affected by other members of the *Stijl* group. Some years before the formation of *de Stijl* van der Leck had painted flat, geometrized figures in reds, blues and yellows and in 1917 had retained these simple tones in a series of abstractions. Doesburg in 1916 had enlarged Mondrian's plus and minus lines into narrow vertical and horizontal rectangles and with them had made compositions like those in figures 144 and 162, based upon natural forms such as dancers, towns, or cows. Mondrian's *Composition* of 1917 (fig. 145) is a combination of the broad overlapping color squares of van der Leck and the narrow oblong bars of Doesburg, but composed in the horizontal-vertical system which Mondrian had himself derived from Picasso in 1914.

In 1919 Doesburg, who had already abandoned nature even as a starting point, was led by his more rational and intellectual approach to subdivide a perfectly square canvas into smaller squares which he then used as a basis for composition. Mondrian's diamond-shaped composition of 1919 (cat. no. 183) was done on the mathematical, exact scheme. However by 1920, the year of his Neo-Plasticist manifesto he had abandoned this exact geometrical method for a freer style (fig. 146), in which thick black lines divide the canvas into rectangles of various greys and colors, a style which he has refined and simplified but not abandoned to this day.

Architecture and de *Stijl*

As early as 1917 Doesburg began to apply his researches as a painter to architectural decoration. The floor of the hall shown in fig. 147 is Doesburg's design, later to be copied and vulgarized by linoleum and textile manufacturers the world over. The clean rectangular lines of the interior and the suppression of incidental ornament was an essential if negative characteristic of *de Stijl* esthetic. Moldings around the doors were to be abandoned later.

In his *Volume construction* of 1918 (fig. 143) the sculptor Vantongerloo applied the *Stijl* love of rectangles to sculpture. The resulting piling up of cubical volumes was developed by other members of the *Stijl* into a system of

[1] From notes made in conversation with Mondrian.

140 (179) Mondrian: Composition, 1911

141 (180) Mondrian: Composition, 1913

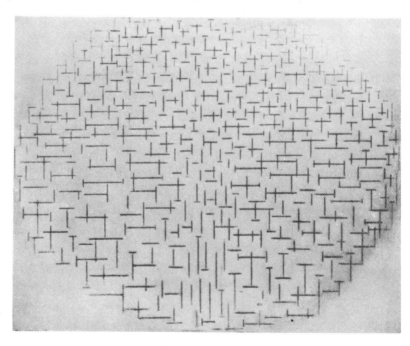

142 (181) Mondrian:
Composition, 1915

architectural composition illustrated by the project for the house (fig. 148) by Rietveld, van Eesteren and Doesburg. This project is clearly a three-dimensional projection of a Neo-Plasticist painting such as Mondrian's *Composition* of 1921 (fig. 146). Even the painter's colors are retained and different walls of a single room are painted red, yellow, blue, grey or white.

Among completed buildings Rietveld's house in Utrecht of 1924 (fig. 149) illustrates the characteristic asymmetric composition of rectangles and, more important, the partition of space into volumes instead of into cubistic masses, the principle suggested in Vantongerloo's sculpture of six years previously (fig. 143), and imitated by superficially modernistic architects like Mallet-Stevens in Paris three years later. In Rietveld's house the sense of space cut into volumes by vertical and horizontal rectangular planes is emphasized by the use of moving partitions.[1] Rietveld's furniture for this house, like the chair (fig. 150), shows again how the architects of the movement made practical use of the design elements of such abstract pictures as Doesburg's *Cow* (fig. 144D).

Technically and imaginatively the boldest creation in the *Stijl* tradition was the *Space construction* (fig. 151) designed by Kiesler, an Austrian member of the group, for his country's section at the Paris Exposition of Decorative Arts in 1925. It was a suspended framework constructed on a tension system without foundations or walls and without a static axis. In its radical technics it suggests the experimental designs of the Russian Constructivist architects but in its consistent use of rectangles asymmetrically arranged it is a development of such *Stijl* designs as Rietveld's house (fig. 149) of the year before.

Oud's Café facade of 1925 (fig. 152), done between more serious designs for Rotterdam civic housing blocks, is a frank and amusing adaptation of such paintings as Mondrian's *Composition* of 1921 (fig. 146). Oud's facade is similar in design, even in the lettering, to the steamship poster of 1927 (fig. 153) which also depends upon Mondrian. The poster (fig. 154) for a series of concerts in Utrecht is a late but ingenious adaptation of *de Stijl* principles to typography. The cover of the magazine, *de Stijl*, designed by Doesburg in 1920 (fig. 167) is a pioneer example of *Stijl* typographical layout with its asymmetrical arrangement of letters blocked into rectangles.

As is indicated in the chronology, the years 1920-24 saw an astounding expansion of the influence of *de Stijl*, first in Belgium, then in Germany, France, Eastern Europe and even in Russia where it met the earlier but less practicable abstract traditions of Suprematism and Constructivism.

In Holland itself the importance of *de Stijl* tradition dwindled partly

[1] See H.-R. Hitchcock Jr. *Modern Architecture*, New York, 1929, p. 183.

144

143 (269) Vantongerloo: Volume construction, 1918 (*not in exhibition*)

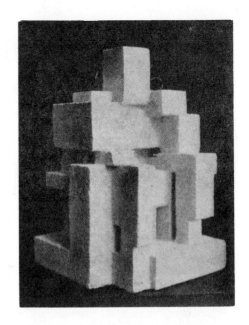

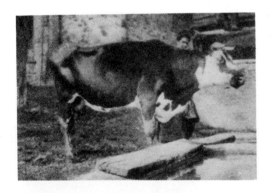

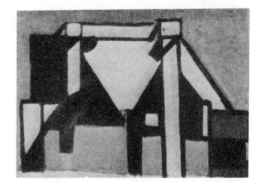

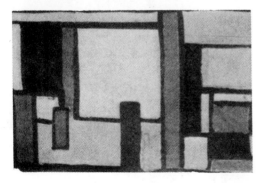

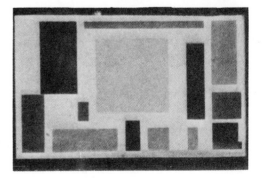

144 (52-A) Doesburg: Esthetic transformation of the object, *c.* 1918

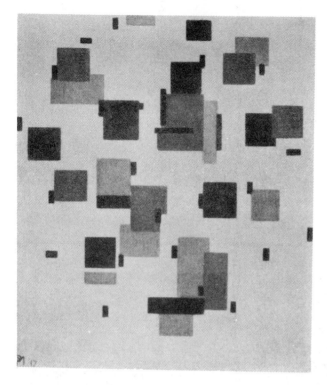

145 (182) Mondrian: Composition, 1917

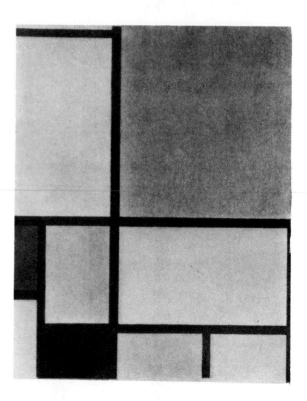

146 (184) Mondrian: Composition, 1921

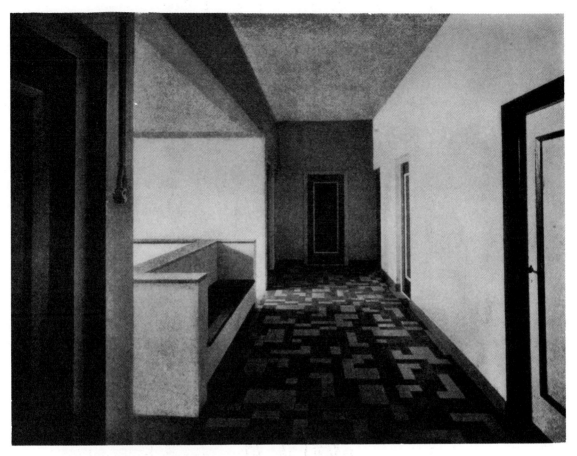

147 (307) Oud: House at Nordwijkerhout, Holland, 1917; floor by Doesburg

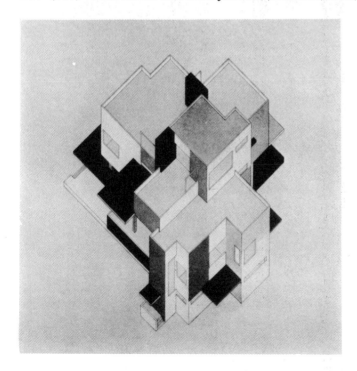

148 (284) Doesburg: Project for a private house, 1922

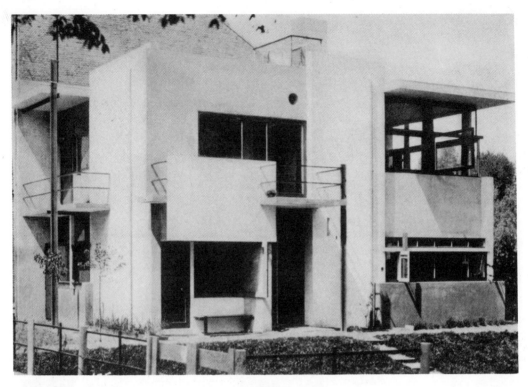

149 (310) Rietveld: House at Utrecht, Holland, 1924

Right, **151** (294) Kiesler: The city in space, Model in Austrian section, International Exposisition, Paris, 1925

150 (321) Rietveld: Chair, before 1924

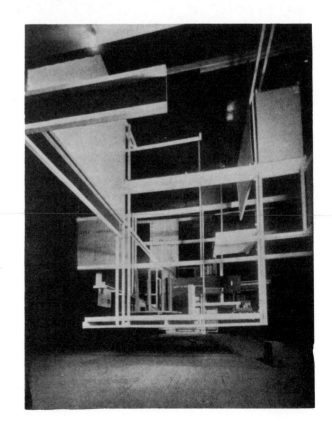

152 (309) Oud: Café de Unie, Rotterdam, 1925

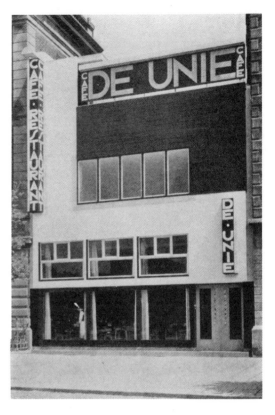

153 (336) Gispen: Poster for Rotterdam–South America line, *c.* 1927

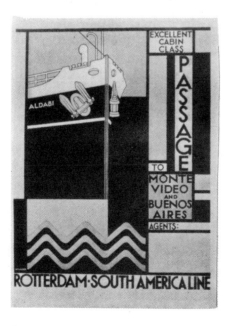

154 (357) Artist unknown: Concert poster, 1927

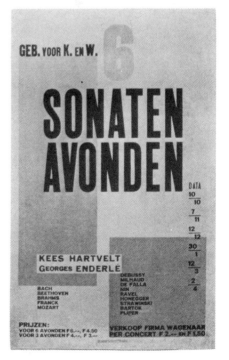

through the removal of the leading artists to Germany or Paris and partly because of the generally conservative nature of the public. Oud continued to work as a city architect of Rotterdam, designing in 1924 one of the masterpieces of modern architecture, the row houses at the Hook of Holland, which however, were free from the mannerisms and excessive asymmetry of the orthodox *Stijl* manner. Indeed Oud's use of curved lines at the Hook caused Doesburg to call his work "van de Velde architecture," after the great Belgian master of *art nouveau*. Rietveld became a city architect of Utrecht and van Eesteren of Amsterdam.

Later work of Mondrian, Doesburg, Vantongerloo

By 1924 Mondrian, Doesburg and Vantongerloo had established themselves in Paris. Since 1919, when he had experimented with Doesburg's mathematical squares, Mondrian had progressed slowly toward an extreme simplification of style. Steadily he decreased the number of rectangles and returned from a variety of greys and colors to the "primaries," red, blue and yellow. The frequently mentioned *Composition* of 1921 (fig. 146) marks a halfway stage in his development. Sometimes, as in the diamond-shaped *Composition* of 1926 (fig. 157), he eliminated all color and simplified the lines of his composition almost to the point reached by Malevich in Moscow ten years before. His recent paintings like *Composition* (fig. 158) are frequently more complex. For fifteen years Mondrian has confined himself with ascetic devotion to the problem of composing rectangles. By sheer perfection of sensibility he has impressed his style not only upon a host of younger painters but also, directly and through Doesburg and Rietveld, upon architects and commercial artists.

Vantongerloo continues to build constructions, often architectural in character, the proportions of which, as in fig. 155, he sometimes describes in a mathematical formula.

Doesburg continued to collaborate with architects and in 1929 designed his own house near Paris. In his paintings he broke with Mondrian, establishing a style he called Elementarist, which consisted in a more dynamic handling of rectangles. In his *Simultaneous counter-composition* of 1930 (fig. 156) the static squares of Neo-Plasticism slide into a diagonal axis, a problem already explored by Malevich and Rodchenko fifteen years before.

As indicated in the chronology the art of the *Stijl* group dominated the *Abstraction-Création* group which in Paris in the early thirties proclaimed a renaissance of abstract art.

150

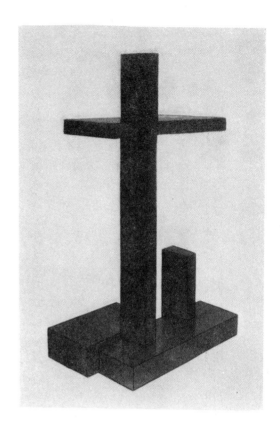

155 (271) Vantongerloo: Construction
of volume relations: $y=-ax^2+bx+18$,
1930

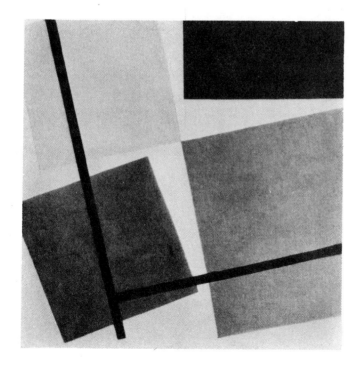

156 (55) Doesburg:
Simultaneous counter-
composition, 1929-30

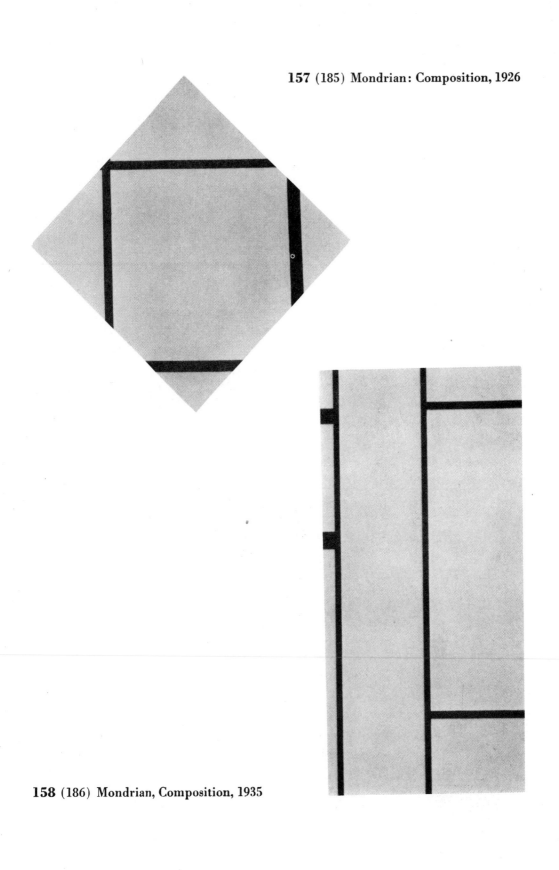

157 (185) Mondrian: Composition, 1926

158 (186) Mondrian, Composition, 1935

Post-War Germany; The Bauhaus

Abstract movements

German art emerged from the confusion of 1914-1918 with a variety of abstract and near-abstract movements, the most important of which had already developed before the War. The Dadaists were active in Cologne, Berlin and Hanover. Ernst, Schwitters and the German-trained Alsatian Arp all contributed some more or less abstract work to the Dada movement. In Berlin, Expressionism in a variety of forms occupied the *Sturm* group. Of the pre-War Munich group, Marc had been killed and Kandinsky was still in Russia, but Klee and Feininger, who had associated himself with The Blue Rider just before the War, were influential. In Stuttgart, the Compressionists, led by Baumeister and Schlemmer, closely paralleled the French Purists in their effort to clarify the Cubist tradition and turn it into a more architectonic style.

Possibly the most famous German work of art of the immediate post-War years was the Expressionist film *The cabinet of Doctor Caligari* (fig. 159). The distorted angles of the architectural settings were derived directly from German Cubist-Expressionist painting, particularly that of Feininger (fig. 55). Not only the film but the theatre and even architecture such as Mendelsohn's *Einstein Tower* were characterized by the dislocated curves and angles of Expressionism.

A third abstract current, machinism, first appeared in Germany after the War in the satirical constructions of the Dadaists. Machinism in its most obvious and vigorous form was seen in the settings for the super-machine-age play, *R.U.R.*, designed by the Austrian Kiesler and produced in Berlin in 1923 (fig. 160). It may be compared with the contemporary paintings of Léger and with the bronze *Head* (fig. 161) of the same year by Belling, a member of the Berlin *Sturm* group. Machinism, in a less romantic and overt form, persisted in the later functionalism and *neue Sachlichkeit* of the Bauhaus.

Bauhaus

The various abstract currents alive in Germany after the War, together with influences from Holland and Russia, were united in the famous Bauhaus, founded by the architect Gropius in Weimar in 1919. Before the War Gropius had designed buildings which anticipated the "functional" architecture of recent years.[1] But immediately after the War Gropius, too, was absorbed by Expressionism. He invited to Weimar, as Bauhaus professors, Klee, Feininger and Kandinsky, all three of whom remained with the Bauhaus long after it

[1] See: *Modern Architects*, Museum of Modern Art, 1932, p. 57.

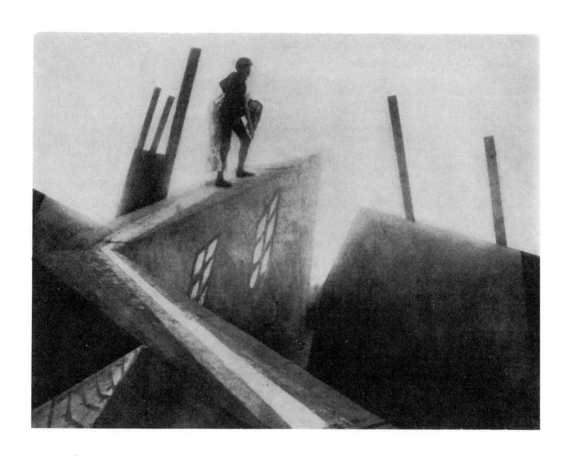

159 (386) Reiman: Setting for *The Cabinet of Dr. Caligari*, Decla-Bioskop, Berlin, 1919;
cf. Feininger, fig. 55 and Delaunay, fig. 37

160 (364) Kiesler: Setting for *R. U. R.*, Berlin, 1923

161 (13) Belling: Head, 1923

had moved to Dessau in 1926 and had passed in spirit from Expressionist to geometrical, functionalist and constructivist principles. Later came Moholy-Nagy, photographer and Constructivist, and Schlemmer, the Compressionist painter and designer for the theatre.

Influence of de *Stijl* at the Bauhaus

In 1919, through Feininger, the influence of the Dutch *Stijl* group began to permeate the Bauhaus. Two years later Doesburg, the leader of the *Stijl*, began to divide his time between Weimar and Berlin. His presence at Weimar brought about a veritable revolution: from the mysticism and transcendentalism of the Expressionists the Bauhaus turned toward clarity, discipline and the desire for a consciously developed style in architecture and the allied arts which the Dutch movement had already initiated. Within a few months, Gropius, who had been engaged in designing a picturesque wooden block house with Cubistic decorations, remodelled the theatre at Jena under the influence of the *Stijl* and sent to the Chicago *Tribune* competition a skyscraper project of extreme simplicity.

The influence of *de Stijl* or, to use Mondrian's name, Neo-Plasticist painting upon German architecture may be illustrated more precisely by two designs, a plan by Miës van der Rohe (who was not yet connected with the Bauhaus) and a facade by Gropius. Miës van der Rohe's plan for a country house (fig. 163) done in 1922, a year after Doesburg's arrival in Berlin, may be compared with Doesburg's painting *Russian dance* (fig. 162) of 1918. The resemblance is obvious and by no means superficial. The broken, asymmetrical, orthogonal character of the plan was a direct result of Doesburg's sojourn in Berlin in 1921 and '22, at which time he publicized not merely the paintings of the *Stijl* but the work of its architects as well. Back of Doesburg's *Russian dance*, of course, lies Mondrian's work of 1913-17 (figs. 141, 142) and back of Mondrian, Picasso's Cubism of 1910 to 1912, in particular such works as the drawing (fig. 27). In the history of art there are few more entertaining sequences than the influence by way of Holland of the painting of a Spaniard living in Paris upon the plans of a German architect in Berlin—and all within twelve years.

In 1925 the Bauhaus moved from Weimar to Dessau where Gropius designed a group of new buildings, among them the Director's house. The facade (fig. 164) is directly under *Stijl* influence and is handled as if it were an abstract painting like Doesburg's *Cow* (fig. 144D). The variety of size and position of the windows can be rationalized functionally, but, nevertheless, the

156

162 (52) Doesburg: Russian dance, 1918 (*not in exhibition*); *cf.* Picasso, fig. 27

163 (305) Miës van der Rohe: Project for a brick country house, plan, 1922

164 (290) Gropius: Professor's house, Dessau, 1925-26; *cf.* Doesburg, fig. 144, *lower right*

facade is essentially a pictorial and not an architectural conception. Other of Gropius' buildings at Dessau were even more *Stijl* in character.

Stijl influence at the Bauhaus was not limited to architecture. Its typography was a direct imitation of *Stijl* precedents as may be seen by comparing the cover of *de Stijl* of 1921 (fig. 167) with the cover of the Bauhaus prospectus of 1923 (fig. 168). Asymmetrical layout such as that of the Bauhaus yearbook of 1923 (fig. 169) soon spread throughout Germany and Europe and, by 1930, was extensively used in America. Most of the famous *Bauhausbucher* (figs. 172, 173) were designed by Moholy-Nagy under *Stijl* influence; Doesburg's was designed by himself (fig. 171).

The chair (fig. 165) by Breuer, who is generally considered the designer of the first tubular steel furniture, is related to Rietveld's *Stijl* chair of a few years before but, on the whole, it is an independent and original piece of furniture. It illustrates clearly how the Bauhaus in many of its products went far beyond the *Stijl* by using a functional rather than abstract geometrical system of design. The *Stijl* in its use of materials was curiously limited; furthermore it was often too much dominated by abstract painting to permit a piece of furniture (fig. 150) or a building (figs. 148, 152) to take a natural form based upon function, or to be finished with any emphasis upon materials or textures, modern or old-fashioned. Breuer's chair (fig. 165), however, was a bold innovation in materials which were frankly emphasized by the contrast between the shining tubular steel and the texture of the canvas strapping.

The Bauhaus chess set (fig. 166) is another illustration of the gradual emancipation of the Bauhaus from *Stijl* domination. Certain pieces, notably the knights, suggest *Stijl* sculpture such as Vantongerloo's (fig. 143), but the knights are really designed to suggest the right angle direction of the knight's move. The bishop is designed in the form of St. Andrew's cross, suggesting its diagonal moves; the rook, which moves either directly forward or directly sideways, is in the shape of a cube. The chess set, like Gropius' facade and Breuer's chair, epitomizes Bauhaus design which was, during the transitional period 1922-1928, an eclectic fusion in various quantities of abstract geometrical elements with the new ideal of utilitarian functionalism.

The Russian influence

The Dutch *Stijl* dominated modern German architecture and typography during the middle 'twenties but Russian Constructivism strongly influenced the German theatre and Russian Suprematism was at least as important as *de Stijl* in transforming the German poster.

158

165 (313) Breuer: Chair, before 1925

166 (315) Hartwig: Chess set, *c.* 1924

de Stijl tradition in German typography

Top row, left to right, **167** (332) Doesburg, Leyden, designed *c.* 1920; **168** (349) Schmidt, Bauhaus *c.* 1923; **169** (343) Moholy-Nagy, Bauhaus, 1923; *Bottom row, left to right:* **170** (357A) Artist unknown, Amsterdam, 1927; **171** (333) Doesburg, Bauhaus; **172, 173** (345) (344) Moholy-Nagy, Bauhaus; **174** (340) Leistekow Sisters, Frankfort, 1929

Russian abstract art first became generally known in Germany through the large exhibition in Berlin in 1922. After the exhibition Gabo and Lissitzky stayed in Germany and together with Moholy-Nagy helped to spread Russian theories and methods.

To German typographical layout and poster design Russian abstract painting of the Malevich-Rodchenko tradition contributed the use of the diagonal and the circle (fig. 4), both of them diametrically opposed to *Stijl* horizontal-vertical rectangles (fig. 146). The Pressa poster (fig. 2) is directly in the Suprematist manner, as is the jacket by Klusis (fig. 121) published for German readers. More often Suprematist and *Stijl* elements are mixed, as in the jacket of *Das Neue Frankfurt* (fig. 174) and *The Seventh Heaven* poster (fig. 175), both of which anchor the active Russian circle and diagonal by means of the static *Stijl* verticals and horizontals. Elaborate asymmetry was common to both schools.

Lissitzky had been a secondary figure in Russia, where about 1920 he combined in his *Proun* paintings and photomontages certain elements of Suprematism and Constructivism. He was active in Germany between about 1922 and about 1926. In the Hanover Museum he designed a gallery (fig. 177) for abstract paintings, using sliding panels and a corrugated wall surfacing. The general effect is of a *Stijl* interior except for the interesting surface treatment which is definitely Russian. It was the first gallery of its kind and is therefore of special interest to the student of abstract art.

Like Lissitzky, the Hungarian Moholy-Nagy was an eclectic under Russian influence, a man of great versatility, a painter (cat. no. 177), experimental photographer (fig. 188), Constructivist, book designer (figs. 169, 172), teacher and theorist (Bibl. 41, 42). In 1922 he became a professor at the Bauhaus, where he introduced an extremely important method of teaching students to investigate materials by an empirical, experimental method. Problems were given which lead the student to test by means of constructions the esthetic and physical qualities and the functional possibilities of all kinds of materials, glass, metal, rubber, paper, celluloid, cork, wood etc. This discipline was based directly upon the Constructivism of the Russians, Tatlin, Rodchenko, Pevsner and Gabo, but was developed at the Bauhaus by Moholy-Nagy and Joseph Albers into an elaborate and effective pedagogical system.[1]

[1] Albers is now using this method with great success at Black Mountain College, North Carolina. It is of especial value to students who intend to become architects or industrial designers in developing an enterprising, unhackneyed approach to modern materials. Illustrations of students' constructions made both under the original Constructivists in Moscow and later at the Bauhaus are to be found in Moholy-Nagy, Bibl. 42, and also in various numbers of the magazine, *Bauhaus*.

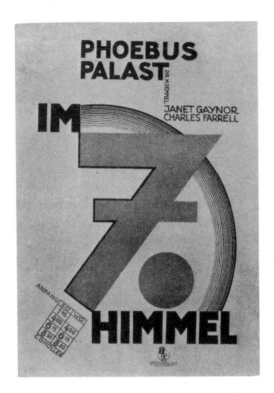

175 (346) Müller: Poster for moving picture theatre. 176 (337) Humener: First of May poster, 1927

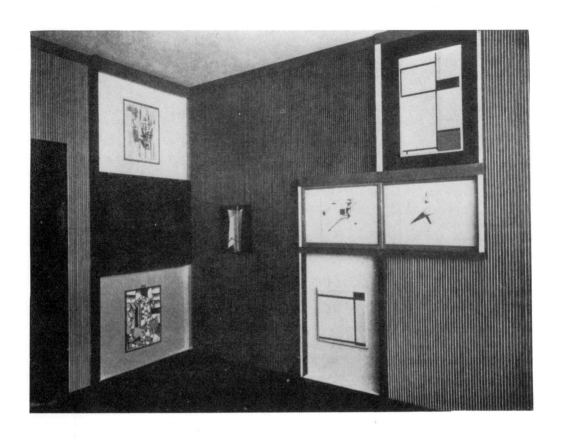

177 (302A) Lissitzky: Gallery for abstract painting, Art Museum, Hanover, *c.* 1925.
Works by Picasso, Mondrian, Moholy-Nagy, Lissitzky (?), *Léger*

Purism

Chronology

1916 Ozenfant in *l'Elan* attacks Cubism.

1918 Ozenfant and Charles Edouard Jeanneret (Le Corbusier) publish *Après le Cubisme* and hold first exhibition of Purism, Paris, Galerie Thomas.

1920–1925 Magazine, *l'Esprit nouveau*, edited by Ozenfant and Jeanneret.

1921 Jeanneret takes name of Le Corbusier and as an architect goes into partnership with his cousin Pierre Jeanneret; continues to sign his paintings Jeanneret.

1923 Le Corbusier publishes *Vers une architecture*.

1925 *La peinture moderne*, by Ozenfant and Jeanneret, published.
Purism, as a movement, loses impetus.

Purism was preceded by Constructivism in Russia and *de Stijl* in Holland. Like them it was a reform movement, technological in atmosphere, self-consciously modern, aware of social problems and embracing eventually not merely painting but architecture and the practical arts within its scope. It differed in making "reactionary" use of recognizable objects in painting.

In *L'Elan* as early as 1916 Ozenfant had decried what seemed to him the trivial decorative turn which Cubism had taken since 1914 when within a year Braque turned from the severity of the *Oval still life* (fig. 73) to the soft-contoured, confetti-dotted *Music* (fig. 74) and Picasso from the ascetic *Violin* of 1912 (fig. 31) to the gay *Green still life* (fig. 75). Braque's *Still life* of 1918 (fig. 77) is contemporary with the birth of Purism and partially explains it.

Positively, the Purists insisted that twentieth century paintings should hold their own with machines in precision and workmanship. The dynamism, the speed, the modernity of machines had excited the Futurists of 1909; the powerful shape of the machine had influenced Duchamp-Villon's *Horse* of 1913 (fig. 97); the complexity and uncanny, inhuman life of machines had fascinated the Dadaists of 1916 (certain works of Duchamp [fig. 190] and Picabia [fig. 191] definitely anticipated Purism); the color of machines, their stencilled lettering and cylindricality of tubing and pistons, had inspired Léger in his work of 1917-22 (figs. 84, 85); but it was above all the precision, the cleanness of line, the impersonal elegance of machines which affected Purism and, later, the architecture of Le Corbusier.

Le Corbusier's *Still life* of 1920 (fig. 178) is characteristic of the machine esthetic in its faultlessly precise drawing, its smooth color and the way the contours of the forms fit together. The forms themselves are not very abstract and often resemble the silhouettes of ordinary objects. This is a deliberate

163

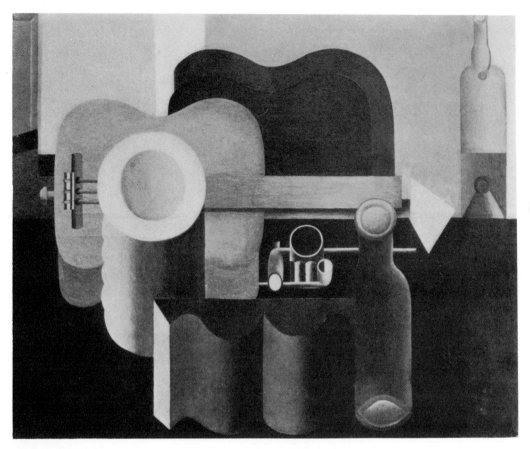

178 (129) Le Corbusier (Jeanneret) : Still life, 1920

179 (317) Le Corbusier: Chair

180 (299) Le Corbusier: Model of Savoye house, Poissy-sur-Seine, 1929-30; *cf.*
Le Corbusier, fig. 178.

181 (300) Le Corbusier: de Beistegui penthouse, Paris, 1931

choice, for it was part of the Purist program to use as motives the shapes of familiar objects which would be recognizable to all Europeans of all classes. The elimination of depth, the free use of overlapping transparent planes, the arbitrary color and the atmosphere of *nature-mortisme* make Purist painting a methodical kind of Cubism. In its elaborate, systematic theories of color and line it suggests Neo-Impressionism and Seurat was in fact much admired by the Purists.

Impressionism : Neo-Impressionism = Cubism : Purism

Monet, Pissarro	Seurat,		Picasso, Braque	Ozenfant,
Intuitive	Signac		*Intuitive*	Le Corbusier
development	*Rationalization*		*development*	*Rationalization*

This equation does not concern artistic importance but is merely to suggest a similarity in sequences.

Purist paintings were designed architectonically so that they were appropriate decorations for the new architecture which Le Corbusier was just developing. Furthermore they were exercises in color which Le Corbusier was to use so subtly in his architecture: light blues, pinks and dark browns in contrast to the insistent primary blue, red, and yellow of *de Stijl;* and finally they gave him practice in that sensitive adjustment of subtle curves to straight lines which was to distinguish the planning of his later architecture (figs. 180, 181) and furniture (fig. 179) from that of the orthodox *Stijl* and Bauhaus designers who rarely departed from the straight line and right angle (figs. 147, 149, 164, and 150, 165). This is not to say that Le Corbusier's architecture is an outgrowth of his Purist painting: they were, rather, interdependent developments united by the same esthetic and the same immaculate taste.

In recent years Ozenfant has given up Purism and Le Corbusier now paints more or less as a relaxation from architecture. Purist painting, originally intended to be intelligible to a wide public, achieved its end obliquely through a brilliant poster by Cassandre for the *Wagon-Bar* (fig. 83).

Abstract films

Broadly speaking abstract films are of two kinds. The first kind is made in a series of gradually altered drawings in the technique of animated cartoons. The second is made by photographing objects with ordinary film technique.

The pioneers in making abstract films of the animated cartoon type were Eggeling and his follower Richter. Eggeling's *Diagonalsymphonie* (fig. 182), begun about 1917, is analogous to, but in no sense dependent upon, the abstract designs of Malevich and Klee. Richter's somewhat later *Rhythmus* (fig. 183) is directly derived from the *Stijl* paintings of Doesburg and Mondrian (fig. 145). Richter became a member of the *Stijl* group in 1921 after Doesburg had established his center in Berlin. The strip from *Rhythmus* suggests how Mondrian's static squares are made to change in size and position.

In 1924, seven years after Eggeling had begun to experiment in Germany with "animated" abstract drawings, the painter Léger with the help of the American photographer Dudley Murphy made in Paris the *Ballet mécanique*, the first important abstract film in the ordinary technique. His abstract effects were achieved in a number of ways: by arranging ordinary objects such as straw hats (fig. 184, middle) or saucepan lids (fig. 184, above) in rhythmic moving patterns; by photographing fragments of figures such as dancers' legs; by such trick photography as double exposure and distorting lens. The effect of mechanical rhythm was enhanced by the player-piano music composed by the American, George Antheil.

In 1923, the year before Léger's film, the American Man Ray had made some thirty feet of abstract film called *Le retour de la raison* for a Dadaist celebration. His *Emak Bakia* (fig. 185) is a longer and much more serious film, abstract for the most part, but with Surrealist atmosphere.

167

182 (381) Eggeling: *Diagonalsym-phonie*, begun 1917

183 (382) Richter: *Rhythmus*, 1921; *cf.* Mondrian, fig. 145

184 (383) Léger: *Ballet mécanique*, 1924

185 (384) Man Ray: *Emak Bakia*, 1927

Abstract photography

Man Ray was also a pioneer in abstract photography. He was probably the first to make use of the rayograph technique in making abstract compositions. In making a rayograph no camera is used; objects are placed directly upon sensitized paper which is then developed. With such objects as a fly-screen, a darning egg, brass rings and a lock of hair Man Ray achieved compositions of great subtlety (figs. 186, 187). They were acclaimed by Man Ray's fellow-Dadaists because of their anti-"artistic" and apparently casual technique but many of them are in fact consummate works of art closely related to abstract painting and unsurpassed in their medium.

The Hungarian Moholy-Nagy, formerly a professor at the Bauhaus in Dessau, was, until his recent removal to London, one of the most inventive and original of the masters of photogram (fig. 188), another name for the rayograph.

Francis Bruguiere, an American living in London, uses the camera in making his abstract photographs of light falling upon white folded or wrinkled paper (fig. 189).

186 (281) Man Ray: Rayograph, 1922 **187** (280) Man Ray: Rayograph, 1922

170

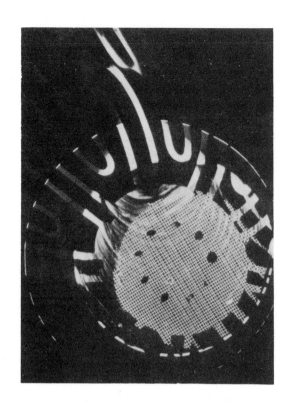

188 (279) Moholy-Nagy: Photogram, 1925

189 (278) Bruguiere: Abstraction (photograph)

Abstract Dadaism

Abstract Dadaism is a provisional name for the diverse kinds of Dada paint-ing which approached or achieved abstraction. Dadaism itself was primarily a state of mind. It began in Zurich in 1916, partly as a literary movement, and developed strongholds during or after the War in New York, Cologne, Paris and Hanover with outposts in many other cities.

Dada[1] was born of scepticism, disillusion, cynicism, and nourished by war, peace and inflation. The Dadaists scoffed at all standards and traditions, both conservative and advanced. This program of contempt for art did not, how-ever, prevent the Dadaist painters from appropriating and developing the ideas and techniques of pre-War movements of which in many cases they had been members.

Duchamp and Picabia

Duchamp and Picabia, active as pioneers of Dada, brought to the movement not merely a spirit of iconoclasm bitter and humorous by turns but also two methods of abstract design. The first of these can be called organic or bio-morphic abstraction and is admirably illustrated by Duchamp's half-Cubist *Bride* of 1912 (fig. 41), four years before the Dada explosion occurred. The abstract anatomy of the *Bride* anticipates in form not only certain aspects of Dadaism but, even more, the later, abstract Surrealist art of Ernst, Arp, Picasso, Miro, Tanguy and Giacometti.

The second method contributed to Dada by Duchamp and Picabia was an abstraction not of organic forms but of mechanical forms. Duchamp, as usual, was the pioneer, but Picabia's *Very rare picture upon the earth* (fig. 191) and *Amorous procession* (fig. 194), done just before and just after the beginning of Dadaism, are characteristic of Dadaist "machinism." Max Ernst's *Little tear gland that says tic-tac* (fig. 195), done at the height of the Dada movement, is simpler in form but subtler in conception.

These biomorphic and mechanomorphic experiments were combined in the elaborate masterpiece of Marcel Duchamp, *The bride stripped bare by her bachelors*, painted on a gigantic piece of plate glass from studies made from 1912 to 1918. Two of the studies are illustrated: *The bride* of 1912 just men-tioned, and *The bachelors* (fig. 190), a fusion of mechanical and organic forms, done in 1914. Still more abstract is Duchamp's glass painting of 1918 (fig. 193) which must have influenced the eclectic Lissitzky's *Proun* compo-sition (fig. 125) of six years later.

[1] *Cf.* Bibl. 177, 178, 183, 93.

172

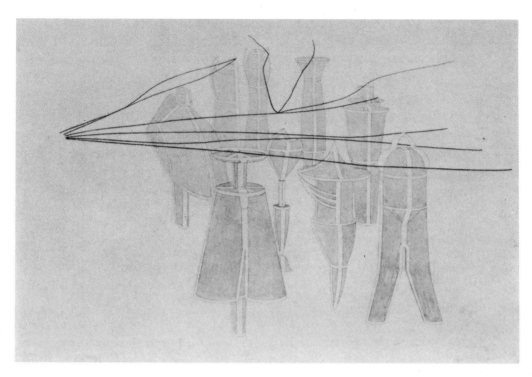

190 (59) Duchamp: The bachelors, 1914

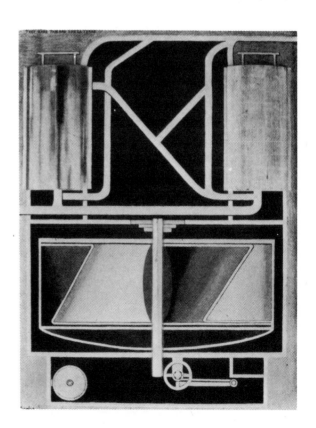

191 (201) Picabia: Very rare picture upon the earth, 1915

Schwitters, Man Ray

Cubism, though theoretically scorned by the Dadaists, contributed the technique of *collage* to Dadaism, especially in the work of Ernst (fig. 195) and Kurt Schwitters (fig. 196). Schwitters made much more exclusive use than had the Cubists of the dustbin and wastebasket, from the contents of which he pasted together Merz pictures, compositions of exquisite sensitiveness. Schwitters' Merz construction (fig. 197) of 1921 is obviously a development of Picasso's proto-Dada Cubist reliefs of 1913-14 (fig. 98). Schwitters carried to a Dada extreme the use of commonplace, non-artistic materials in making works of art.

Futurist influence on Dadaism was also considerable not only in the technique of propaganda, manifesto and noise but also through its exaltation of the machine and its contempt for traditional esthetics and attitudes. Boccioni was perhaps the first to insist upon the validity of using non-traditional materials in works of art.[1]

Man Ray's photographs or rayographs (figs. 186, 187), by which he made abstract compositions from the silhouettes of miscellaneous gadgets, were also considered by the Dadaists and later by the Surrealists as orthodox. Man Ray, who had been a Dadaist painter, turned to photography as a repudiation of "Art" just as Schwitters had turned to rubbish and Duchamp at one time to plumbing fixtures.

de Chirico and Klee

Two painters outside the movement were particularly admired by the Dadaists, the Italian de Chirico, and the German-Swiss Klee. In 1915, at a time when the Cubists were completely eliminating depth and space, de Chirico was engaged in painting compositions of abstract still life objects in a realistic technique of insistent modelling, cast shadows, and emphatic perspective. Often he painted *trompe-l'oeil* biscuits and other objects in a way comparable to Cubist illusionistic texture and nails. Psychological factors predominate in de Chirico's *Evangelical still life* (fig. 192) but it may nevertheless be considered, from a formal point of view, as an original contribution to abstract art.

Paul Klee, originally a member of The Blue Rider group in Munich, influenced both Dadaism and Surrealism by the inexhaustible variety of his ingenious fantasies.

[1] *Cf.* Boccioni, quoted on page 60.

192 (41) de Chirico: Still
life, 1916

193 (60) Duchamp: Disturbed
balance, 1918 (*not in exhibition*)

195 (65) Ernst: The little tear gland that says
tic-tac, 1920

194 (202) Picabia: Amorous procession, 1918

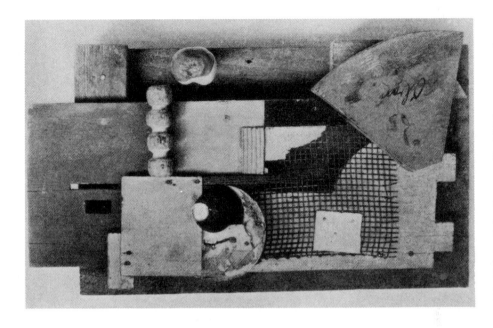

197 (252) Schwitters: Rubbish construction, 1921

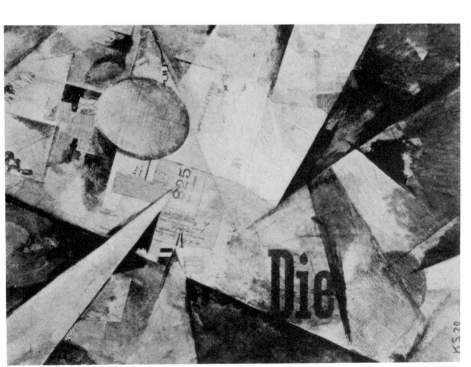

196 (251) Schwitters: Radiating world: rubbish picture 31B, 1920

Abstract tendencies in Surrealist art

Surrealism, a schismatic outgrowth of Dadaism, was announced in Paris in 1924. Many of the more important Surrealist artists had been Dadaists, notably Arp, Ernst and Man Ray. Like the Dadaists the Surrealists also "claimed" Chirico and Klee, to whom they added Picasso. Masson and Miro were, Tanguy, Giacometti and Dali still are, official members of the movement. Surrealism was, like Dadaism, a point of view, a faith, almost a way of life. The Surrealists developed and codified the theories of the Dadaists. Like them they advocated absolute spontaneity and license and despised all conventional systems of values; but, unlike the Dadaists, their anarchy was systematic. In their rejection of the rational and intellectual in favor of the subconscious world of impulse they looked for sanction to Freud and the psychology of the subconscious. Many of their paintings and drawings are the result of automatic technique[1] or of an attempt to recapture the atmosphere of dreams—both related to psychoanalytic method. Like the Dadaists they discovered values in the commonplace curiosities and bizarre banalities of popular art but they had little interest in machine esthetic which had been so important in Dadaism. They turned, rather, to primitive art as a revelation of unspoiled group expression and to the art of the insane and of children as the uninhibited expression of the individual. The elaborate dialectic of Surrealism cannot be presented here[2] but even these slight indications throw light on Surrealist art even at its most abstract.

Abstract art, it should be clearly understood, was no more a part of the Surrealist program than it had been of Dada. From a strictly Surrealist point of view an abstract design is merely a by-product. For instance a Picasso *collage* (fig. 65), considered not as a pattern of line and texture but from the point of view of subject-matter, as a representation of a still life, is sufficiently bizarre to excite the Surrealist emotion of *disquieting* amazement. But, to reverse the point of view, Masson's pastel (fig. 200) and Tanguy's drawing (fig. 205), whatever their Surrealist significance may be, are even more abstract than Picasso's *collages* and may be considered one of the results of the early 20th century impulse towards abstract design.

Surrealist painting may be divided into two kinds. The first might be called automatic pictures; the second dream pictures. The first kind suggests a maximum of technical spontaneity, a direct record of an uncensored graphic or pic-

[1] Automatic drawing, like automatic writing, is done in a state of semi-hypnosis in which conscious control is presumably abandoned.
[2] *Cf.* Bibl. 175, 176, 177, 180, 182, 93.

torial impulse. To this category belongs much of the Surrealist work of Masson, Miro, Arp and often of Ernst and Picasso. The second kind of Surrealist painting also depends upon spontaneity of imagination but not of technique. Chirico, in his work of 1910-20, Tanguy, Dali, Magritte and often Ernst, in their effort to make as convincing as possible a fantastic or dream-like world, use a technique as realistic and deliberate as that of a Flemish or Italian master of the 15th century.

Surrealism and Abstract Expressionism

From a formal, plastic point of view the first kind of Surrealist painting in its abstract aspects belongs not to the tradition of Cézanne and Cubism but to that which comes down from Gauguin and Redon through Matisse to Kandinsky and Klee of the Blue Rider group in Munich.

The connection between the pre-War Munich Expressionists and the Paris Surrealists is partly one of direct influence, especially through Klee, and partly one of analogy of form and method. Kandinsky's method in his *Improvisations* has been described. It seems virtually the same as the more deliberate automatic method of the Surrealists. Furthermore Kandinsky's results, as seen in the abstract watercolor (fig. 3) or the famous "cannon" *Improvisation* (fig. 52) with its mixture of amorphous forms and vaguely represented objects, are analogous to the work of Masson (fig. 200), Miro (fig. 204), Tanguy (fig. 205) and possibly of Arp, who had actually been a participant in the Munich movement before the War.

Klee refused to have any formal connection with the Surrealists in spite of their admiration for his work; he had no desire to involve himself in their dogmatic program. Klee achieved along with his more "literary" and representational work a long series of abstract and near-abstract fantasies, minor in key and of extreme subtlety and wit. His *Abstract trio* (fig. 198) and his later *In the grass* (fig. 199) are obviously related to the linear abstractions of Miro, Masson and Ernst.

Masson and Miro

The art of Masson or Miro at its most characteristic is flat, two-dimensional and linear. Masson's drawing, *Furious suns* (fig. 201), in spite of its vehemence suggests the half-conscious (but not disorderly) scrawl of an absent-minded man, or the scribbling of a child of four. It is, in fact, practically an automatic

180

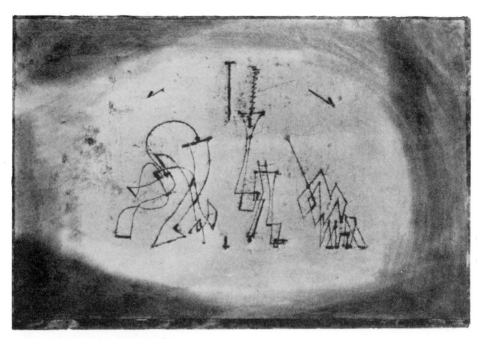

198 (109) Klee: Abstract trio, 1923

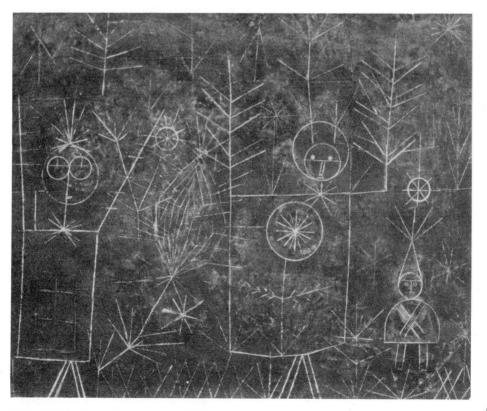

199 (113) Klee: In the grass, 1930

drawing done almost without conscious control. It achieves a maximum of what may be called manual spontaneity, the untrammelled weaving of the pen. Masson's large pastel (fig. 200), though of course much less purely spontaneous, displays to a remarkable degree an extreme calligraphic freedom.

Miro's art is similar to Masson's in its spontaneity but it lacks the impetuosity and fury of Masson's line. Miro's drawing is at times almost meditative, wandering, like a river over a flat plain; his color possesses an extraordinary freshness; and his forms have the convincing gusto of primitive cave paintings or children's watercolors. Of all the Surrealists Miro has the most plastic humor (fig. 202) but at times he can drop his clowning and paint imposing compositions, unsurpassed among recent paintings in elegance of line and color (fig. 204).

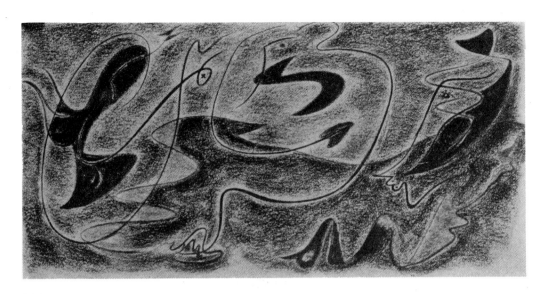

200 (165) Masson: Metamorphoses, 1929

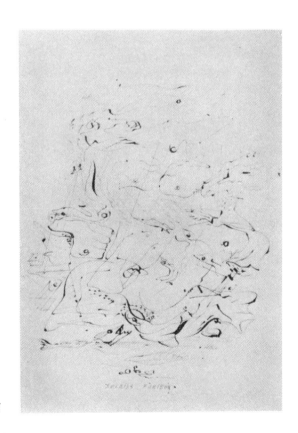

201 (164) Masson: Furious suns, 1927

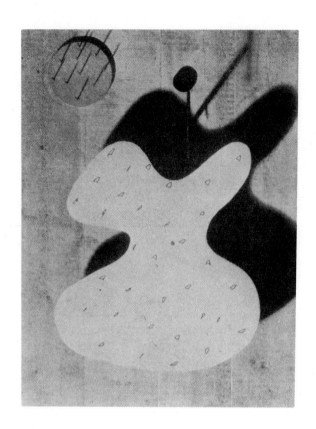

202 (170) Miro: Relief construction, 1930

203 (171) Miro: Head of a man, 1932

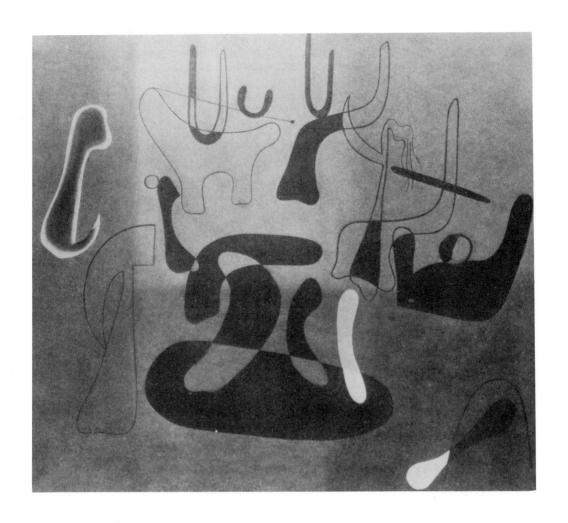

204 (173) Miro: Composition, 1933

Ernst, Tanguy

Unlike Masson and Miro, Ernst depends very little upon linear arabesque and concerns himself more with textures, sometimes using *frottages*, rubbings made directly from the surface of rough-sawn planks as in *Illusion* (fig. 206) or, like the Cubists of 1912, simulating such textures. Ernst is, in general, less abstract than Miro or Masson and often works partly or altogether in a representational manner. He is by far the most versatile, technically, of the Surrealists excepting Picasso. His *collages*, for instance, range all the way from the early Dada *Little tear gland* (fig. 195) and the recent abstract *Personage* to composite illustrations for his full-length novels which are the opposite of abstract.

Of the second group of Surrealist painters, those who paint fantastic scenes with extreme realism, only Tanguy is consistently abstract. He took the flat, organic, biomorphic shapes of Arp and Miro, and, about 1927, painted or drew them in the round (fig. 205) and with them populated his lunar and submarine landscapes. Tanguy learned the value of space and perspective from de Chirico who had used it in his "metaphysical" still life of 1915-17 (fig. 192).

Arp

Arp's art is far simpler in form and more reticent both in spirit and subject matter. In the Surrealist tradition he is the puritan. In 1915, between periods of Munich Blue Rider Expressionism and Zurich Dadaism, he made *collage* compositions of almost geometrical purity (fig. 57). His Dada reliefs of which the *Head* (fig. 207) is a late example are built up of stratified sections of jigsawn, brightly painted wooden planking, like greatly enlarged units of a picture puzzle. His recent reliefs are of extreme simplicity, the cut-out shapes confined to a single level or stratum and severely framed in a rectangle. Often the relief shapes are mingled with painted shapes as in the *Relief* (fig. 208).

Recently Arp has turned from stratified relief to sculpture in the round. His *Human concretion* (fig. 209) is a kind of sculptural protoplasm, half organic, half the water-worn white stone. In his concretions he was partly anticipated by an extraordinary work of Vantongerloo, the *Composition within a sphere* done in 1917 (fig. 210). Vantongerloo, a member of the severely rectilinear *Stijl* group, never again returned to such a biomorphic form. Arp had done his *collages* in squares just before 1916—and never again returned to geometric form. The Arp "shape," a soft, irregular, curving silhouette half-way between a circle and the object represented, appears again and again in the work of Miro, Tanguy, Calder, Moore and many lesser men.

186

206 (67) Ernst: Illusion, 1929

205 (262) Tanguy: Drawing, 1932

207 (8) Arp: Head, 1924-25

208 (9) Arp: Relief, 1930

209 (10) Arp: Human concretion, 1935

210 (268) Vantongerloo: Construction within a sphere, 1917

Picasso

Picasso's Cubist paintings and especially his *collages* had interested the Surrealist leaders. After 1925 some of his work began to take on a more Surrealist character, as in the *Head* of 1927, the year of the famous *Seated woman.*[1] In 1928 he began a series of *Metamorphoses*, some of which were popularly called "bones." In them fairly abstract organic forms are modelled in the round with the same powerful technique he had used a few years before in his colossal neo-classic nudes. These imposing biomorphic constructions of Picasso are sometimes organic in shape, sometimes geometrical (fig. 212), sometimes mixed (fig. 211). They were anticipated in different ways by Brancusi, Masson and Tanguy and by Duchamp's *Bride* of 1912, which is perhaps the first anatomical abstraction.

About the same year, 1928, Picasso began to turn his attention to sculpture and construction.[2] Some of his plaster figures are related to his *Metamorphoses*. His wire constructions resemble the linear forms in his paintings *The painter and his model* and *The studio* (figs. 88 and 89).

[1] *Cf. Painting in Paris*, Museum of Modern Art, New York, 1930, pl. 76.
[2] All Picasso's recent sculpture is still in the artist's possession but was not available for exhibition.

190

Gonzales

Picasso was instructed in metal technique by his countryman Gonzales who in turn was influenced by Picasso in such wrought iron constructions as the *Head* (fig. 216). Gonzales' work, in marked contrast to the machine-like precision of much modern sculpture, is unmistakably hand-wrought, whether in roughly patined iron (fig. 216) or in fragile silver (cat. no. 92).

Lipchitz

Lipchitz, at one time one of the most important Cubist sculptors, has in recent years done work of great originality and power which relates him to the Surrealists. Starting in 1927, he executed a long series of open-work constructions in cast bronze (fig. 213). They were abstract anthropomorphic figures achieving great formal interest by their transparent effect of intertwining lines. The free, weaving character of these constructions or *transparents* as Lipchitz calls them have little in common with the rigidity and architectural character of the Russian constructions. They are more nearly an extreme development of the pierced Cubist sculpture with which Archipenko was the first to experiment. Lipchitz, like so many of his post-Cubist contemporaries, continued to draw inspiration from Negro sculpture. His monumental *Sculpture* (fig. 215) of 1930, designed for a garden, is an awe-inspiring amplification of such Negro forms as the Ivory Coast buffalo mask (fig. 214). Characteristic also of biomorphic sculpture is Lipchitz' *Song of the vowels* in which anthropomorphic figures are fused in a continuous organism with two colossal harps.

211 (231) Picasso: Bather by the sea, 1929

212 (230) Picasso: Woman in an armchair, 1929

213 (141) Lipchitz: She, 1930

214 (277A) African mask, Ivory Coast; *cf.* Lipchitz, fig. 215

215 (140) Lipchitz: Sculpture, 1930

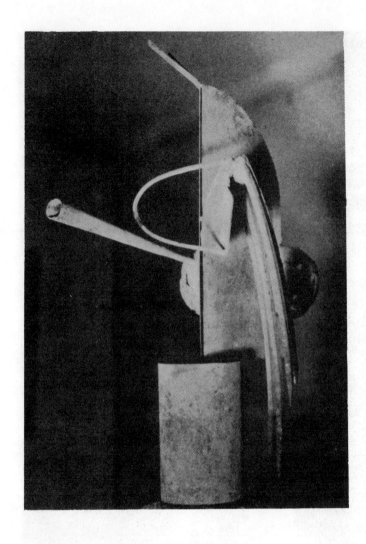

216 (93) Gonzales: Head, 1935-36

The younger generation

"Younger generation" is not perhaps an apt title for paragraphs on the work of men most of whom are in their thirties and mature masters of their art. All of them work in traditions already established though their own work has come to the fore only within the last five years. They illustrate the remarkable renaissance of interest in abstract art among the younger artists who not only have strengthened recent developments but have actually resurrected problems which excited the vanguard of twenty years before. Most of these younger men were members of the *Abstraction-Création* group which flourished in Paris during the early '30s, uniting under its banner both the abstract geometrical traditions of Holland and Russia and the abstract non-geometrical traditions of Expressionism and Surrealism.

Domela was an apprentice member of the *Stijl* Group as early as 1926. He turned from painting in the manner of Mondrian to relief construction in glass and metal in which Neo-Plasticist "geometry" is freely varied (fig. 217).

Calder, under the joint influence of Mondrian and Gabo, turned his back on the popular success of his wire portraits to experiment with mobile constructions built of wire, iron pipe and metal (fig. 218). Many of the mobiles were composed of objects hung by strings or supported by flexible wires. Others were driven by motors. They display an ingenuity and visual humor quite different from the kinetic constructions which Gabo designed as early as 1922 or Rodchenko's hanging constructions of 1920 (figs. 130, 131). Recently Calder has deserted geometrical shapes for irregular quasi-organic forms (fig. 219).

Hélion was also a devoted follower of Mondrian but has gradually broken away from flat squares and straight lines to curved, slightly modelled forms without, however, sacrificing the purity of his earlier style (fig. 220).

Giacometti is at present the official Surrealist sculptor as well as one of the youngest members of the group. His *Head-landscape* (fig. 222) is, from the Surrealist point of view, a successful plastic pun but it is also an interesting biomorphic abstraction and a solution of one of the problems which has recently held the attention of sculptors, namely the composition of isolated forms which Arp had suggested in his reliefs and which Giacometti carries further in his project for a *City square*. In others of his works, constructions or "cages," Giacometti combines dangling and static objects, some abstract, some realistic, with great imaginative virtuosity.

Outside of Paris abstract art continues to gain adherents among the younger generation in most European countries. Lack of space forbids even a brief

218 (30) Calder: A mobile, 1934

217 (56) Domela-Nieuwenhuis: Construction, 1932

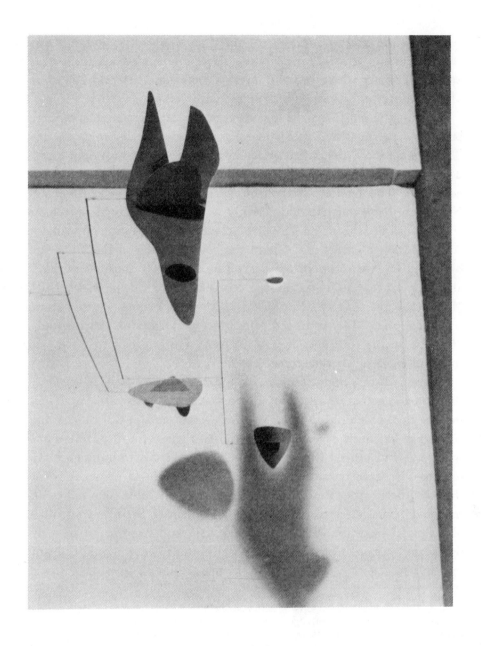

219 (31) Calder: A mobile, 1936

review of the groups in Italy, Spain, Czechoslovakia, Poland, Switzerland.[1] In Holland and Russia, formerly creative centers, abstract art is nearly extinct and in Germany where it had flourished between 1910 and 1933 the survivors of official antipathy carry on their art with furtive anxiety.

Perhaps the most surprising resurgence of abstract art has occurred in England.[2] Vorticism, the English pre-War movement, disintegrated about 1920. Wyndham Lewis, the Vorticist leader, remains the most important figure in English abstract painting but his reputation, as a painter, has not spread to the continent. The leaders of the younger generation, the sculptors Moore and Nicholson, have participated actively in the international movement.

The work of Moore and Nicholson clearly illustrates the opposite poles of the contemporary abstract movement, the geometrical and the non-geometrical or biomorphic. Nicholson in his carved and chastely painted reliefs (fig. 221) attacks the problem of composing rectangles and circles which had interested Malevich (figs. 111, 112) and his followers twenty years before. Moore's sculpture (fig. 223), indebted somewhat to the art of Picasso and Arp. (fig. 209), is, on the contrary, organic in form with a sensitive feeling for the texture and color of his varied materials.

At the risk of generalizing about the very recent past, it seems fairly clear that the geometric tradition in abstract art, just illustrated by Nicholson's relief, is in the decline. Mondrian, the ascetic and steadfast champion of the rectangle, has been deserted by his most brilliant pupils, Hélion and Domela, who have introduced in their recent work various impurities such as varied textures, irregularly curved lines and graded tones. Geometric forms are now the exception rather than the rule in Calder's mobiles. The non-geometric biomorphic forms of Arp and Miro and Moore are definitely in the ascendant. The formal tradition of Gauguin, Fauvism and Expressionism will probably dominate for some time to come the tradition of Cézanne and Cubism.

[1] The exhibition of American abstract art at the Whitney Museum of American Art in 1935, though conceived, like this one, in a retrospective spirit, included the work of many younger men. As this volume goes to press, an exhibition of five young American abstract painters opens in New York and at the Charleston Museum the large S. R. Guggenheim collection of abstract art has recently been put on view. The Gallery of Living Art of New York University, primarily concerned with abstract art, has steadily increased its collections under the guidance of its director, A. E. Gallatin.

[2] Including architecture and allied arts. The former Bauhaus leaders, Gropius and Moholy-Nagy, now live in London. The *Penguin House* at the London Zoo (fig. 139) was designed by Lubetkin, a former Russian Constructivist, now a member of the English architectural group, *Tecton*.

221 (188) Nicholson: Relief, 1934

220 (101) Hélion: Composition, 1934

222 (86) Giacometti: Head-landscape, 1932

223 (187) Moore: Two forms, 1934

Catalog

Painting and Sculpture; Drawings, Constructions

ARCHIPENKO, Alexander. Sculptor and draughtsman. Born Kiev, Russia, 1887. Studied Kiev, 1902-05; Moscow, 1905-08; Paris, 1908. Associated with Cubist painters. First Cubist sculpture, 1911. In Nice during War; Berlin, 1921; New York, 1923. Lives in Hollywood, California.

*1. **Hero,** 1910
Gilded terra cotta, 33 inches high
Collection Mrs. Alexander Archipenko, Hollywood, California
Figure 92

*2. **Walking woman,** 1912
Terra cotta, 27 inches high
Collection Mrs. Alexander Archipenko, Hollywood, California
Figure 93

*3. **Boxing,** 1913
Terra cotta, 30 inches high
Collection Mrs. Alexander Archipenko, Hollywood, California
Figure 94

4. **Statuette,** 1914
Terra cotta, 28 inches high
Collection Mrs. Alexander Archipenko, Hollywood, California

*5. **Bather** (sculpto-painting), 1915
Wood, metal and paper, 20⅛ x 11½ inches
Collection Mr. and Mrs. Walter C. Arensberg, Hollywood, California
Figure 95

6. **Woman dressing her hair,** 1915
Bronze, 12⅞ inches high
Collection Weyhe Gallery, New York

ARP, Hans. Sculptor and painter. Born Strasburg, 1888. Studied painting at Weimar, 1907. Visits to Paris. Switzerland, 1911-12. Munich, 1912, associated with Kandinsky and *Der Blaue Reiter.* One of founders of Dada, Zurich, 1916; Cologne, 1920. Member of Surrealist group, Paris, 1924. Lives at Meudon, near Paris.

*7. **Composition,** 1915
Collage, 35 x 27 inches
Collection the artist, Meudon-val-Fleury, France
Figure 57

*8. **Head,** 1924-25
Painted wood, 11 inches high
Collection Société Anonyme, Museum of Modern Art, 1920
Figure 207

*9. **Relief,** 1930
Painted wood, 23½ x 17¾ inches
Collection Mrs. George Henry Warren, Jr., New York
Figure 208

*10. **Human concretion,** 1935
Plaster, 20 inches high
Collection the artist, Meudon-val-Fleury, France
Figure 209

BALLA, Giacomo. Painter. Born Turin, 1871. Original member of Italian Futurist group, 1910. Lives in Rome.

*11. **Dog on leash,** 1912
Oil on canvas, 35⅝ x 43¼ inches
Collection the artist, Rome
Figure 42

*12. **Progressive lines + dynamic sequences** (The swifts), 1913
Oil on canvas, 38⅜ x 47⅝ inches
Collection the artist, Rome
Figure 44

BELLING, Rudolf. Sculptor. Born Berlin, 1886. Berlin Academy, 1911-12. Moved to New York, 1934.

*13. **Head,** 1923
Bronze, 15 inches high
Collection Weyhe Gallery, New York
Figure 161

BOCCIONI, Umberto. Sculptor and painter, Born Reggio Calabria, Italy, 1882. Rome, 1901. Through Balla, influenced by Neo-Impressionism. Paris and Russia, 1904-05. Met Marinetti, Milan, 1909. Wrote manifesto of Futurist painters, Milan, 1910. Leader of Futurist painters, 1910-14. First Futurist sculpture, 1911. Exhibited in Futurist painting exhibition, Paris, 1912; sculpture, 1913. Knew Picasso and Braque. Died at Verona, 1916.

*14. **Development of a bottle in space,** 1912
Bronze, 16 inches high
Collection The Gallery of Modern Art, Milan
Figure 47

*15. **Unique forms of continuity in space,** 1913
Bronze, 40 inches high
Collection The Gallery of Modern Art, Milan
Figure 49

BRANCUSI, Constantin. Sculptor. Born Roumania, 1876. Studied art, Bucharest, until 1902. To Paris, 1904. Studied with Mercié at *Ecole des Beaux-Arts*, but left on advice of Rodin, 1906. Worked in Rodin's atelier. First exhibition, Paris, 1906. Lawsuit, 1926, over *Bird in Space*, which U. S. Customs held was not a work of art. Lives in Paris.

16. **Sleeping muse,** 1910
Bronze, 11 inches high
Collection The Art Institute of Chicago

*17. **The new-born,** 1915
Brass, 8¼ inches long
Collection Julien Levy Gallery, New York
Figure 106

*19. **Leda,** 1920
Marble, 24 inches high
Collection Miss Katherine S. Dreier, New York
Figure 108

20. **Male torso,** 1922
Bronze, 18⅝ inches high
Collection The Brummer Gallery, New York

21. **The chief,** 1925
Wood, 21 inches high
Collection S. N. Behrman, New York

*21A. **Bird in space,** *c*. 1925
Brass, 54 inches long
Collection The Museum of Modern Art, New York
Figure 107

BRAQUE, Georges. Painter. Born Argenteuil, France, 1882. Studied at Le Havre where he met Friesz. Paris, 1904, studying at *Académie Julian*. Joined *Fauves*, 1905-07. Early work influenced by Signac, van Gogh, Matisse, Friesz, then, 1907-08, by Cézanne. With Picasso founded Cubist movement, 1908. Designs for ballet *Les Fâcheux*, 1924; *Zéphyr et Flore*, 1926. Lives in Paris.

*22. **Nude,** 1908
Oil on canvas, 55¾ x 40 inches
Collection Mme. Cuttoli, Paris
Figure 17

*22A. **Guitar,** 1908
Oil on canvas, 19¾ x 24⅛ inches
Collection the artist, Paris
Figure 16

*23. **Seaport,** 1908
Oil on canvas, 31⅛ x 31⅛ inches
Collection Alfred Flechtheim, Paris
Figure 19, *not exhibited*

*24. **Composition,** 1913
Charcoal and collage of colored papers on paper, 20 x 22½ inches
Collection The Gallery of Living Art, New York University
Figure 64

*25. **Still life with playing cards,** 1913
Oil on canvas, 31⅛ x 23⅝ inches
Collection Paul Rosenberg, Paris
Figure 63

205

***26. Oval still life,** 1914
Oil on canvas, 36 x 25 inches
Collection The Museum of Modern
Art, New York
Gift of the Advisory Committee
Figure 73

***27. Music,** 1914
Oil on canvas, 36 x 23½ inches
Collection Miss Katherine S. Dreier,
New York
Figure 74

***28. Still life,** 1918
Oil on canvas, 19 x 25½ inches
Collection Marie Harriman Gallery,
New York
Figure 77

29. *Le Journal,* 1929
Oil on canvas, 9¾ x 16¼ inches
Collection The Museum of Modern
Art, New York
Gift of Mrs. Sadie A. May

CALDER, Alexander. Sculptor and constructivist. Born Philadelphia, 1898. Graduated as mechanical engineer from Stevens Institute of Technology, 1919; engineer for four years. Studied painting, Art Students' League, New York, 1923. To Paris, 1926. Influenced by Arp, Miro, Mondrian. First mobiles, 1931. First exhibition, Paris, 1932. Lives in New York.

***30. A mobile,** 1934
Pipe, wire and wood, 40½ inches high
Collection The Museum of Modern
Art, New York
Figure 218

***31. A mobile,** 1936
Wire, painted metal, etc., about 7 feet long
Collection the artist, New York
Figure 219

CARRÀ, Carlo. Painter and critic. Born Quargnento, Italy, 1881. Brera Academy,

206

Milan, 1904. With Futurist movement, 1909-15. Joined de Chirico in the *Pittura metafisica* movement, 1915. Lives in Milan.

CÉZANNE, Paul. Painter. Born Aix-en-Provence, 1839. Paris, 1861. Influenced first by Daumier, Delacroix, Courbet, Renaissance and Baroque masters, and later, in the '70's, by Pissarro and the Impressionists with whom he exhibited. Painted principally in Provence, with occasional excursions to Paris and northern France. Died Aix, 1906.

***33. Town of Gardanne,** *c.* 1885-86
Oil on canvas, 31 x 25 inches
Private collection, New York
Figure 29

34. View of Gardanne, *c.* 1885-86
Pencil drawing, 8¼ x 12³⁄₁₆ inches
Collection The Museum of Modern
Art, New York
The Lillie P. Bliss Collection

***35. Pine and rocks,** *c.* 1895-1900
Oil on canvas, 31⅞ x 25⅞ inches
Collection The Museum of Modern
Art, New York
The Lillie P. Bliss Collection
Figure 18

36. House among trees, 1895-1900
Watercolor, 11⅛ x 17⅛ inches
Collection The Museum of Modern
Art, New York
The Lillie P. Bliss Collection

***37. Oranges,** *c.* 1896
Oil on canvas, 23½ x 28⅝ inches
Collection The Museum of Modern
Art, New York
The Lillie P. Bliss Collection
Figure 24

38. Rocky ridge, *c.* 1900
Watercolor, 12⅜ x 18⅝ inches
Collection The Museum of Modern
Art, New York
The Lillie P. Bliss Collection

***39. Anatomical figure** (Study of Houdon's *Ecorché*), *c.* 1900
Pencil drawing, 10¾ x 8¼ inches
Collection The Museum of Modern
Art, New York
The Lillie P. Bliss Collection
Figure 28

40. Foliage, *c.* 1903-06
Watercolor, 17⅝ x 22⅝ inches
Collection The Museum of Modern
Art, New York
The Lillie P. Bliss Collection

de CHIRICO, Giorgio. Painter. Born
Volo, Greece, of Italian parents, 1888. Studied art in Athens; Munich academy; and
in museums in Italy. Paris, 1911-15; period
of deserted arcades. Knew Picasso, Apollinaire, Paul Guillaume. Rome and Florence, 1915-24; period of *Pittura metafisica*,
mannequins and still life, 1914-20. Associated with Dadaists and Surrealists. Designs for ballet *Le Bal*, 1929. Now paints
under the influence of Renoir. Lives in
Paris.

***41. Still life** (*Nature morte évangélique*), 1916
Oil on canvas, 31½ x 28 inches
Collection Sidney Janis, New York
Figure 192

DELAUNAY, Robert. Painter. Born Paris,
1885. St. Séverin series, 1908-09. Member
of Cubist group, 1910. Orphist or Simultanéist period, 1912. Designs for ballet
Cleopatra, 1918. Lives in Paris.

***42. St. Séverin,** 1909
Lithograph, 1927, after a painting of
1909; 22⅜ x 16⅝ inches
Collection The Museum of Modern
Art, New York
Figure 36

***43. Tower with a ferris wheel,** 1909-10
Ink drawing, 25½ x 19½ inches
Collection The Museum of Modern
Art, New York
Figure 38

***44. Eiffel Tower,** 1910
Ink drawing, 21⅜ x 19⅜ inches
Collection The Museum of Modern
Art, New York
Figure 37

***45. The windows,** 1912
Oil on canvas (oval), 22½ x 48 inches
Collection Léonce Rosenberg, Paris
Figure 58

***46. Disks** (*Composition simultanée; les
disques soleils*), *c.* 1913
Oil on canvas (circular), 53½ inches
in diameter
Collection the artist, Paris
Figure 59

47. Rhythm without end, 1935
Gouache, 10½ x 8¼ inches
Private collection, New York

DERAIN, André. Painter. Born Chatou,
France, 1880. Studied with Carrière; influenced by Signac, van Gogh, Gauguin.
Exhibited with the *Fauves*, 1905. Lives in
Paris.

47A. Bacchic dance, *c.* 1906
Watercolor, 19½ x 25½ inches
Collection The Museum of Modern
Art, New York
Gift of Mrs. John D. Rockefeller, Jr.

DOESBURG, Théo van (pseudonym for
C. E. M. Küpper; also called himself I. K.
Bonset). Painter, architect, theorist, editor. Born Utrecht, The Netherlands, 1883.
Painted in Holland, self-taught. Founded
de Stijl group and magazine, Leyden, 1917.
Weimar (Bauhaus) and Berlin, 1920-23.
Paris, 1923-26. Strasburg, 1926-28. Paris,
1928-31. Knew and influenced Gropius,
Miës van der Rohe, Le Corbusier. Died at
Davos, Switzerland, 1931.

Nos. 48-54, excepting No. 52A, are photographs of paintings, gifts of Mme. Pétro
van Doesburg

48. Self portrait, 1913
49. Card players, 1916

50. **Composition IX: card players,** 1916-17

51. **Three Graces,** 1916

*52. **Russian dance,** 1918
Figure 162

*52A. **Esthetic transformation of the object,** c. 1918.
From Bibl. no. 204
Figure 144

53. **Counter-composition in dissonances XVI,** 1925

54. **Arithmetical composition,** 1930

*55. **Simultaneous counter-composition,** 1929-30
Oil on canvas, 19 x 19 inches
Collection Mme. Pétro van Doesburg, Meudon-val-Fleury, France
Figure 156

See also *Architecture; Typography and Posters*

DOMELA-NIEUWENHUIS, César. Constructivist, painter. Born Amsterdam, 1900. Studied painting, Berlin, 1921. Switzerland, 1922-24. Paris, 1925, influenced by Mondrian; member of *de Stijl* group. Amsterdam, 1926-27. Berlin, 1927-1933. Applied principles of Neo-Plasticism to interior decoration and posters. Neo-Plasticist constructions in metal and glass, c. 1930. Influenced by Pevsner and Gabo. Paris, since 1933.

*56. **Construction,** 1932
Metal and glass, 17⅞ x 13⅝ inches
Collection the artist, Paris
Figure 217

DUCHAMP, Marcel. Painter, Dadaist. Born Blainville (Seine Inférieure), France, 1887. Brother of Jacques Villon and Raymond Duchamp-Villon. Joined Cubist group, 1910. *Nude Descending a Staircase,* 1912, caused great excitement at New York "Armory Show," 1913. Preoccupied with esthetics of machinery, 1912. Great composition in painted glass, *Bride Stripped Bare by Her Bachelors,* 1915-23. Influenced Dada movement, 1916-20. New York, 1917.

In 1920 abandoned painting for chess. Founder with Katherine Dreier of *Société Anonyme,* New York, 1920. Lives in Paris.

*57. **Nude descending a staircase,** 1912
Oil on canvas, 58⅜ x 35⅜ inches
Collection Mr. and Mrs. Walter C. Arensberg, Hollywood, California
Figure 40

*58. **The bride,** 1912
(Study for *La mariée mise à nu par ses célibataires, même,* 1915-23)
Oil on canvas, 34 x 22 inches
Collection Julien Levy Gallery, New York
Figure 41

*59. **The bachelors** (*Neuf moules mâlic*), 1914
(Study for *La mariée mise à nu par ses célibataires, même,* 1915-23)
Pencil drawing and watercolor, 25½ x 39 inches
Collection Miss Katherine S. Dreier, New York
Figure 190

*60. **Disturbed balance,** 1918
Inscribed: *A regarder (l'autre côté du verre) d'un oeil, de près, pendant presque une heure.*
(Original: glass, oil paint, etc., 20 inches high, collection Miss Katherine S. Dreier, New York)
Figure 193, *photograph only exhibited*

61. **Six roto-reliefs,** 1934
Paper, 7⅞ inches diameter
Private collection, New York

DUCHAMP-VILLON, Raymond. Sculptor. Born Damville (Eure), France, 1876. Influenced by Rodin, then by Cubists. First Cubist sculpture, 1912. Project for Cubist house, 1912. Gassed in War, 1916; died, 1918.

62. **The lovers** (first sketch), 1913
Bronze relief, 13½ x 20¼ inches
Collection estate of the artist

*63. **The lovers** (final version), 1913
Bronze relief, 11 x 14½ inches
Collection estate of the artist
Figure 96

*64. **The horse,** 1914
Bronze, 40 inches high
Collection estate of the artist
Figure 97

ERNST, Max. Painter, collagist, illustrator. Born Brühl, near Cologne, 1891. Studied Cologne University. Member of *Der Stürm* group, Berlin; founded Dadaist group, Cologne, 1919. Paris since 1922. Surrealist since 1924. First collages, 1919. With Miro designs for ballet *Roméo et Juliette*, 1926. Publishes collage novels. Lives in Paris.

*65. **The little tear gland that says tic-tac,** 1920
Gouache, 14½ x 10 inches
Collection The Museum of Modern Art, New York
Figure 195

66. **The forest,** 1925
Oil on canvas, 45⅝ x 26⅝ inches
Collection Miss Katherine S. Dreier, New York

*67. **Illusion,** 1929
Oil on canvas, 31⅝ x 25⅛ inches
Collection Miss Katherine S. Dreier, New York
Figure 206

68. **Personage,** 1931-32
Collage, 19¾ x 25½ inches
Collection Julien Levy Gallery, New York

FEININGER, Lyonel. Painter and illustrator. Born of German parents, New York, 1871. Decorative arts school, Hamburg, 1887; Berlin academy, 1888. Paris, 1892-93. Illustrator for German, French and American journals. Berlin, 1894-1906. Paris, 1906-08. First Cubist paintings, 1912.

Associated with Marc and Klee, 1913, Paris and Berlin, 1906-19. Bauhaus (Weimar, Dessau), 1919-33. Lives in Halle.

69. **Benz no. II,** 1912
Charcoal drawing, 8⅛ x 10½ inches
Collection J. B. Neumann, New York

*70. **Tall buildings no. II,** 1913
Charcoal drawing, 10 x 8 inches
Collection J. B. Neumann, New York
Figure 55

71. **Harbor**
Woodcut, 8⅝ x 11 inches
Collection The Museum of Modern Art, New York
Gift of Paul J. Sachs

GABO, Nahum. (Changed his name to avoid confusion with brother, Antoine Pevsner.) Constructivist, designer for theatre. Born Bryansk, Russia, 1890. University of Munich, 1909; later technical school where he studied mathematics and model construction. Christiania (Oslo), Norway, 1914-17. First constructions, 1915. Returned to Moscow with Pevsner after Revolution, 1917. "Realistic Manifesto" of Constructivism, 1920. Left Moscow for Berlin, 1921. Exhibited Berlin, 1922; Paris, 1925; New York, 1927. Designs for ballet *La Chatte*, 1927. Lives in Paris.

*72. **Column** (space construction), 1923
Glass and metal, 38½ inches high
Collection the artist, Paris
Figure 135

*73. **Monument for an airport** (space construction), 1925-26
Glass and metal on oval composition base, 19½ inches high, 28⅞ inches long
Collection the artist, Paris
Figure 138

74. **The red cavern** (space construction)
Celluloid, glass and metal, 25⅝ x 20⅝ inches
Collection the artist, Paris

Drawings
75. **Head,** 1916
Drawing, 7½ x 6⅝ inches
Collection the artist, Paris
76. **Still life with lamp,** 1917
Drawing, 6½ x 6½ inches
Collection the artist, Paris
77. **Still life with table,** 1917
Drawing, 5⅝ x 3¾ inches
Collection the artist, Paris
78. **Still life with instruments,** 1918
Drawing, 4¼ x 2⅞ inches
Collection the artist, Paris

GAUGUIN, Eugène-Henri-Paul. Painter,
graphic artist, sculptor. Born Paris, 1848.
Childhood in Peru. Seaman, 1865-68. Stock
broker, 1868-83. Painted in France, 1873-
86. Influenced by Impressionists, especial-
ly Pissarro, then by Cézanne. Martinique,
1887. Arles, with van Gogh, 1888. In-
fluenced by peasant sculpture of Brittany.
Leader of Pont-Aven or Pouldu (Brittany)
Synthetist group, 1889-90. Tahiti, 1891-93.
Paris, 1893-95. Tahiti and the Marquesas,
1895 until his death in 1903.

*79. **Hospital garden at Arles,** 1888
Oil on canvas, 9½ x 15 inches
Mr. and Mrs. L. L. Coburn Memorial
Collection
The Art Institute of Chicago
Figure 50
*80. **Goose girl, Brittany,** 1888
Oil on canvas, 9½ x 15 inches
Collection Hunt Henderson, New
Orleans
Figure 7
81. **The universe is created,** 1893-96
Wood cut, 8 x 14 inches
Collection The Museum of Modern
Art, New York
The Lillie P. Bliss Collection
82. **Women at the river** (*Aute te Papi*),
1893-96
Wood cut, 8 x 14 inches
Collection The Museum of Modern
Art, New York
The Lillie P. Bliss Collection

GIACOMETTI, Alberto. Sculptor. Born
Stampa, Switzerland, 1901. Painted, 1913-
21. First sculpture, 1915. Studied Geneva
School of Arts and Sciences, 1920. Italy,
1921-22; Paris, 1922. Joined Surrealists
about 1930. Lives in Paris.

83. **Standing figure,** *c.* 1927
Plaster (design for stone),
16⅝ inches high
Collection the artist, Paris
84. **Sculpture,** 1927
Carved plaster, 12½ inches high
Collection A. E. Gallatin, New York
85. **Disagreeable object,** 1931
Wood, 19 inches long
Private collection, New York
*86. **Head-landscape,** 1932
Plaster (design for stone), 9½ inches
high, 27½ inches long
Collection the artist, Paris
Figure 222
87. **Project for a city square,** 1932
Model in wood, 12⅝ x 9⅝ inches
Collection the artist, Paris

GLEIZES, Albert. Painter and theorist.
Born Paris, 1881. Apprenticed to father,
industrial draughtsman. Early work, Im-
pressionist. Joined Cubists, 1910. With Met-
zinger wrote *Du Cubisme,* 1912, followed
by many books on Cubism (see Bibl. nos.
159-164). Cubist *Section d'Or,* 1912. New
York, 1915. Developed abstract art based
on Cubism, 1915-20. Lives in Paris.

*88. **Brooklyn Bridge,** 1915
Oil on canvas, 40 x 40 inches
Collection J. B. Neumann, New York
Figure 72
*89. **Composition,** 1920
Gouache, 10½ x 5⅝ inches
Collection Léonce Rosenberg, Paris
Figure 80
90. **Composition,** 1921
Gouache, 6⅛ x 8⅞ inches
Collection Léonce Rosenberg, Paris

210

van **GOGH, Vincent Willem.** Painter. Born Zundert, Brabant, The Netherlands, 1853. Art dealer, The Hague, Paris, London, 1869-75. Schoolmaster, then evangelist, 1876-80. Draughtsman and painter, Etten, The Hague, Nuenen, Antwerp, 1881-86. Paris, 1886-88, painting under influence of Impressionists. Provence, 1888-90. Suicide, Auvers, 1890.

91. **Landscape near Saint-Rémy,** 1889-90
Oil on canvas, 13 x 16⅛ inches
Private collection, New York

GONZALES, Julio. Sculptor. Born Barcelona, 18—. Self-taught; influenced by Picasso, Brancusi. Began as a painter, then worked in wrought iron, copper and silver. Taught Picasso technique of metal construction. Lives in Paris.

92. **Sculpture,** 1932
Silver, 9 inches high
Collection A. E. Gallatin, New York

★93. **Head,** 1935-36
Wrought iron, 39 inches high
Collection the artist, Paris
Courtesy Christian Zervos, Paris
Figure 216

GRIS, Juan (José Gonzales). Painter and illustrator. Born Madrid, 1887. School of Arts and Sciences, Madrid, until 1906. Paris, 1906. Influenced by Picasso's Cubism, 1910. Exhibited, *Indépendants*, 1912. Ceret with Picasso, 1913. Designs for three ballets, 1926. Worked in Paris until death, 1927.

★94. **Portrait of Picasso** (*Homage à Picasso*), 1912
Oil on canvas, 36¼ x 28¾ inches
Collection The Bignou Gallery, New York
Figure 33

★95. **Composition,** *c.* 1914
Oil on canvas, 25 x 19 inches
Collection The Museum of Modern Art, New York
Gift of the Advisory Committee
Figure 68

★96. **Still life,** 1914
Collage of colored paper, gouache, etc., on canvas, 23½ x 17½ inches
Collection The Gallery of Living Art, New York University
Figure 66

★97. **Still life,** 1916
Oil on wood, 21⅜ x 15 inches
Collection The Museum of Modern Art, New York
Gift of Mrs. John D. Rockefeller, Jr.
Figure 70

★98. **Still life,** 1917
Oil on canvas, 27½ x 36 inches
Collection George L. K. Morris, New York
Figure 76

★99. **Toreador,** 1917
Carved and painted plaster, 21¼ inches high
Collection A. E. Gallatin, New York
Figure 103

HÉLION, Jean. Painter, theorist, editor. Born Couterne (Orne), France, 1904. Studied engineering, Lisle. Studied architecture, *Ecole des Arts Décoratifs*, Paris. Met Torres-Garcia, 1926, who introduced him to work of Cubists and Mondrian. Met van Doesburg, 1930. Edited *L'Art Concret* with Carlsund, 1930; collaborated with Seuphor and Torres-Garcia in *Cercle et Carré* (see Bibl. no. 5). To Russia, 1931. Active in *Abstraction-Création* group, 1931-34. Lives in Paris.

100. **Composition,** 1933
Oil on canvas, 32 x 25¾ inches
Collection Valentine Gallery, New York

★101. **Composition,** 1934
Oil on canvas, 14 x 10⅝ inches
Collection Christian Zervos, Paris
Figure 220

JEANNERET, Charles Édouard
See **Le Corbusier**

211

KANDINSKY, Vasily. Painter and theorist. Born Moscow, 1866. Childhood in Italy; educated in Odessa, Moscow, 1884. Studied painting in Munich. Tunis and Cairo, 1903-04. Rapallo, 1905. Paris, 1906; influenced by Gauguin. Berlin, 1907. Munich, 1908. First abstract painting, 1911. With Marc founded *Der Blaue Reiter*, 1912. Russia, 1914. Taught Moscow Academy, 1919. Director, Museum of Pictorial Culture, Moscow, and helped form other museums throughout the U. S. S. R. Professor, University of Moscow, 1920. Founded Russian Academy of Artistic Sciences, 1921. Berlin, 1921. Professor, Bauhaus Weimar and Dessau, 1922-32. Vice-president, *Société Anonyme*, New York, 1923. Has lived in Paris since 1934.

***102. Landscape with two poplars,** 1912
Oil on canvas, 31 x 39½ inches
Arthur Jerome Eddy Collection
The Art Institute of Chicago
Figure 51

***103. Improvisation no. 30,** 1913
Oil on canvas, 43¼ x 43¾ inches
Arthur Jerome Eddy Collection
The Art Institute of Chicago
Figure 52

***104. Improvisation,** 1915
Watercolor, 13¼ x 8⅞ inches
Collection The Museum of Modern Art, New York
Gift of Mrs. John D. Rockefeller, Jr.
Figure 3

***105. Composition no. 1,** 1921
Oil on canvas, 54¼ x 70¼ inches
Collection Société Anonyme, Museum of Modern Art, 1920
Figure 53

106. Composition, 1934
Gouache, 23 x 15½ inches
Collection J. B. Neumann, New York

KLEE, Paul. Painter. Born near Berne, Switzerland, 1879. Studied Munich, 1898-1900. Italy, 1901. Berne, 1903-06. Paris,

212

1905. Munich, 1906-20. Original member *Der Blaue Reiter*, 1912. Visit to Paris, 1912; met Picasso. Professor, Bauhaus, 1920-29. Discharged from professorship, Düsseldorf Academy, 1933. Lives in Switzerland.

***107. Opus 32,** 1915
Watercolor, 7 x 5⅝ inches
Collection Weyhe Gallery, New York
Figure 56

108. Christmas picture, 1923
Watercolor, 8¾ x 13¾ inches
Collection The Gallery of Living Art, New York University

***109. Abstract trio,** 1923
Ink drawing and watercolor, 12⅞ x 19¾ inches
Private collection, New York
Figure 198

110. Sacred islands, 1926
Ink drawing and watercolor, 18½ x 12⅜ inches
Collection Philip Johnson, New London, Ohio

111. The black arrow, 1929
Gouache, 10½ x 8¼ inches
Collection Weyhe Gallery, New York

112. The mocker mocked, 1930
Oil on canvas, 17⅛ x 20⅝ inches
Collection J. B. Neumann, New York

***113. In the grass,** 1930
Oil on canvas, 16¾ x 20¾ inches
Collection Sidney Janis, New York
Figure 199

KUPKA, Frank. Painter. Born Czechoslovakia, 1871. Studied Prague and *Ecole des Beaux-Arts*, Paris, 1894. First abstract paintings, 1911-12. Considered Orphist by Apollinaire, 1913. Professor, *Ecole des Beaux-Arts*, Prague, delegated from Paris. Lives in Paris.

***114. Disks of Newton,** 1912
Oil on canvas, 39⅝ x 29⅛ inches
Collection the artist, Paris
Figure 60

*115. **Fugue in red and blue,** 1912
(Original: oil on canvas, collection
the artist, Paris)
Figure 61, *photograph only
exhibited*

*116. **Vertical planes,** 1912-13
Oil on canvas, 79⅜ x 46¾ inches
Collection the artist, Paris
Figure 62

117. **Elementary toy,** 1931
Oil on canvas, 35½ x 35¼ inches
Collection the artist, Paris

LA FRESNAYE, Roger de. Painter. Born
Le Mans, 1885. Studied *Ecole des Beaux-
Arts, Académie Ranson,* Paris. Influenced
by Cubism, 1911. Traveled Italy and Ger-
many. Exhibited, *Section d'Or,* 1912. Died
Grasse, 1925. Important retrospective ex-
hibition, Paris, 1926.

*118. **The bottle of port,** 1914
Oil on canvas, 23¾ x 28¾ inches
Collection César M. de Hauke,
New York
Figure 69

119. **Bottle,** 1920
Watercolor, 9 x 6 inches
Collection Mrs. Charles H. Russell,
Jr., New York

LARIONOV, Michael. Painter and design-
er for theatre. Born Teraspol, Ukrainia,
1881. Studied art school, Moscow. Paris,
1905. Leader with his wife, Goncharova,
of Russian Primitivist movement, *c.* 1905-
10. Founder of Rayonism, Moscow, 1911
(Russian: Lutchism). Many designs for
Russian Ballet settings, 1915-29. Lives in
Paris.

120. **Rayonist composition: domina-
tion of red,** 1911
Oil on canvas, 20 x 27¾ inches
Collection the artist, Paris

*121. **Rayonist composition,** 1911
Figure 109, *not exhibited*

122. **Spiral,** 1915
Tempera, 31 x 21½ inches
Collection the artist, Paris

123. **Dance balance,** 1916
Tempera, 30½ x 21 inches
Collection the artist, Paris

124. **Rayonist composition no. 8**
Tempera, 19½ x 14⅞ inches
Collection the artist, Paris

125. **Rayonist composition no. 9**
Tempera, 9¼ x 17¼ inches
Collection the artist, Paris
See also *Theatre*

LAURENS, Henri. Sculptor. Born Paris,
1885. Self-taught. Introduced to Cubism
by Braque, 1911. First Cubist sculpture in
plaster, 1912; in iron, 1913-14. Polychrome
Cubist constructions in wood and metal,
1915-18. Cubist sculpture and polychrome
bas-reliefs, 1916-20. Began to abandon Cu-
bism after 1925. Lives in Paris.

126. **Bottle of rum,** 1917
Painted construction in wood and
metal, 11⅞ inches high
Collection Galerie Simon, Paris

*127. **Head,** 1918 (also dated 1915)
Painted construction in wood, 19⅝
inches high
Collection Galerie Simon, Paris
Figure 104

*128. **Guitar,** 1920
Cast stone, 15¾ inches high
Collection Galerie Simon, Paris
Figure 105

LE CORBUSIER (Charles-Édouard
Jeanneret).
See *Architecture*

*129. **Still life,** 1920
Oil on canvas, 32 x 39½ inches
Collection the artist, Paris
Figure 178
See also *Furniture*

213

LEGER, Fernand. Painter. Born Argentan (Normandy), France, 1881. Paris, 1898. Studied with Gérôme and Gabriel Féry, 1901-03. Reaction against Impressionism, 1908, under influence of Henri Rousseau. Allied with Cubist movement, 1910-14. Dynamic Cubism influenced by machine esthetic, 1917-20. Monumental figures, 1920-24. Allied with *L'Effort Moderne* of Léonce Rosenberg and with Purism of Le Corbusier and Ozenfant. Designs for Swedish Ballet, 1923. Film, *Ballet Mécanique,* 1924. Mozaics seen during trip to Italy, 1924, led to static still life compositions and the "cult of the object." Lives in Paris, with frequent visits to New York.

*130. **Seamstress,** 1910
Oil on canvas, 29 x 21½ inches
Collection Henry Kahnweiler, Paris
Figure 32

*131. **Village in the forest,** 1914
Oil on canvas, 29⅛ x 36⅝ inches
Private collection, New York
Figure 71

*132. **Breakfast,** *c.* 1920
Oil on canvas, 25 x 19½ inches
Collection The Museum of Modern Art, New York
Gift of the Advisory Committee
Figure 84

*133. **Luncheon,** 1921
Oil on canvas, 72¼ x 99 inches
Collection Paul Rosenberg, Paris
Figure 85

*134. **Composition no. 7,** 1925
Oil on canvas, 51⅛ x 35 inches
Collection Société Anonyme,
Museum of Modern Art, 1920
Figure 86

See also *Furniture; Theatre; Films*

LEWIS, Wyndham. Painter, draughtsman, writer. Born, 1884. Studied Slade School, London. Founded Vorticism, London, 1914. First abstract paintings influenced by Cubism and Futurism, 1914. Published *Blast,* 1914-15; *The Tyro,* 1921-22 (?). Lives in London.

135. **Roman actors,** 1934
Gouache, 15 x 21⅛ inches
Collection A. Zwemmer, London

LIPCHITZ, Jacques. Sculptor. Born Druskeniki, Polish Lithuania, 1891. Paris, 1909. Influenced by Cubists, 1913-14, and by Negro sculpture. First "open" sculpture of twisted cast bronze strips, 1927. Lives near Paris.

*136. **Bather,** 1915
Bronze, 31⅝ inches high
Collection the artist, Paris
Courtesy The Brummer Gallery, New York
Figure 100

*137. **Sculpture,** 1916
Cast stone, 39 inches high
Collection the artist, Paris
Courtesy The Brummer Gallery, New York
Figure 102

138. **Woman and guitar,** 1927
Gilded bronze, 10⅛ inches high
Collection the artist, Paris
Courtesy The Brummer Gallery
New York

139. **Reclining woman with a guitar,** 1928
Black basalt, 14¼ inches high
Collection the artist, Paris
Courtesy The Brummer Gallery
New York

*140. **Sculpture,** 1930
Plaster, 86 inches high
Collection the artist, Paris
Courtesy The Brummer Gallery
New York
Figure 215

***141. She, 1930**
Bronze, 12 inches high
Collection the artist, Paris
Courtesy The Brummer Gallery
New York
Figure 213

142. Song of the vowels, study for large
outdoor sculpture, 1931
Terra cotta, 14½ inches high
Collection the artist, Paris
Courtesy The Brummer Gallery
New York

LISSITZKY, El. Painter, constructivist,
architect, editor. Born Smolensk, Russia,
1890. Technical school, Darmstadt, 1909-
14. Influenced by Malevich's Suprematism,
1919. Professor, Moscow Civic Art School,
1921. Editor, *Vesch-Gegenstand-Objet*, Ber-
lin, 1922; with van Doesburg and Miës van
der Rohe, *G* □, 1922-23; *ABC* with Mart
Stam and H. Witwer, Switzerland, 1923-25.
Designed gallery for abstract art, Hanover
Museum, *c.* 1925. Lives in Moscow.

143. Construction, 1923
Lithograph from *Kestner-mappe*,
24 x 17½ inches
Collection The Museum of Modern
Art, New York

144. Construction, 1923
Lithograph from *Kestner-mappe*,
24 x 17½ inches
Collection The Museum of Modern
Art, New York

145. Construction *(Proun)*
Gouache, 26 x 19¾ inches
Lent anonymously

***146. Construction 99** *(Proun 99)*,
1924-25
Oil on panel, 50½ x 38¾ inches
Collection Société Anonyme,
Museum of Modern Art, 1920
Figure 125

See also *Architecture; Typography
and Posters*

MALEVICH, Kasimir. Painter and theo-
rist. Born Kiev, 1878. Painted in *Fauve*
manner, Moscow, 1908-10. Influenced by
Cubism, *c.* 1910-13. Founder, Suprematist
movement, Moscow, 1913. First semi-archi-
tectural drawings, 1917. "White on White,"
1918. Professor, Moscow Academy after the
Revolution. Leningrad Academy, *c.* 1921,
until death in Leningrad, 1935.

***147. Woman with water-pails: dynamic
arrangement,** 1912
Oil on canvas, 31½ x 31½ inches
Lent anonymously
Figure 110

***148. Fundamental suprematist
element,** 1913
Pencil drawing, 11⅝ x 11⅛ inches
Lent anonymously
Figure 111

***149. Fundamental suprematist
elements,** 1913
Pencil drawing, 6¾ x 11⅜ inches
Lent anonymously
Figure 112

150. Suprematist composition, 1913-15
Pencil drawing, 14⅞ x 12¼ inches
Lent anonymously

151. Private of the First Division,
Moscow, 1914
Oil on canvas with collage, ther-
mometer, etc., 21⅛ x 17⅝ inches
Lent anonymously

***152. Suprematist composition** (after a
drawing of 1913), 1914
Oil on canvas, 23 x 19 inches
Collection The Museum of Modern
Art, New York
Figure 114

153. Suprematist composition, 1914-16
Pencil drawing, 12¾ x 11 inches
Lent anonymously

154. Suprematist composition, *c.* 1915
Oil on canvas, 21 x 21 inches
Collection The Museum of Modern
Art, New York

*155. **Suprematist composition: red square and black square**
Oil on canvas, 28¼ x 17½ inches
Lent anonymously
Figure 113

156. **Suprematist architectural drawing, 1917**
Pencil, 14 x 20½ inches
Inscribed: (top) *Suprematism 79. The construction of the center of the intersection of dynamic movements;* (side) *Architectural construction in black, white and pale grey;* (bottom) *Diagonal plane.*
Collection The Museum of Modern Art, New York

*157. **Suprematist composition: white on white,** 1918
Oil on canvas, 31½ x 31½ inches
Lent anonymously
Figure 115

*158. **Suprematist composition**
Oil on canvas, 38½ x 26½ inches
Lent anonymously
Figure 4

159. **Suprematist architectural drawing, 1924**
Pencil, 12¼ x 17½ inches
Inscribed: (top) *Super-form A F 2. Group of dynamic constructions;* (side) *Suprematism in architecture. Plans of the houses of the future Leningrad. Air view.*
Collection The Museum of Modern Art, New York

160. **Four placards,** with mounted photographs and drawings illustrating the development of abstract art.
Lent anonymously

MARC, Franz. Painter. Born Munich, 1880. Visit to Paris. Influenced by Cubism, Persian miniatures, and Kandinsky. With Kandinsky founded *Der Blaue Reiter,* Munich, 1912. Killed at Verdun, 1916.

*161. **Landscape with animals,** 1912-14
Gouache, 16¾ x 14⅛ inches
Collection Weyhe Gallery, New York
Figure 54

MARCOUSSIS, Louis (Louis Markous). Painter and etcher. Born Warsaw, Poland, 1883. Warsaw Academy, 1901. Paris, studio of J. Lefebvre, 1903. Joined Cubist group, 1910. Exhibited, *Section d'or,* 1912-13. Continues to work in Cubist tradition. Lives in Paris.

*162. **Matches** (*Le pyrogène*), 1912
Oil on canvas, 9¼ x 12¾ inches
Private collection, New York
Figure 34

163. **Music**
Etching, 27⅜ x 9 inches
Collection M. Knoedler and Company, New York

MASSON, André. Painter and illustrator. Born Balagny (Oise), France, 1896. Influenced at first by Derain, then by Gris. Allied with Surrealists, 1924-28. Designs for ballet, *Les Présages,* 1933. Lives in Paris.

*164. **Furious suns,** 1927
Ink drawing, 16⅝ x 12½ inches
Collection The Museum of Modern Art, New York
Figure 201

*165. **Metamorphoses,** 1929
Pastel, 20¾ x 42¼ inches
Collection T. Catesby Jones, New York
Figure 200

MATISSE, Henri-. Painter, sculptor. Born Le Cateau (Picardy), France, 1869. Paris 1892. Influenced by Signac, Gauguin, Cézanne. Near Eastern art. Leader of the *Fauves,* 1905. Morocco, 1911-13. Has lived in Nice since 1917.

216

***166. Joy of Life,** 1905
(Study for *Joy of Life*, 1906-07, oil
on canvas, collection The Barnes
Foundation, Merion, Pennsylvania)
Oil on canvas, 16⅛ x 21⅝ inches
Collection Mr. and Mrs. Michael
Stein, Palo Alto, California
Figure 8

167. Broom (*Les genêts*), 1906
Oil on wood, 15¾ x 12⅝ inches
Collection Mr. and Mrs. Michael
Stein, Palo Alto, California

168. Seascape, 1906
Oil on canvas, 11 x 13⅝ inches
Collection Pierre Matisse Gallery,
New York

MIRO, Joan. Painter. Born Montroig near
Barcelona, 1893. Studied *Ecole des Beaux-
Arts*, Barcelona, 1907; Gali Academy, Bar-
celona, 1915. First exhibition, Barcelona,
1918. Paris, 1919. Influenced by Cubism.
Allied with Surrealists, 1924. Designs for
ballet, *Jeux d'Enfants*, 1932. Lives at
Montroig.

***170. Relief construction,** 1930
Wood, 35⅞ x 27⅞ inches
Collection André Breton, Paris
Figure 202

***171. Head of a man,** 1932
Oil on wood, 13¾ x 10¾ inches
Collection Pierre Matisse Gallery,
New York
Figure 203

172. Composition, 1933
Painting on sandpaper, 14¼ x 9¼
inches
Collection Pierre Matisse Gallery,
New York

***173. Composition,** 1933
Oil on canvas, 68½ x 77¼ inches
Collection George L. K. Morris,
New York
Figure 204

174. Composition, 1934
Watercolor, 25 x 18½ inches
Collection Henry McBride,
New York

MOHOLY-NAGY, Ladislaus. Painter,
constructivist, photographer, typographer,
theorist, designer for theatre. Born Bor-
sod, Hungary, 1895. Turned from study of
law to painting, 1915. Allied with Activist
and MA groups, Budapest, 1920. Influ-
enced by Russian Suprematism and Con-
structivism, Berlin, 1921-22. Professor at
Bauhaus, Weimar and Dessau, 1923-28. Co-
editor with Gropius of the Bauhaus books
(see Bibl.). Lives in London.

175. Construction, 1923
Lithograph (from *Kestner-mappe
Konstruktionen*), 23¾ x 17½ inches
Lent anonymously

176. Construction, 1923
Lithograph (from *Kestner-mappe
Konstruktionen*), 23¾ x 17½ inches
Lent anonymously

177. Composition, 1925
Oil on canvas, 37⅝ x 29¾ inches
Collection Walter P. Chrysler, Jr.,
New York

See also *Photography*; *Typography
and Posters*

MONDRIAN, Piet (Pieter Cornelis Mon-
driaan). Painter. Born Amersfoort, Hol-
land, 1872. Studied Amsterdam Academy.
Early work influenced successively by
Dutch romanticism and mannerism. Paris,
1910-11, influenced by Picasso. "Plus and
minus" period, 1914-17. Foremost painter
of *de Stijl* group, Holland, 1917. First
pure-abstract paintings, 1917. Founder,
Neo-Plasticism, 1920. Leader, *Abstraction-
Création* group, Paris, 1932. Lives in Paris.

178. Composition, *c.* 1911
Oil on canvas, 29 x 21½ inches
Collection The Kröller-Müller
Foundation, Wassenaar,
The Netherlands

***179. Composition,** 1911
Oil on canvas, 33⅛ x 29⅞ inches
Collection The Kröller-Müller
Foundation, Wassenaar,
The Netherlands
Figure 140

***180. Composition,** 1913
Oil on canvas, 38 x 25¾ inches
Collection The Kröller-Müller
Foundation, Wassenaar,
The Netherlands
Figure 141

***181. Composition,** 1915
Oil on canvas, 34 x 42¾ inches
Collection The Kröller-Müller
Foundation, Wassenaar,
The Netherlands
Figure 142

***182. Composition,** 1917
Oil on canvas, 20 x 18 inches
Collection The Kröller-Müller
Foundation, Wassenaar,
The Netherlands
Figure 145

183. Composition, 1919
Oil on canvas (diagonal), 19½ x
19½ inches
Collection The Kröller-Müller
Foundation, Wassenaar,
The Netherlands

***184. Composition,** 1921
Oil on canvas, 20½ x 16½ inches
Private collection, New York
Figure 146

***185. Composition,** 1926
Oil on canvas (diagonal), 31½ x
31½ inches
Collection Miss Katherine S. Dreier,
New York
Figure 157

***186. Composition,** 1935
Oil on canvas, 39¾ x 20 inches
Collection the artist, Paris
Figure 158

218

MOORE, Henry. Sculptor. Born Castle-ford (Yorkshire), England, 1898. Art school, Leeds, 1919. London, 1921, learning much from primitive art. France and Italy, 1924-25. First exhibition, London, 1928. Influenced by Brancusi and Arp. Member of Axis group. Lives in London.

***187. Two forms,** 1934
Pynkado wood, 11 inches high
Collection the artist, London
Figure 223

NICHOLSON, Ben. Painter and sculptor. Born 1894, son of English artist, William Nicholson, R.A. Painted under influence of Braque. Turned to carved geometrical reliefs, 1933. Member of *Abstraction-Création*, Paris, and Axis group, London. Lives in London.

***188. Relief,** 1934
Painted wood, 47 x 24 inches
Collection the artist, London
Figure 221, *not exhibited*

188A. Relief, 1935
Painted wood, 22 x 32 inches
Collection the artist, London

OZENFANT, Amédée. Painter, theorist, editor. Born Saint-Quentin (Aisne), France, 1886. Studied with Cottet and J.-E. Blanche. Knew Segonzac and La Fresnaye. Founded *L'Elan*, 1915. With Le Corbusier (Jeanneret) founded Purism, 1918; wrote *Après le Cubisme*, 1918; and founded *L'Esprit Nouveau*, 1920. Began to abandon Purism, *c.* 1925. Lives in Paris.

189. Jug and amphora, 1925
Oil on canvas, 32 x 25⅝ inches
Collection Arthur Sambon, Paris

PEVSNER, Antoine. Constructivist. Born Orel, Russia, 1886. Art school, Kiev, 1907; St. Petersburg, 1911; visited Paris, 1911. Paris 1913-14; knew Modigliani, Archipenko; abstract paintings, influenced by Cubism. Russia, then Norway, 1914, with

brother, Gabo. Moscow, 1917; taught Constructivism at Academy. With Gabo wrote manifesto of Constructivism, "Realistic Manifesto," 1920. Studio closed, 1921. Berlin, 1922. Paris, 1923. With Gabo did design for ballet, *La Chatte,* 1927. Lives in Paris.

190. **Abstract forms,** 1913
Encaustic panel, 17½ x 13½ inches
Collection the artist, Paris

191. **Still life with books,** Christiania, 1916-17
Pencil drawing, 6⅛ x 6¼ inches
Collection the artist, Paris

192. **Nude woman,** Christiania, 1917
Pencil drawing, 9¼ x 4½ inches
Collection the artist, Paris

193. **Project for monument,** Moscow, 1918
Pencil drawing, 6¼ x 4½ inches
Collection the artist, Paris

194. **Composition,** Moscow, 1919
Pencil drawing, 3½ x 3½ inches
Collection the artist, Paris

195. **Still life with squares,** Moscow, 1920
Pencil drawing, 7⅛ x 5⅜ inches
Collection the artist, Paris

196. **Balloons,** Moscow, 1920
Pencil drawing, 5⅞ x 6⅛ inches
Collection the artist, Paris

*197. **Abstract portrait of Marcel Duchamp,** 1926 (?)
Celluloid, 27½ x 17 inches
Collection Société Anonyme, Museum of Modern Art, 1920
Figure 134

*198. **Relief construction,** 1930
Copper on ebonite base, 37⅝ x 27¾ inches
Collection the artist, Paris
Figure 136

*199. **Construction,** 1934
Copper, glass, etc., 30⅞ inches high
Collection the artist, Paris
Figure 137

PICABIA, Francis. Painter, editor, Dadaist. Born Paris, 1878. Impressionist at first, then, 1910, Cubist. Exhibited *Section d'Or,* 1912. With Duchamp, de Zayas and Man Ray formed Dadaist group in New York, 1917. Active as Dadaist, Zürich, Barcelona, Paris. Settings for Swedish Ballet, *Relâche,* 1924. Lives in Paris.

200. *Caoutchouc,* 1909
Watercolor, 18⅛ x 24⅛ inches
Collection Léonce Rosenberg, Paris

*201. **Very rare picture upon the earth,** 1915
Gilt and silver paint and collage of wooden forms on cardboard, 45½ x 34 inches
Lent by the artist, Paris
Courtesy Léonce Rosenberg, Paris
Figure 191

*202. **Amorous procession,** 1918
Oil on cardboard, 38¼ x 29⅛ inches
Collection Mme. Simone Kahn, Paris
Figure 194

PICASSO, Pablo Ruiz. Painter, draughtsman, sculptor, constructivist, designer for theatre. Born Malaga, Spain, 1881. Studied Barcelona, 1895, and Madrid, 1896. Realistic portraits and still life, 1895-1901. Paris, 1901. Influence of Toulouse-Lautrec, van Gogh, El Greco. Pathetic-Sentimental Period, 1901-05 ("Blue" Period, 1902-04; "Rose" Period, 1905-06). Influence of Negro sculpture, 1907, leading, with influence of Cézanne and collaboration of Braque, to beginnings of Cubism, 1907-08. Analytical Cubism, 1908-13 (Facet Cubism, 1908-10). First Cubist sculpture, 1909. Collage (paper-pasting), 1912-14. Synthetic Cubism, after 1913. Neo-classic por-

219

traits and figures begin 1915, predominate 1918-23 ("Colossal" phase, 1919-22).

Italy, 1917. Settings for Diaghileff Russian Ballets: *Parade*, 1917; *Le Tricorne*, 1919; *Pulcinella*, 1920; *Quadro Flamenco*, 1921; *Mercure*, 1927.

Surrealist period begins *c.* 1925 ("Dinard," 1928; "Metamorphoses," 1929-31). "Sleeping Women," 1932. Neo-romantic gouaches, 1933. Since 1928 has also worked on constructions and sculpture. Lives in Paris.

*203. **Study for** *The young ladies of Avignon*: **half-length figure,** 1907
Oil on canvas, 32 x 22½ inches
Collection Mme. Paul Guillaume, Paris
Figure 12

204. **Study for** *The young ladies of Avignon,* 1907
Watercolor, 6¾ x 8¾ inches
Collection The Gallery of Living Art, New York University

*205. **The young ladies of Avignon,** 1906-07
(Original: Oil on canvas, collection Mme. Jacques Doucet, Paris)
Figure 11, *not exhibited*

*206. **Bowls and jug,** 1907
Oil on canvas, 32 x 25½ inches
Collection The Gallery of Living Art, New York University
Figure 15

*207. **Dancer,** 1907-08
Oil on canvas, 59⅜ x 39½ inches
Collection Mme. Paul Guillaume, Paris
Figure 14

*208. **Head of a woman,** 1908-09
Oil on canvas, 25½ x 21¼ inches
Collection Mme. Paul Guillaume, Paris
Figure 20

220

*209. **Portrait of Braque,** 1909
Oil on canvas, 24¼ x 19¾ inches
Collection Frank Crowninshield, New York
Figure 21

*210. **The tube of paint,** 1909
Oil on canvas, 31½ x 25½ inches
Collection Wildenstein and Company, New York
Figure 25

*211. **Drawing,** 1913, to explain *The tube of paint,* 1909
Collection Wildenstein and Company, New York
Figure 26

*212. **Head,** 1909
Bronze, 16¼ inches high
Collection Weyhe Gallery, New York
Figure 90

*213. **Figure,** 1910
Charcoal drawing, 19 x 12¼ inches
Collection Alfred Stieglitz, New York
Figure 27

*214. **The poet,** 1911
(Painted at Ceret, summer 1911; subsequently dated, apparently incorrectly, 1910. Inscribed on back: CERET)
Oil on canvas, 51½ x 35 inches
Collection George L. K. Morris, New York
Figure 30

*215. **Arlésienne,** 1911-12
Oil on canvas, 28¾ x 21¼ inches
Collection Alfred Flechtheim, Paris
Figure 22, *not exhibited*

*216. **Head of young woman,** 1913
Oil on canvas, 21⅝ x 15 inches
Private collection, New York
Figure 23

*217. **Violin,** *c.* 1912
Oil on canvas, 39 x 28 inches (oval)
Collection The Kröller-Müller Foundation, Wassenaar
Figure 31

218. **Head,** 1912
Paper collage and pencil drawing
on paper, 16 x 11 inches
Collection Sidney Janis, New York

*219. **Still life,** 1913
Collage, charcoal, pencil and ink
on paper, 24¼ x 18½ inches
Collection Alfred Stieglitz,
New York
Figure 65

*220. **Still life with guitar,** 1913
Oil and paper collage on canvas,
25 x 21 inches
Collection Sidney Janis, New York
Figure 67

*221. **Green still life,** 1914
Oil on canvas, 23½ x 31¼ inches
Collection The Museum of Modern
Art, New York
The Lillie P. Bliss Collection
Figure 75

*222. **Relief construction: guitar,** 1913
(Original: collage of wooden and
other objects)
Figure 98, *photograph only
exhibited*

*223. **Glass of absinthe,** 1914
Painted bronze, 8¾ inches high
Collection The Gallery of Living
Art, New York University
Figure 99

*224. **The table,** *c.* 1919-1920
Oil on canvas, 50 x 29½ inches
Collection Smith College Museum
of Art, Northampton
Figure 78

*225. **Guitar,** 1919
Oil on canvas, 32 x 17¾ inches
Collection The Kröller-Müller
Foundation, Wassenaar,
The Netherlands
Figure 79

*226. **Still life,** 1923
Oil on canvas, 38 x 51 inches
Collection Mrs. Patrick C. Hill,
Pecos, Texas
Figure 87

227. **Harlequin,** 1927
Oil on canvas, 37⅞ x 26¾ inches
Collection Wildenstein and
Company, New York

*228. **The painter and his model,** 1928
Oil on canvas, 51¼ x 63¾ inches
Collection Sidney Janis, New York
Figure 88

*229. **The studio,** 1928
Oil on canvas, 59 x 91 inches
Collection The Museum of Modern
Art, New York
Gift of Walter P. Chrysler, Jr.
Figure 89

*230 **Woman in an armchair,** 1929
Oil on canvas, 36⅜ x 26⅞ inches
Private collection, New York
Figure 212

*231 **Bather by the sea,** 1929
Oil on canvas, 51¼ x 38¼ inches
Collection The Bignou Gallery,
New York
Figure 211

See *Furniture; Theatre*

PIRANESI, Giovanni-Battista. Etcher.
Born Venice, 1720. Died Rome, 1778. Made
about 2000 large etchings, principally of
Roman ruins in and near Rome. *Le Carceri,*
series of fantastic prison interiors, antici-
pated Cubist-Constructivist esthetics.

*232. **Prison**
Etching (from the *Carceri* series,
no. 7), *c.* 1745, 21¼ x 16 inches
Collection Weyhe Gallery, New York
Figure 39

221

REDON, Odilon. Painter, graphic artist, illustrator. Born Bordeaux, 1840. Pastels and important oils done chiefly after 1900. Died Paris, 1916.

*232A. Roger and Angelica
Pastel, 37¾ x 30¼ inches
Collection The Museum of Modern Art, New York
The Lillie P. Bliss Collection
Figure 9

RODCHENKO, Alexander. Painter, constructivist, typographer, photographer. Born St. Petersburg, 1891. Art school, Kazan. First pure abstractions made with compass, 1914. Leader of Non-Objectivism (related to Suprematism), Moscow, 1915-20. Constructivist, 1917-22. Repudiated art, 1922, for "useful" activities—typography, posters, photography, furniture, theatre design. Designed interior of "Workers Club", Paris exposition, 1925. Settings for film, *Albidum*, 1927. Member of *Lyev* group. Lives in Moscow.

233. Compass composition, 1915
Photograph only exhibited
*234. Suprematist composition: black on black, 1918
Figure 116, *photograph only exhibited*

*235. Composition, 1918
Gouache, 13 x 6⅜ inches
Collection The Museum of Modern Art, New York. Gift of the artist
Figure 117

*236. Composition, 1919
Gouache, 12¼ x 9⅛ inches
Collection The Museum of Modern Art, New York. Gift of the artist
Figure 118

237. Composition, 1919
Watercolor and ink, 14⅝ x 11½ inches
Collection The Museum of Modern Art, New York. Gift of the artist

238-239. Two constructions in cardboard, 1919
Photographs only exhibited

*240-241. Two hanging constructions, 1920
Figure 130, *photographs only exhibited*

242. Line construction, 1920
Colored crayon, 14 x 10½ inches
Collection The Museum of Modern Art, New York. Gift of the artist

*243. Line construction, 1920
Colored ink, 12¾ x 7¾ inches
Private collection, New York
Figure 119

*244-247. Four constructions, 1921
Figure 131, *photographs only exhibited*
See *Typography and Posters*

ROUSSEAU, Henri-Julien. Painter. Born Laval (Mayenne), France, 1844. Military musician, Mexico, 1862-67. Sergeant, War of 1870. Customs officer, Paris, 1885. Self-taught. First paintings, 1885; first jungle paintings, 1904. Much admired by young artists of the Cubist group, Picasso, Delaunay, Léger, etc. Died Paris, 1910.

*248. Child with a doll
Oil on canvas, 26 x 20 inches
Collection Mme. Paul Guillaume, Paris
Figure 10

249. Jungle with a lion
Oil on canvas, 14¾ x 18 inches
Collection The Museum of Modern Art, New York
The Lillie P. Bliss Collection

RUSSOLO. Luigi. Painter. Born near Venice, 1885. Original member of Italian Futurist group, Milan, 1910.

*250. Automobile (Dynamism), 1913
Figure 43, *not exhibited*

SCHWITTERS, Kurt. Painter and writer. Born Hanover, 1887. Realistic figures of Munich school, 1913. Influence of Marc, 1917; Kandinsky, 1919. Founded Merzism, a variety of Dadaism, Hanover, 1919; paper collages, Merz pictures and Merz constructions, influenced by Picasso. Inventor of new literary forms. Lives in Hanover.

*251. **Radiating world; rubbish picture 31B** (*Strahlen Welt; Merz 31B*), 1920. Collage 36¼ x 26½ inches
Collection Miss Katherine S. Dreier, New York
Figure 196

*252. **Rubbish construction** (*Merz-Konstruktion*), 1921
Collage, 14½ x 8½ inches
Collection A. E. Gallatin, New York
Figure 197

253. **Rubbish picture 199** (*Merz 199*), 1921
Collage, 7⅛ x 5¾ inches
Collection Miss Katherine S. Dreier, New York

254. **Rubbish picture 369** (*Merz 369*), 1922
Collage, 3⅝ x 2⅝ inches
Collection Miss Katherine S. Dreier, New York

255. **Santa Claus: rubbish picture** (*Merz: Der Weihnachtsmann*), 1922
Collage, 7½ x 6 inches
Collection The Museum of Modern Art, New York

256. **Portrait of Lissitsky: rubbish picture 17** (*Merz 17*), 1926
Collage, 5¼ x 4 inches
Collection Miss Katherine S. Dreier, New York

SEURAT, Georges-Pierre. Painter. Born Paris, 1859. Studied *Ecole des Beaux-Arts*,

1875-80. Developed theory and technique of Neo-Impressionism, 1884-86. Six major paintings: *The bathers*, 1884, *Sunday on the Grande-Jatte*, 1885-86, *The models*, 1888, *Side-show*, and *Le chahut*, 1889, *The circus*, 1891. Died, 1891.

257. **House at dusk** (*La cité*)
Conté crayon, 11⅝ x 9⅛ inches
Collection The Museum of Modern Art, New York
The Lillie P. Bliss Collection

*258. **The quay,** 1883(?)
Oil on canvas, 6⅝ x 5 inches
Collection Albert Rothbart, New York
Figure 5

259. **The nurse,** 1884
(Study for *Un Dimanche d'Eté à la Grande-Jatte*, oil on canvas, collection The Art Institute of Chicago, Birch-Bartlett Collection)
Pencil, 9¼ x 12¼ inches
Private collection, New York

*260. **Study for *Side-show*,** 1888-89
Oil on wood, 6¾ x 10⅝ inches
Collection Jacques Seligmann and Company, New York
Figure 6

SEVERINI, Gino. Painter. Born Cortona, 1883. Rome, 1901. Met Boccioni and Balla. Paris, 1906. Met Modigliani and Max Jacob. One of five original Italian Futurist painters, 1910-15. Later turned to Cubism and Neo-classicism. Lives in Paris.

*261. **Sea-dancer,** 1914
Oil on canvas, 39¾ x 32 inches
Collection Mme. Pétro van Doesburg, Meudon-val-Fleury, France
Figure 45

*261A. **Armored train,** 1915
Oil on canvas, 46 x 34½ inches
Collection Mrs. Charles J. Liebman. New York
Figure 46

TANGUY, Yves. Painter. Born Paris, 1900. Member of Surrealist group. Influenced by de Chirico, Ernst, Miro. Lives in Paris.

*262. **Drawing,** 1932
Ink, 10⅜ x 6⅝ inches
Collection The Museum of Modern Art, New York
Figure 205

TATLIN, Vladimir Evgrafovich. Constructivist, painter, designer for theatre. Born Moscow, 1885. Graduated from art school, 1910. Affiliated with Moscow Primitivist and Cubist groups, 1910-13. First relief constructions, 1913. Counter-relief constructions, 1915. Taught Constructivism, Moscow Academy, 1919. Project for monument to Third International, 1920. Lives in Moscow.

263-264. **Two relief constructions,** 1913-14
Wood, glass, cardboard, etc.
Reproductions only exhibited, from Bibl. no. 441

*265. **Relief construction,** 1914
Figure 126, *reproduction only exhibited, from Bibl. no. 440*

*266. **Corner counter-relief construction,** 1914-15
Various materials
Figure 127, *reproduction only exhibited, from Bibl. no. 440*

267. **Counter-relief construction,** 1917
Various materials
Reproduction only exhibited, from Bibl. no. 440

See also *Architecture; Theatre*

VANTONGERLOO, Georges. Sculptor and theorist. Born Antwerp, 1886. Ant-werp and Brussels academies. Original member of *de Stijl* group, 1917-22. Active in *Abstraction-Création* group, Paris, 1932-35. Lives in Paris.

*268. **Construction within a sphere,** 1917
Silvered plaster, 7 inches high
Collection the artist, Paris
Figure 210

*269. **Volume construction,** 1918
Figure 143, *not exhibited*

270. **Construction of volume relations,** 1921
Mahogany, 16⅞ inches high
Collection the artist, Paris

*271. **Construction of volume relations:** $y = -ax^2 + bx + 18$, 1930
Ebonite, 23⅝ inches high
Collection the artist, Paris
Figure 155

VILLON, Jacques. Painter, engraver. Born Damville (Eure), France, 1875. Paris, 1894. First Cubist works, 1912. Exhibited *Section d'Or*, 1912, 1913. Color engravings of modern paintings edited by Bernheim Jeune, 1920-29. Continues to paint Cubist and abstract compositions. Lives in Paris.

*272. **The dinner table** (*La table servie*), 1912
Oil on canvas, 25¾ x 32 inches
Collection Mr. and Mrs. Francis Steegmuller, New York
Figure 35

*273. **Color perspective,** 1922
Oil on canvas, 28¾ x 23⅝ inches
Collection Miss Katherine S. Dreier, New York
Figure 81

African Negro Sculpture

*274. **Mask.** Cameroon, Bangwa
Wood, 8¼ inches high
Collection Tristan Tzara, Paris
Figure 91

*275. **Ancestral figure.** Gabun
Wood, 27 inches high
Collection Frank Crowninshield,
New York
Figure 101

*276. **Ancestral figure.** Gabun, BaKota
Copper over wood, 22¾ inches high
Collection Frank Crowninshield,
New York
Figure 13

277. **Ancestral figure.** Gabun, BaKota
Copper over wood, 22½ inches high
Collection Mme. Helena
Rubinstein, New York

*277A. **Buffalo mask.** Ivory Coast
Wood, 25 inches high
Collection Frank Crowninshield,
New York
Figure 214

Photography

BRUGUIERE, Francis

*278. **Abstraction**
Photograph, 13½ x 10½ inches
Collection Mrs. Edith J. R. Isaacs,
New York
Figure 189

MOHOLY-NAGY, Ladislaus
See *Painting and Sculpture*

*279. **Photogram,** 1925
Print made without a camera on
photographic paper, 15¾ x 11¾
inches
Private collection, New York
Figure 188
See also *Typography and Posters*

RAY, Man. Painter, photographer. Born
Philadelphia, 1890. New York, 1897. Exhibited paintings, New York, 1912. "Armory Show," 1913, interested him in abstract painting. With Duchamp and de Zayas, founded Dadaist group, New York, 1917. Paris, 1921, member of Dadaist group and later, 1924, of Surrealists. Took up photography, 1921; using "Rayograph"
technique and exploring other possibilities of photography, especially in making abstract and Surrealist compositions. Films: *Emak Bakia*, 1926; *L'Etoile de Mer*, 1928; *Les Mystères du Chateau de Dés*, 1929. Also active as painter. Lives in Paris.

*280. **Rayograph,** 1922
Print made without a camera on
photographic paper, 9½ x 7 inches
Collection The Museum of Modern
Art, New York
Figure 187

*281. **Rayograph,** 1922
Print made without a camera on
photographic paper, 9¼ x 6⅞ inches
Collection The Museum of Modern
Art, New York
Figure 186

282. **Rayograph,** 1927
Print made without a camera on
photographic paper, 12 x 10 inches
Collection The Museum of Modern
Art, New York

See also *Furniture; Films*

225

Architecture

DOESBURG, Théo van
See *Painting and Sculpture*

283. **Interior,** 1919; **plan**
Plate 12, *L'Architecture Vivante,*
Autumn, 1925

*284. **Project for a private house,** 1922
(In collaboration with van Eesteren
and Rietveld)
Colored lithograph, Berlin Photo-
graphische Gesellschaft, lent by Ray-
mond, & Raymond Inc., New York
Plate 5, *L'Architecture Vivante,*
Autumn, 1925
Photograph
Figure 148

285. **Small house at Alblasserdam,**
Holland, 1923-24
(In collaboration with van
Eesteren)
Plate 20, *L'Architecture Vivante,*
Spring, 1924
Plate, 18 *L'Architecture Vivante,*
Autumn, 1925

286. **House of the architect,** Meudon-
val-Fleury, France, 1929
Photograph

See also *Typography and Posters*

EESTEREN, Cornelis van. Architect.
Member of *de Stijl*

See **Doesburg, Théo van,** nos. 284-5

GROPIUS, Walter. Born Berlin, 1883.
Studied Berlin and Munich. Architectural
training under Peter Behrens, 1908-10. Ap-
pointed Director of Industrial Section of
Werkbund Exposition, Cologne, 1914. Di-
rector of Bauhaus, Weimar (1919-25) and
Dessau (1925-28), where he built complete
new plant for school. Resumed private
practice 1928. Now living in England.

226

287. **Sommerfeld block house,**
Berlin, 1922
Photograph

288. **Remodelling of Civic Theatre,**
Jena, Germany, 1922
Photograph

289. **Bauhaus,** Dessau, Germany,
1925-26
Photograph

*290. **Professors' houses,** Dessau,
Germany, 1925-26
Photographs
Figure 164

HOFF, Robert van't. Member of *de Stijl*

291. **House at Huis ter Heide,**
Holland, 1916
Photograph

292. **House at Huis ter Heide,**
Holland, 1917
Photograph

HUSZAR, Vilmos. Member of *de Stijl*

293. **Interior,** 1924
L'Architecture Vivante,
Autumn, 1924

KIESLER, Frederick
See *Theatre*

*294. **The city in space,** model in Aus-
trian Section, International Exposi-
tion of Decorative Arts, Paris, 1925
Photograph lent by the architect
Figure 151

See also *Furniture*

**LE CORBUSIER (Charles-Édouard
Jeanneret).** Architect, painter, theorist.
Born La Chaux-de-Fonds, Switzerland,
1888. Worked under L'Epplatennier in
Switzerland, Perret in Paris, and Behrens

in Berlin, 1906-10. Settled in Paris as painter. Created Purism with Ozenfant, 1918 (see Bibl. no. 168). With Ozenfant edited review *L'Esprit Nouveau*, 1920-25. Architectural partnership with Pierre Jeanneret, 1922. *Citrohan* model, 1922. Pavillon de L'Esprit Nouveau, 1925. One of nine first prize winners in Competition for Palace of the League of Nations, 1927. Swiss building at the Cité Universitaire, 1932.

295. **La Roche house,** Auteuil, Paris, 1923
 Plate 13, *L'Architecture Vivante*, Autumn, 1927
 Photograph of interior

296. **Miestchaninoff house,** Boulogne-sur-Seine, 1924
 Photograph

297. **Pavillon de L'Esprit Nouveau,** International Exposition of Decorative Arts, Paris, 1925
 Photograph

298. **Double house at Werkbund Housing Exposition,** Stuttgart, 1927
 Photograph

*299. **Savoye house,** Poissy-sur-Seine, 1929-30
 Model
 Figure 180

*300. **de Beistegui penthouse,** Paris, 1931
 Photograph
 Figure 181

 See also *Painting and Sculpture; Furniture*

LEUSDEN, Willem van. Born Utrecht, 1886. Studied Hague Academy; Amsterdam Academy under Dupont, 1909-12. Expressionist. With Frau Bakhuizen van der Brink wrote drawing manual, Rotterdam, 1928.

301. **Construction,** 1922
 Plate 19, *L'Architecture Vivante*, Autumn, 1925

LISSITZKY, El
See *Painting and Sculpture*

302. **Project for skyscraper,** 1924
 Photograph

*302A. **Gallery for abstract painting,** Art Museum, Hanover, *c.* 1925
 Photograph
 Figure 177

 See also *Typography and Posters*

LUBETKIN, Berthold. Worked in Russia with Pevsner and Gabo. Now practicing architecture in England. Member of *Tecton* group.

*303. **Penguin Pond,** Zoölogical Gardens, London, 1935
 Photograph
 Figure 139

MENDELSOHN, Erich. Born Allenstein, Germany, 1887. Studied in Berlin and under Theodor Fischer in Munich, 1907-11. Pioneer in modern factory construction. Influenced by Expressionism. Now working in England and Palestine.

304. **Einstein Tower,** Potsdam, Germany, 1920-21
 Photograph

MIËS VAN DER ROHE, Ludwig. Born Aachen, 1886. Worked under Bruno Paul and Peter Behrens, Berlin, 1905-11. Independent architect, Berlin, 1911. Director of Werkbund Exposition, Stuttgart, 1927. Succeeded Hannes Meyer as Director of Bauhaus at Dessau, 1930, until cessation of Bauhaus, 1932. Resumed private practice, Berlin.

*305. **Project for brick country house,** plan, 1922
 Photograph
 Figure 163

227

306. German pavilion, International Exposition, Barcelona, 1929
Photograph and plan

OUD, J. J. P. Born Pumerend, Holland, 1890. Studied in Amsterdam and in Delft. Worked under Cuijpers, 1907-8 and under Fischer in Munich, 1911. One of the founders of review and group *de Stijl*, 1917. City architect of Rotterdam, 1918. Retired 1927.

***307. House at Nordwijkerhout,** Holland, 1917
Photograph
Figure 147

 308. Temporary building, Rotterdam, 1923
Plate 34, *L'Architecture Vivante*, Summer, 1924

***309. Café de Unie,** Rotterdam, 1925
Plate 24, *L'Architecture Vivante*, Autumn, 1925
Photograph
Figure 152

RIETVELD, Gerrit Thomas. Born Utrecht, 1888. Self taught. Member of *de Stijl*.

***310. House at Utrecht,** Holland, 1924
Photograph
Figure 149
See **Doesburg, Théo van,** no 284
See also *Furniture*

SANT'ELIA, Antonio. Born Como, 1888. Studied Brera Academy and Bologna. Private practice, Milan. Through his designs for the City of the Future (1913) and his writings (1914), established esthetic and technic of Futurist movement in architecture. Killed in War, Monfalcone, 1916.

 311. Projects for the architecture of the future, 1913-14

TATLIN, Vladimir Evgrafovich
See *Painting and Sculpture*

***312. Model for monument to the Third International,** 1920
From Bibl. no. 440
Figures 128, 129
See also *Theatre*

Furniture

BREUER, Marcel. German. Master at Bauhaus at Weimar where first developed tubular steel chair. Architect and designer.

***313. Chair,** before 1925
Lent by William Muschenheim, New York
Figure 165

CHAREAU, Pierre. French. Architect and designer.

 314. Table, wrought iron, *c.* 1927
Lent by M. Thérèse Bonney, New York

HARTWIG, Josef. German. Student at Bauhaus.

***315. Chess set,** wood, *c.* 1924
Private collection
Figure 166

KIESLER, Frederick
See *Theatre*

 316. Standing lamp, 1933
Lent by Frederick Kiesler, New York
See also *Architecture*

LE CORBUSIER
See *Architecture*

***317. Chair**
The Museum of Modern Art
Gift of Thonet Brothers, Inc.
Figure 179
See also *Painting and Sculpture*

228

LEGER, Fernand
See *Painting and Sculpture*

318. **Rug,** Edition Myrbor, Paris, 1926
7¼ x 4 feet
Lent by M. Thérèse Bonney,
New York
See also *Theatre; Films*

LURÇAT, Jean. Painter. Born Paris, 1892.
Studied in Paris, and in Munich and Berlin. Lives in Paris.

318A. **Rug,** Edition Myrbor
4½ x 8 feet
Private collection, New York

PICASSO, Pablo
See *Painting and Sculpture*

319. **Rug,** Edition Myrbor, Paris, *c.* 1925
6½ x 5 feet
Lent by M. Thérèse Bonney,
New York
See also *Theatre*

RAY, Man
See *Photography*

320. **Chess set,** metal, before 1920
Lent by Miss Elsie Ray, New York

See also *Films*

RIETVELD, Gerrit Thomas
See *Architecture*

*321. **Chair,** before 1924
Lent by Alexander Calder,
New York
Figure 150

PHOTOGRAPHS
From the collection of M. Thérèse Bonney, New York.

322. Binding by Madeleine Gras for
Carte Blanche by Jean Cocteau,
Paris

323. Cigarette case, lighter and watch by
Gerard Sandoz, Paris

324. Jewelry by Dusausoy, Paris

225. Pillow by L. Bouix, Paris

326. Table lamp, unknown French

Typography and Posters

BAYER, Herbert. German. Student and master at the Bauhaus both at Weimar and Dessau. Typographer in Berlin.

327. **Poster for lecture series,** Bauhaus-Dessau, 1925-26

328. **Kandinsky exhibition poster,**
Bauhaus-Dessau, 1926

329. **Poelzig lecture poster,** Bauhaus-Dessau, *c.* 1927

330. **Arts and Crafts exhibition poster,**
Leipzig, *c.* 1927

CASSANDRE, A. M. Born 1901, Kharkov,
Russia. French citizen; works in Paris.
First poster published 1922.

*331. **Wagon Bar,** poster for dining cars,
1932
Figure 83

DOESBURG, Théo van
See *Painting and Sculpture*

*332. *De Stijl,* periodical, Vol. IV, no. 6,
Leyden, 1921
Figure 167

*333. **Jacket,** *Grundbegriffe der neuen
Gestaltenden Kunst* by Theo van
Doesburg. Bauhausbuch, no. 6,
Dessau
Figure 171

See also *Architecture*

SCHMIDT, Joost. German. Studied at Bauhaus.

*349. **Prospectus for the Staatliches Bauhaus,** Weimar, c. 1923
Figure 168

STENBERG, W. and G. Russian.

350. **Cover,** *Kamerny Theatre* by Jakov Aputchkine, Moscow, 1927

STERENBERG, David. Russian.

*351. **Cover,** *Izobrazitelnoe iskusstvo,* periodical, no. 1, Petersburg, 1919
Figure 120

TSCHICHOLD, Jan. German typographer. Author of several books on typography. Now working in Switzerland.

352. **Program** for moving picture theatre, Munich

Artist unknown, *Dada* movement.

353. **Cover,** *DADAphone,* periodical, no. 7, Paris, 1920

354. **Dada manifesto,** Paris, c. 1920

355. **Cover,** *catalog,* exposition Pierre Roy, Paris, c. 1925

356. **Marie, journal bimensuel pour la belle jeunesse,** Brussels, 1926

Artist unknown, *de Stijl* influence.

*357. **Concert poster,** Utrecht, 1927
Figure 154

*357A. *i. 10,* periodical, no. 6, Amsterdam, 1927
Figure 170

Theatre

EXTER, Alexandra Alexandrovna. Russian painter and designer for theatre. Cubist and Constructivist. Moscow. Now lives in Paris.

358. **Setting,** *Romeo and Juliet,* Kamerny (Tairov) Theatre, Moscow, 1921
Photograph lent by *Theatre Arts Monthly*
See also *Films*

GAMREKELI, Irakli. Georgian theatre designer.

359. **Settings,** *Anzor,* Roustaveli (Akmeteli) Theatre, Tiflis, 1928
Five photographs lent by *Theatre Arts Monthly*

360. **Setting,** *The Business Man,* Roustaveli (Akmeteli) Theatre, Tiflis, 1928
Photographs from The Museum of Modern Art Theatre Art Corpus

GONCHAROVA, Natalia. Russian painter and designer for theatre. With husband, Larionov, founded abstract Rayonist movement, Moscow, 1911. Many designs for Diaghileff Ballet since 1914.

361. **Costumes,** *Contes Russes,* Diaghileff's Russian Ballet, 1916
From *Les Ballets Russes,* Paris, 1930

362. **Setting,** *Les Noces,* Diaghileff's Russian Ballet, 1922
From *Les Ballets Russes,* Paris, 1930

JAKULOV, Grigory. Russian Cubist-Expressionist theatre designer.

363. **Setting,** *Princess Bambilla,* Kamerny (Tairov) Theatre, Moscow, 1920
Photographs lent by *Theatre Arts Monthly*

231

KIESLER, Frederick. Born Vienna, 1892. Studied at Technical School and Academy. Worked with Loos 1910. Stage set for *R.U.R.*, Berlin, 1923; *Emperor Jones*, 1923, first "space-stage." Member *de Stijl* group, 1923. Director International Theatre and Music Festival, Vienna, 1924; fully developed "space-stage." Architect, Austrian section at International Exposition of Decorative Arts, Paris, 1925. New York, 1926. Space House, New York, 1933. Settings for Juillard Foundation productions, 1934-36.

*364. **Setting, *R.U.R.*,** Berlin, 1923
Photograph lent by the artist
Figure 160

365. **Setting, *Emperor Jones*,** Berlin, 1923
Photograph and plan lent by the artist

366. **Space-stage,** Vienna, 1924
Photograph lent by the artist
See *Architecture; Furniture*

LARIONOV, Michael
See *Painting and Sculpture*

367. **Design for setting, *Baba-Yega*,** Diaghileff's Russian Ballet, 1916
Color reproduction from *Les Ballets Russes*, Paris, 1930

LÉGER, Fernand
See *Painting and Sculpture*

370. **Curtains for *La Création du Monde*,** Swedish Ballet, 1923
Two photographs from The Museum of Modern Art Theatre Art Corpus
See also *Furniture; Films*

NIVINSKI, I. Russian Cubist-Expressionist theatre designer.

371. **Designs for settings, *Princess Turandot*,** Moscow Art (Vakhtangov) Theatre, Moscow, 1921
Photographs from The Museum of Modern Art Theatre Art Corpus

PICASSO, Pablo
See *Painting and Sculpture*

372. **Costume of manager, *Parade*,** Diaghileff's Russian Ballet, 1917
From R. Cogniat, *Décors de Théâtre*, Paris, 1930

373. **Setting, *Pulcinella*,** Diaghileff's Russian Ballet, 1920
Color reproduction from *Les Ballets Russes*, Paris, 1930
See also *Furniture*

POPOVA, Lyubov Sergeievna. Member of Suprematist and, later, of Constructivist groups, Moscow, 1916 until her death, 1922.

*374. **Setting, *The Magnificent Cuckold*,** Meyerhold Theatre, Moscow, April 1922
From A. A. Gvosdev, *The Theatre of Meyerhold*, Leningrad, 1927
Figure 132

PRAMPOLINI, Enrico. Italian Futurist theatre designer.

375. **Polydimensional space-setting**
Photograph from *Theatre Arts Monthly*

SCHLEMMER, Oskar. German painter, sculptor and designer for theatre. Active at Bauhaus.

376. **Two costumes, *Triadic Ballet*,** 1923
Reproductions from *Die Bühne im Bauhaus*, Bauhausbuch, no. 4, Munich, 1924 (?)

SCHENK VON TRAPP, Lothar. German theatre designer, Wiesbaden.

377. **Settings, *Angelina*,** Wiesbaden (?), 1928
Photographs from The Museum of Modern Art Theatre Art Corpus

STEPANOVA, Varvara (Varst). Member of Constructivist group, Moscow, from 1920. Active in theatre. From 1926 on has worked in typography, montage, layout, etc.

*378. Settings, *The Death of Tarelkin*, Meyerhold Theatre, Moscow, 1922
From Bibl. no. 30
Figure 133

Films

Abstract or absolute films

EGGELING, Viking. Danish (?) birth. Worked in Germany. First master of abstract or absolute film made by method of multiple drawings as in Disney's animated cartoons. Influenced by abstract painting. Died about 1926.

*381. *Diagonalsymphonie,* begun, 1917
Strip of film
Reproduced from Bibl. no. 128A
Figure 182

RICHTER, Hans. German. Follower of Eggeling. Has made many abstract films, both by the multiple drawing method and by photography of moving objects. Lives in Berlin.

*382. *Rhythmus,* 1921
Strip of film
Reproduced from Bibl. no. 128A
Figure 183

LÉGER, Fernand
See *Painting and Sculpture*

*383. *Ballet mécanique,* 1924
Strip reproduced from the original film. The film was produced by Léger in Paris and was photographed by Dudley Murphy
Collection the Museum of Modern Art Film Library, New York
Figure 184
See also *Furniture; Theatre*

379. Two water color drawings for costumes
Gift of the artist

TATLIN, Vladimir Evgrafovich
See *Painting and Sculpture*

380. Design for setting, 1912
From Bibl. no. 439
See also *Architecture*

RAY, Man
See *Photography*

*384. *Emak Bakia,* 1927
Contact print made by Man Ray from the original negative
Collection the Museum of Modern Art Film Library, New York
Figure 185

See also *Furniture*

Film settings influenced by Cubism and Expressionism

EXTER, Alexandra Alexandrovna
See *Theatre*

385. Settings for *Aëlita,* Mezrapom-Russ, Moscow, 1919-20; Protozanov, director
Two photographs lent by the Museum of Modern Art Film Library, New York

REIMANN, Walter. German Expressionist.

*386. Settings for *The Cabinet of Dr. Caligari,* Decla-Bioskop, Berlin, 1919, under direction of Robert Wiene
Two photographs lent by *Theatre Arts Monthly*
Figure 159

233

Bibliography

This bibliography, listing the more important publications of abstract art, is in no sense definitive. Lack of space has necessitated the exclusion of periodical articles in all classes where adequate material is available in book form. The titles have been arranged in a simple classification, commencing with the few publications devoted solely to abstract art (titles 1-13), followed by general works on modern art (14-72), painting (73-110), sculpture (111-120) and photography (125-129) which include discussion of the various fields of abstract art; these are subdivided by countries. The remaining sections, "Movements" (130-217) and "Monographs" (218-444) are subdivided alphabetically by "-isms" and artists' surnames. To save space, titles have been listed but once and further reference is by number. Unless otherwise indicated, all publications are illustrated. No attempt has been made to list books illustrated by artists.

Symbols and abbreviations:

* More important work.

/ Not seen by the compiler, but listed because of its inclusion in a reliable bibliography.

Bibl. Containing bibliographical data.

Biog. Containing biographical material.

The bibliography compiled by Konrad Faber for the catalog (12) of the exhibition *Thèse, Antithèse, Synthèse* held by the Lucerne Kunstmuseum in 1935, and those assembled by Germain Bazin for *L'histoire de l'art contemporain* (83) edited by René Huyghe, 1935, have been most helpful. The friendly cooperation of Mr. James Johnson Sweeney has been invaluable. The Russian titles were transliterated by Mme. Lydia Nadejena.

<div align="right">

BEAUMONT NEWHALL
Librarian of the Museum

</div>

Abstract Art

Special literature concerned solely with abstract art

1 *Abstraction, création, art non-figuratif.* Paris, 1933-

2 *Art concret.* Paris, 1930-

3 *Axis; a quarterly review of contemporary "abstract" painting and sculpture.* London, 1935-

4 **Braun & cie., Galerie d'art, Paris.** *Vingt-cinq ans de peinture abstraite.* June 3-16, 1932. Exhibition catalog; preface by André Salmon.

5 ○ *et* □ *(Cercle et carré.)* Rédaction: M. Seuphor. Paris, 1930.

6 **Dorner, Alexander.** "Die neue Raumvorstellung in der bildende Kunst." *Museum der Gegenwart,* 1931, v. 2, no. 1, p. 30-37.

7 "De l'art abstrait." *Cahiers d'art,* 1931, v. 6, no. 1, p. 41-43; no. 3, p. 151-152; no. 7-8, p. 350-358. Articles by Piet Mondrian, Fernand Léger, W. Kandinsky, A. Dorner and Hans Arp.*

8 **Flake, Otto.** "Über abstrakte Kunst." *Jahrbuch der jungen Kunst,* 1920, p. 96-109. Not illustrated.

9 **Hélion, Jean.** "The evolution of abstract art." New York university, Gallery of living art, *Catalog,* 1933.

10 **Kandinsky, W.** "Abstrakte Kunst." *Cicerone,* 1925, v. 17, no. 13, p. 638-647.

11 **Klumpp, Hermann.** *Abstraktion in der Malerie: Kandinsky, Feininger, Klee.* Berlin, Deutscher Kunstverlag, 1932.

12 **Lucerne. Kunstmuseum.** *Thèse, antithèse, synthèse.* Feb. 24-Mar. 31, 1935. Exhibition catalog. Bibl.*

13 **Zürich. Kunsthaus.** *Katalog der Ausstellung: Abstrakte und surrealistische Malerei und Plastik.* 1929. Preface by W. Wartman.

Modern Art

General works which include discussion of abstract art

14 **Association of American painters and sculptors, inc., New York.** *International exhibition of modern art,* Feb. 17 - Mar. 15, 1913. Catalog of the "Armory Show." A supplement, first issued separately, was incorporated in a second edition published for the exhibition at the Chicago Art Institute, Mar. 24 - Apr. 16, 1913, and reprinted for the Boston showing, Apr. 28-May 19, 1913.

15 **Breysig, Kurt.** *Eindruckskunst und Ausdruckskunst; ein Blick auf die Entwicklung des zeitgenössischen Kunstgeistes von Millet zu Marc.* Berlin, 1927. /

16 *Bulletin de l'effort moderne.* Paris, 1924-27. Nos. 1-40. Editor: Léonce Rosenberg.

17 **Burger, Fritz.** *Cézanne und Hodler; Einführung in die Probleme der Malerei der Gegenwart.* München, Delphin-Verlag, 1913. 3d ed., 1919. 2 v.

18 ———— *Einführung in die moderne Kunst.* Berlin, Athenaion, 1917. (Handbuch der Kunstwissenschaft.) *

19 *Cahiers d'art; revue d'art.* Paris, 1926-date. Editor, Christian Zervos.

20 **Cheney, Sheldon.** *Expressionism in art.* New York, Liveright, 1934.

21 ———— *A primer of modern art.* New York, Boni & Liveright, 1927.

22 **Collings, E. H. R.** *Modern European art, a student's introduction to modern continental sculpture and painting.* London, C. Palmer, 1929.

23 **Coquiot, Gustave.** *Cubistes, futuristes, passéistes. 3e éd.* Paris, Ollendorf, 1914.

24 ———— *Les indépendants, 1884-1920 4e éd.* Paris, Ollendorf, n.d. [1920 or later].

25 *Documents; Archéologie, beaux-arts, ethnographie, variétés.* Paris, 1929-

26 **Einstein, Carl.** *Die Kunst des 20. Jahrhunderts. 3. Aufl.* Berlin, Propyläen Verlag, 1931. Biog.*

27 *L'Esprit nouveau; revue internationale d'esthétique.* Paris, 1919-25. Important articles by the editors. Amédée Ozenfant and Charles-Edouard Jeanneret [Le Corbusier].

28 *Europa-Almanach 1925. Malerei, Literatur, Musik, Architektur, Plastik, Bühne, Film, Mode. Herausgeber: Carl Einstein und Paul Westheim.* Potsdam, G. Kiepenheuer, 1925. /

29 *Formes; an international review of plastic art.* Paris, 1929-33. Nos. 1-33. Editor: Waldemar George. Also a French edition.

30 **Fülop-Miller, René & Joseph Gregor.** *The Russian theatre.* Philadelphia, J. B. Lippincott, n.d.

31 **Grigson, Geoffrey,** ed. *The arts to-day.* London, J. Lane, 1935.

32 **Grohmann, Will.** *Die Sammlung Ida Bienert, Dresden.* Potsdam, Müller & Kiepenheuer, 1933.

33 **Hausenstein, Wilhelm.** *Die bildende Kunst der Gegenwart; Malerei, Plastik, Zeichnung.* Stuttgart und Berlin, Deutsche Verlags-Anstalt, 1914. 2d ed., 1920; 3d ed., 1923.

34 **Hildebrandt, Hans.** *Die Kunst des 19. und 20. Jahrhunderts.* Potsdam, Akad. Verlag Kiepenheuer, 1924. (Handbuch der Kunstwissenschaft.) *

35 *Jahrbuch der jungen Kunst. Herausgegeben von Prof. Dr. Georg Biermann.* Leipzig, Klinkhardt & Biermann, 1920-24. 5v.

36 **Joseph, Edouard.** *Dictionnaire biographique des artistes contemporains, 1910-1930.* Paris, Grund, 1930-34. 3v.

37 **Lissitzky, El, & Hans Arp.** *Die Kunstismen, 1914-24.* Erlenbach-Zürich, E. Rentsch, 1925. Title-page and text in German, French and English.

38 **Mats, I.** *Iskusstvo sovremennoi evropy.* Moskva & Leningrad. Gosydarstvennoe izdatelstvo, 1926. Bibl.

39 **Meier-Graefe, Julius.** *Entwicklungsgeschichte der modernen Kunst. 2. umgearbeitete und ergänzte Auflage.* München, R. Piper, 1914-1915. The English translation *Modern art* is of the first edition which does not discuss abstract art.

40 *Minotaure; revue artistique et litéraire.* Paris, A. Skira, 1933-. Edited by E. Tériade.

41 **Moholy-Nagy, Ladislaus.** *Malerei, Fotografie, Film. 2. veränderte Aufl.* München, A. Langen, 1927. (Bauhausbücher 8.)

42 ———— *Von Material zu Architektur.* München, A. Langen, 1929. (Bauhausbücher 14.) Translation, with fewer illustrations: *The new vision; from material to architecture.* New York, Brewer, Warren & Putnam, n.d. [1930 or later].*

43 **Mullen, Mary.** *An approach to art.* Merion, Pa., Barnes foundation, 1923.

235

44 **New York. Museum of modern art.** *Modern works of art; fifth anniversary exhibition.* Nov. 20, 1934-Jan. 20, 1935. Text by Alfred H. Barr, Jr. and Philip Johnson.

45 **New York. Société anonyme, Museum of modern art.** *International exhibition of modern art arranged by the Société anonyme for the Brooklyn museum.* Nov.-Dec., 1926. Text by Katherine S. Dreier.

46 **New York university. Gallery of living art.** *A. E. Gallatin collection.* 1933.

47 *Omnibus; eine Zeitschrift.* Berlin und Düsseldorf, Galerie Flechtheim, 1931-32. 2 v. Editors: René Crevel (1931), Martel Schwichtenberg (1931-32), Curt Valentin (1931-32).

48 **Ozenfant, Amédée.** *Art. 6e éd.* Paris, Budry, 1928. / Translations: *Foundations of modern art.* New York, Brewer, Warren & Putnam, 1931. *Leben und Gestaltung.* Potsdam, 1930. /

49 **Pach, Walter.** *The masters of modern art.* New York, B. Huebsch, 1924.

50 **Pavolini, Corrado.** *Cubismo, futurismo, espressionismo.* Bologna, Zanichelli, 1926. /

51 **Poore, Henry Rankin.** *The new tendency in art; post-impressionism, cubism, futurism.* Garden City, Doubleday, Page, 1913.

52 **Read, Herbert.** *Art now; an introduction to the theory of modern painting and sculpture.* New York, Harcourt Brace, 1934.

53 **Rothschild, Edward F.** *The meaning of unintelligibility in modern art.* Chicago, University of Chicago press, 1931.

54 **Rutter, Frank.** *Evolution in modern art.* London, G. C. Harrap, 1926.

55 **Thieme, Ulrich & Felix Becker,** eds. *Allgemeines Lexicon der bildende Künstler.* Leipzig, Englemann [later Seemann] 1907-date. Vol. 29, through "Scheffauer," was pub. in 1935. Biog. Not illus.

56 **Thireau, Maurice.** *L'art moderne et la graphie.* Paris, Au Bureau de l'éditeur, 1930.

57 **University of Chicago. The Renaissance society.** *Catalogue of the summer exhibition.* June 20-Aug. 20, 1934. A selection of works by 20th century artists.

58 **Walden, Herwarth.** *Einblick in Kunst: Expressionismus, Futurismus, Kubismus. 3. bis 5. Auflage.* Berlin, Verlag der Sturm, 1924.

59 **Wilenski, Reginald Howard.** *The modern movement in art.* London, Faber & Gwyer, 1927. New ed., New York, Stokes, 1935.

England

60 **Read, Herbert.** *Unit 1: the modern movement in English architecture, painting and sculpture.* London, Cassell & Cassell, 1934.

Germany

61 **New York. Museum of modern art.** *German painting and sculpture.* Mar. 13-Apr. 26, 1931. Exhibition catalog. Introduction by Alfred H. Barr, Jr.

Italy

62 **Corra, Bruno.** *Per l'arte nuova della nuova Italia.* Milano, Studio ed. lombardo, 1918. Not illus.

63 **Scheiwiller, Giovanni.** *Art italien moderne.* Paris, Editions Bonaparte, 1930. Bibl.*

Russia

64 *Bush, M. & A. Zamoshkin.* "Soviet pictorial art." *VOKS illustrated almanac,* 1934, no. 9-10, p. 9-30.

65 **Gosudarstvennyi Institut istorii iskusstv.** *Ejegodvik rossiiskogo Instituta istorii iskusstv.* 1921. /

66 **Fiodorov-Davidov.** *Russko iskussto promislepnogo kapitalizma.* Moskva, Izdatel'stvo G. A. Kh. N., 1929.

67 **Karpfen, Fritz.** *Gegenwartskunst; I. Russland.* Wien, Verlag "Literaria," 1921.

68 **Lozowick, Louis.** *Modern Russian art.* New York, Société anonyme, 1925.

69 **Malevich, K.** *Bog ne skinut; iskusstvo, tserkov, fabrika.* Vitebsk, Unovis, 1922. /

70 **Salmon, André.** *Art russe moderne.* Paris, Editions Laville, 1928. /

71 **Tugenhold, Ia.** *Iskusstvo oktyabr'sky epokhi.* Leningrad, Academia, 1930. /

72 **Umanskij, Konstantin.** *Neue Kunst in Russland, 1914-1919.* Potsdam, Kiepenheuer; München, H. Goltz, 1920. Bibl.*

Painting

General works which include discussion of abstract painting

73 **Behne, Adolf.** *Von Kunst zur Gestaltung; Einführung in die moderne Malerei.* Berlin, Arbeiterjugend-Verlag, 1925.

74 **Castelfranco, Giorgio.** *La pittura moderna.* Firenze, L. Gonnelli, 1934.

75 **Coellen, L.** *Die neue Malerei.* München, E. W. Bonsch. /

76 **College art association, New York.** *8 modes of modern painting; a College art association exhibition.* 1934. Catalog compiled by Agnes Rindge.

77 **Deri, Max.** *Die neue Malerei: Impressionismus, Pointillismus, Futuristen, die grossen Uebergangsmeister, Kubisten, Expressionismus, absolute Malerei.* München, Piper, 1913. / New ed., Leipzig, Seemann, 1921.

78 **Focillon, Henri.** *La peinture, XIXe et XXe siècles. Tome II: Du réalisme à nos jours.* Paris, Librairie Renouard, 1928.

79 **Frankfurt am Main. Staedelschen Kunstinstitut.** *Vom Abbild zum Sinnbild; Ausstellung von Meisterwerken moderner Malerei.* June 3-July 3, 1931. Catalog; preface by Fritz Wichert.

80 **Gordon, Jan.** *Modern French painters.* New York, Dodd, Mead, 1923.

81 **Guerrisi, Michele.** *La nuova pittura.* Torino, Ed. de l'Erma, 1932.

82 **Guy, Michel.** *Le dernier état de la peinture; les successeurs des impressionistes.* Paris, Le Feu, 1911. /

83 **Huyghe, René, ed.** *Histoire de l'art contemporain. La peinture.* Paris, F. Alcan, 1935. First published by instalments in *L'Amour de l'art*, 1933-34, v. 14-15. Bibl. Biog.*

84 **Kröller-Müller, Mme. H.** *Die Entwicklung der modernen Malerei.* Leipzig, Klinkhardt & Biermann, 1925.

85 **Lhote, André.** *La peinture; le coeur et l'esprit.* Paris, Denoël et Steele, 1933.

86 **Mariott, Charles.** *Modern movements in painting.* London, Chapman & Hall, 1920. (Universal art series.)

87 *Le Néoclassicisme dans l'art contemporain.* Rome, Ed. de "Valori plastici" [1921 or later].

88 **Ozenfant, Amédée & Charles-Edouard Jeanneret [Le Corbusier].** *La peinture moderne.* Paris, G. Crès, 1924. (Coll. de L'Esprit nouveau).*

89 **Pisis, Filippo de.** *Pittura moderna.* Ferrara, Taddei, 1919. /

90 **Raphael, Max.** *Von Monet zu Picasso; Grundzüge einer Aesthetik und Entwicklung der modernen Malerei. 3. Aufl.* München, Delphin-Verlag, 1919.

91 **Salmon, André.** *L'art vivant.* Paris, Crès, 1920.

92 **Sarfatti, Margherita G.** *Storia della pittura moderna.* Roma, Paolo Cremonese, 1930. (Collezione Prisma.) Biog.

93 **Sweeney, James Johnson.** *Plastic redirections in 20th century painting.* Chicago, Univ. of Chicago press, 1934. Biog.*

94 **Walden, Herwarth.** *Die neue Malerei. 2. Aufl.* Berlin, Verlag der Sturm, 1919.

95 **Wright, Willard Huntington.** *Modern painting, its tendency and meaning.* New York & London, John Lane, 1915. 2d ed., New York, Dodd, Mead, 1926.

France

96 **Arp, Hans, & L. H. Neitzel.** *Neue französische Malerei.* Leipzig, Verlag der Weissen Bücher, 1913. /

97 **Courthion, Pierre.** *Panorama de la peinture française contemporaine. 3e éd.* Paris, S. Kra, 1927. /

98 **Grautoff, O.** *Französische Malerei seit 1914.* Berlin, 1920. /

99 **Klingsor, Tristan L.** *La peinture.* Paris, Ed. Rieder, 1928. (L'art français depuis vingt ans.)

100 **Raynal, Maurice.** *Anthologie de la peinture en France de 1906 à nos jours.* Paris, Editions Montaigne, 1927. Translation: *Modern French painters.* New York, Brentano's, 1928. Bibl. Biog.*

101 **Salmon, André.** *La jeune peinture française.* Paris, Messin, 1912. /

102 **Uhde, W.** *Picasso et la tradition française.* Paris, Ed. des Quatre-chemins, 1928. Translation: *Picasso and the French tradition.* New York, E. Weyhe, 1929.

Germany

103 **Justi, Ludwig.** *Von Corinth bis Klee.* Berlin, J. Bard, 1931.

Holland

104 **Citroen, Paul.** *Palet, een boek gewijd aan de hedendaagsche nederlandsche schilderkunst.* Amsterdam, "De Spieghel," 1931.

105 **Huebner, F. M.** *Die neue Malerei in Holland.* Leipzig, Klinkhardt & Biermann, 1921.*

106 **Plasschaert, Alb.** *Korte geschiedenis der Hollandsche schilderkunst.* Amsterdam, Mij voor goede en goedkoope lectuur, 1923.

Italy

107 **Bernasconi, Ugo.** *Le presenti condizioni della pittura in Italia.* Milano, S. Piantanida, 1923. /

237

108 **Costantini, Vincenzo.** *Pittura italiana contemporanea dalla fine dell '800 ad oggi.* Milano, U. Hoepli, 1934. Bibl. Biog.*

Russia

109 **Beskin, Os. M.** *Formalizn v jivopisi.* Moskva, Vsekhudozhnik, 1933.
110 **Tugenhold, Ia.** "Zhivopis." *Pechat i revolutsia,* 1927, p. 158-182.

Sculpture

General works which include discussion of abstract sculpture.

111 **Benson, E. M.** "Seven sculptors: Calder, Gargallo, Lehmbruck, Lipchitz, Manolo, Moore, Wolff." *American magazine of art,* 1935, v. 28, p. 468-9.
112 **Bragaglia, A. G.** *Scultura vivente.* Milano, Eroica, 1928. /
113 **Fierens, Paul.** *Sculpteurs d'aujourd'hui.* Paris, Ed. des Chroniques du jour; London, Zwemmer, 1933. (XXe siècle.) Bibl. Biog.*
114 **Kuhn, Alfred.** *Die neuere Plastik. 2. Aufl.* München, Delphin-Verlag, 1922.
115 **Raynal, Maurice.** "Dieu — table — cuvette." *Minotaure,* 1933, no. 3-4, p. 39-53.
116 **Schack, William.** "On abstract sculpture." *American magazine of art,* 1934, v. 27, p. 580-588.
117 **Wilenski, Reginald Howard.** *The meaning of modern sculpture.* New York, Stokes, 1932. Also **Moholy-Nagy** (42).

France

118 **Basler, Adolphe.** *La sculpture moderne en France.* Paris, Crès, 1928.
119 **Salmon, André.** *La jeune sculpture française.* Paris, Imprimé pour la Société des trente, 1919. /

Russia

120 **Bakushinski, A.** "Sovremennaya russkaya skulptura." *Isskustvo,* 1927, no. 2-3, p. 86-94.
121 **Ternovetz, B. N.** "Ruskie skulptori." *Iskusstvo,* 1924, p. 46.
122 **Tugenhold, Ia.** "Nasha skulptura." *Novyi mir,* 1926, no. 5.
123 **Federov-Davidov.** "Skulptura." *Pechat i revolutsia,* 1927, p. 185-201.
124 "Zaumnaya skulptura." *Zritel,* no. 2, p. 7. /

Photography and films

General works which include discussion of abstract photography and moving pictures.

125 "Experimentale Fotografie." *Das neue Frankfurt,* 1929, v. 3, no. 3, p. 45-64. Articles by J. Gantner, Moholy-Nagy and others.
125A **Bagier, Guido.** *Der kommende Film; eine Abrechnung und eine Hoffnung.* Stuttgart, Deutsche Verlags-Anstalt, 1928. Bibl.
125B **Braak, Menno ter.** *De absolute film.* Rotterdam, Brusse, 1931. (Serie Monografieën over filmkunst, no. 8.)
126 **Bruguiere, Francis.** "Creative photography." Foreword to *Modern photography, The Studio annual of camera art,* 1935-36. London & New York, The Studio, 1935.
126A **Kurtz, Rudolf.** *Expressionismus und Film.* Berlin, Die Lichtbildbühne, 1926.
127 **Moholy-Nagy, Ladislaus.** "The future of the photographic process." *Transition,* 1929, no. 15, p. 289-293.
128 **Ray, Man.** "On photography." *Commercial art,* 1934, v. 17, p. 62-64.
128A **Richter, Hans.** *Filmgegner von Heute, Filmfreunde von Morgen.* Berlin, H. Reckendorf, 1929.
129 **Roh, Franz & Jan Tschichold,** eds. *Foto-Auge. Oeil et photo. Photo-eye.* Stuttgart, Wedekind, 1929. Text in German, French and English.
Also **Moholy-Nagy** (41).

Movements

Abstract Expressionism

130 **Bahr, Hermann.** *Der Expressionismus.* München, Delphin-Verlag, 1916. Reprinted, 1920. Translation: *Expressionism.* London, F. Henderson, 1925.
131 **Braxton gallery, Hollywood, Cal.** *The blue four; Feininger, Jawlensky, Kandinsky, Paul Klee.* 1930. Exhibition catalog.
132 **Fechter, Paul.** *Der Expressionismus. 3. Aufl.* München, R. Piper, 1919.
133 **Fischer, Otto.** *Das neue Bild.* München, Delphin-Verlag, 1912. /
134 **Herzog, Oswald.** "Der abstrakte Expressionismus." *Der Sturm,* 1919, no. 2. /
135 **Kandinsky, Vasily.** *Punkt und Linie zu Fläche.* München, A. Langen, 1926. (Bauhausbücher 9.) Reprinted in 1928. At head of title: Wassily Kandinsky.

136 ———— *Über das Geistige in der Kunst, inbesondere in der Malerei.* München, Verlag Piper, 1910. 2d ed., 1912. At head of title: Wassily Kandinsky. Translation: *The art of spiritual harmony, by Wassily Kandinsky.* London, Constable, 1914. Also published in Boston, Houghton Mifflin, 1914.*

137 **Kandinsky, Vasily & Franz Marc,** eds. *Der blaue Reiter.* München, R. Piper, 1912. 2d ed., 1914.

138 **Klee, Paul.** *Pädagogisches Skizzenbuch. 2. Aufl.* München, A. Langen, 1925. (Bauhausbücher 2.)

139 **Marzinski, Georg.** *Die Methode des Expressionismus.* Leipzig, Klinkhardt & Biermann, 1920. /

140 *Der Sturm.* Berlin, 1910-32. 21 v. Editor: Herwarth Walden.

141 **Sydow, Eckart von.** *Die deutsche expressionistische Kultur und Malerei.* Berlin, Furche Verlag, 1920. Bibl.

142 **Walden, Herwarth.** *Expressionismus. Die Kunstwende.* Berlin, Verlag des Sturm, 1918. /

Also *Jahrbuch der jungen Kunst* (35) **Pavolini** (50) *Staatliche Bauhaus* (146).

Bauhaus Group

143 *Bauhaus; Vierteljahr-Zeitschrift für Gestaltung.* Dessau, 1927-32.

144 "Bauhaus." *ReD*, 1930, v. 3, no. 5, p. 129-160. Articles on the Bauhaus work by Walter Peterhans, Otti Berger and others.

145 **Gropius, Walter.** *The new architecture and the Bauhaus.* London, Faber and Faber, 1935.

145A **Harvard society for contemporary art, Cambridge.** *Bauhaus.* Dec. 1930-Jan. 1931. Exhibition catalog. Not illus. Bibl.

146 *Staatliches Bauhaus Weimar, 1919-1923.* Weimar-München, Bauhausverlag, n.d. Also published in English and Russian.

The Bauhaus also published **Doesburg** (204) **Gleizes** (159) **Kandinsky** (135) **Klee** (138) **Malevich** (210) **Moholy-Nagy** (41, 42).

Constructivism

147 **Badovici, Jean.** Born Kiev, 1878. "Les constructivistes." *L'architecture vivante*, 1925, v. 3, no. 9, p. 5-10.

148 **Efros, A.** "Vosstanie zritelya." *Russky sovremennik*, 1924, no. 1-2. /

149 *G□; Zeitschrift für elementare Gestaltung.* Berlin, 1923-. Editors: Werner Gräff, El Lissitzky, H. Richter. /

150 **Gabo, N. & A. Pevsner.** *Realistic manifesto.* Moscow, 1920. / In Russian (title translated); the constructivist manifesto. Abridged French translation in *Abstraction-création*, 1932, p. 27.

151 **Kállai, Ernst.** "Konstruktivismus." *Jahrbuch der jungen Kunst*, 1924, p. 374-386.

152 **Lissitzky, El.** *Russland; die Rekonstruktion der Architektur in der Sowjetunion.* Wien, Schroll, 1930. (Neues Bauen in der Welt.)

153 *Vesch. Gegenstand. Objet. Publié sous la direction de El Lissitzky et Elie Ehrenburg.* Berlin, Verlag "Skythen," 1922.

Also **Bush & Zamoshkin** (64) **Fülop-Miller** (30) **Lozowick** (68).

Cubism

154 **Apollinaire, Guillaume.** *Les peintres cubistes. 9e éd.* Paris, Figuière, 1913.

155 **Blümner, Rudolf.** *Der Geist der Kubismus und die Künste.* Berlin, Verlag der Sturm. /

156 **Eddy, Arthur Jerome.** *Cubists and post-impressionism.* Chicago, McClurg, 1914. New ed., 1919. Bibl.

157 **Einstein, Carl.** "Notes sur le cubisme." *Documents*, 1929, no. 3, p. 146-159.

158 **Les Expositions de "Beaux-arts" & de "La Gazette des beaux-arts,"** Paris. *Les créateurs du cubisme.* 1935. Catalog; prefaced by M. Raynal and compiled by Raymond Cogniat.

159 **Gleizes, Albert & Jean Metzinger.** *Du cubisme.* Paris, Figuière, 1912. Translations: *Cubism.* London, T. F. Unwin, 1913. *Kubismus.* München, A. Langen, 1928. (Bauhausbücher 13.)

160 **Gleizes, Albert.** *Du cubisme et des moyens de le comprendre.* Paris, Ed. La Cible, 1920. Translation: *Vom Kubismus; die Mittel zu seinem Verständnis.* Berlin, 1922. /

161 ———— *La mission créatrice de l'homme dans le domaine plastique.* Paris, J. Povolozky, 1922. /

162 ———— *Peinture et perspective descriptive.* Sablons, Moly-Sabata, 1927. Not illus.

163 ———— *La peinture et ses lois; ce qui devrait sortir du cubisme.* Paris, 1924. Reprinted from *La Vie des lettres et des arts*, March, 1923.

164 ———— *Traditions et cubisme; vers une conscience plastique.* Paris, J. Povolozky, 1927.

165 **Janneau, Guillaume.** *L'art cubiste: théories et réalisations.* Paris, C. Moreau, 1929.*

166 [**Kahnweiler, Henry**] *Der Weg zum Kubismus, von Daniel Henry [pseud.].* München, Delphin-Verlag, 1920.*

167 **Küppers, P. E.** *Der Kubismus.* Leipzig, Klinkhardt & Biermann, 1920. /

168 **Ozenfant, Amédée & Charles-Edouard Jeanneret [Le Corbusier].** *Après le cubisme. 2e éd.* Paris, Ed. des Commentaires, 1918. Not illus.

169 **Raynal, Maurice.** *Quelques intentions du cubisme.* Paris, L'Effort moderne, 1919. Not illus.

170 **Rosenberg, Léonce.** *Cubisme et empirisme.* Paris, L'Effort moderne, 1921. Not illus.

171 ———— *Cubisme et tradition.* Paris, L'Effort moderne, 1920. Not illus.

172 **Schewtschenko, A.** *Kubism.* Moskva, Izdania avtora, 1916. /

173 **Severini, Gino.** *Du cubisme au classicisme. 5e éd.* Paris, J. Povolozky, 1921.

174 **Soffici, Ardengo.** *Cubismo e futurismo. 2a ed.* Firenze, Libreria della Voce, 1914.

Also **Coquiot** (23) **Fechter** (132) **Huyghe** (83) **Pavolini** (50) **Walden** (58).

Dada and Surrealism

175 **Aragon, Louis.** "La peinture au défi." Foreword to catalog: **Galerie Goermans, Paris.** *Exposition de collages.* Mar., 1930.

176 **Breton, André.** *Le surréalisme et la peinture.* Paris, Nouvelle revue française, 1928.

177 **Gascoyne, David.** *A short survey of surrealism.* London, Cobden-Sanderson, 1935.*

178 **Hugnet, Georges.** "L'esprit dada dans la peinture." *Cahiers d'art,* 1932, v. 7, no. 1-2, p. 57-65; no. 6-7, p. 281-285; no. 8-10, p. 358-364. 1934, v. 9, no. 1-4, p. 109-114.*

179 *La Révolution surréaliste,* Paris, 1924-29. Nos. 1-12. Editors: Pierre Naville and Benjamin Péret (1925); André Breton (1925-29). Continued as *Le Surréalisme au service de la révolution,* Paris, [1930-33]. Nos. 1-6. Editor: André Breton.

180 **Soby, James Thrall.** *After Picasso.* Hartford, E. V. Mitchell; New York, Dodd, Mead, 1935.

181 "Le surréalisme en 1929." *Variétés,* 1929, numéro hors série et hors abonnement, p. 1-61. Articles by Sigm. Freud, René Crevel and others.

182 "Surrealist number. Guest editor: André Breton." *This quarter,* 1932, v. 5, p. 1-208. Contributions by André Breton, Paul Eluard, René Char and others.

183 **Tzara, Tristan.** *Sept manifestes dada.* Paris, J. Budry, [1925]. /
Also **Sweeney** (93).

240

Futurism

The various futurist manifestos have been collected under the title:

184 *I manifesti del futurismo.* Milano, Istituto editoriale italiano, n.d.* 4 v. (Raccolta di breviari intellettuali, nos. 168-170, 192). Of those dealing with art the following are most important:

1909 Feb. 20 *Manifesto del futurismo.* Marinetti. Reprinted in Boccioni (189).

1910 Feb. 11 *Manifesto dei pittori futuristi.* Boccioni, Carrà, Russolo, Balla, Severini. Reprinted in Boccioni (189).

1910 Apr. 11 *La pittura futurista; manifesto tecnico.* Boccioni, Carrà, Russolo, Balla, Severini. Reprinted in Boccioni (189).

1910 Apr. 27 *Contro Venezia passatista.* Marinetti, Boccioni, Carrà, Russolo.

1912 Apr. 11 *Manifesto tecnico della scultura futurista.* Boccioni. Abridged translation in *Bulletin de l'effort moderne,* 1923, no. 15, p. 11-13. Reprinted in Boccioni (189).

1913 June 29 *L'antitradizione futurista.* Guillaume Appollinaire.

1913 Aug. 11 *La pittura dei suoni, rumori e odori.* Carrà. Reprinted in Boccioni (189).

185–188 The following galleries have published illustrated catalogs of the first international exhibition of 1912: **Bernheim Jeune & Cie., Paris; Sackville Gallery, Ltd., London; Der Sturm, Berlin; La Galerie Georges Giroux, Brussels.**

189 **Boccioni, Umberto.** *Pittura, scultura futuriste. Dinamismo plastico.* Milano, Poesia, 1914.*

190 **Cangiulio, Francesco.** *Le serate futuriste.* Napoli, Casa editrice Tirrena, 1930. /

191 **Carrà, Carlo.** *Guerrapittura; futurismo politico, dinamismo plastico.* Milano, Poesia, 1915.

192 **Fillià.** *Il futurismo; ideologie, realizzazioni e polemiche del movimento futurista italiano.* Milano, Casa editrice Sonzogno, 1932. (Biblioteca del popolo, vol. 391-392). Not illus.

193 ———— *Pittura futurista, realizzazioni, affermazioni, polemiche.* Torino, Editrice Europea, 1929. /

194 **Flora, Francesco.** *Dal romanticismo al futurismo. Nuova ed.* Milano, A. Mondadori, 1925. Not illus.

195 **Marinetti, F. T.** *Le futurisme.* Paris, Sansot, 1911. /*

196 ———— *Il tattilismo.* Milano, Poesia, 1921. /

197 *Noi futuristi . . . teorie essenziali e chiarificazioni.* Milano, Quinteri, n.d. /

198 **Paladini, V.** *Arte d'avanguardia e futurismo.* Roma, La Bilancia, 1923.

199 **Sartoris, A.** *L'architetto Antonio Sant'Elia.* Milano, G. Scheiwiller, 1930. /

200 **Soffici, Ardengo.** *Primi principi di una estetica futurista.* Firenze, Valleochi, 1920.
Also **Fechter** (132) **Huyghe** (83) **Pavolini** (50).

Neo-Plasticism
See *de Stijl* group and Neo-Plasticism (202-208).

Orphism
See **Huyghe** (83).

Purism
See **Huyghe** (83) **Ozenfant** (48) **Ozenfant & Jeanneret** (88*, 168).

Rayonism

201 **Larionov, N.** *Luchism.* Moskva, 1913. / In Russian.
Also **Lozowick** (68).

de Stijl Group and Neo-Plasticism

202 **Doesburg, Théo van.** *Drie voordrachten over nieuwe beeldende kunst.* Amsterdam. Wereldbibliotheek, 1919. /

203 ———— "Elémentarisme." *Abstraction-création,* 1932, p. 39.

204 ———— *Grondbegrippen der nieuwe beeldende kunst.* 1917. / Translation: *Grundbegriffe der neuen gestaltenden Kunst.* München, A. Langen, [pref. 1924]. (Bauhausbücher 6.) *

205 ———— *De nieuwe beweging in de schilderkunst.* Delft. J. Waltmann, 1916. /

206 ———— *Klassiek, barok, modern.* Antwerpen, De sikkel, 1920. / Translation: *Classique, baroque, moderne.* Paris, L. Rosenberg, 1920. /

206A **Mondrian, Piet.** "L'architecture future néo-plasticienne." *L'Architecture vivante,* 1925, v. 3, no. 9, p. 11-13.

207 ———— *Le néo-plasticisme.* Paris, L. Rosenberg, 1920. Translation: *Neue Gestaltung, Neoplastizismus, nieuwe beelding.* München, A. Langen, 1925. (Bauhausbücher 5.) Written 1922-23.*

208 *De Stijl; maanblad voor nieuwe kunst, wetenshap en kultur.* Redactie: *Théo van Doesburg.* Leiden [later Clamart and Meudon, France], 1917-32.*
Also "Van Doesburg" (274).

Suprematism

209 **Klub V. S. P.** [Moscow]. *5 x 5 = 25. Vistavka jivopisi. Khud.: Varst, Vesnin, Popova, Rodchenko, Exter.* Sept., 1921. Exhibition catalog. Mimeographed with ms. illus.

210 **Malevich, Kasimir.** *Die gegenstandslose Welt.* München, A. Langen, 1927. (Bauhausbücher 11.) At head of title: Kasimir Malewitsch.*

211 ———— *Suprematism. Suprematism kak bezto predmenost. O novich sistemakh v iskusstve.*
213 Titles published before 1922. /
Also **Lozowick** (68) **Umanskij** (72).

Synchromism
See **Coquiot** (23) **Wright** (95).*

Vorticism

214 *Blast; review of the great English vortex.* Editor: *Wyndham Lewis.* London, 1914-15. Nos. 1-2.*

215 **Lewis, Wyndham.** *The caliph's design; Architects! where is your vortex?* London, The Egoist, 1919.

216 ———— "Plain home builder! Where is your vortex?" *Architectural review,* 1934, v. 76, p. 155-158. Not illustrated.

217 *The Tyro; a review of the arts of painting, sculpture and design.* Edited by Wyndham Lewis. London, The Egoist, [1921-1922?].
Also **Lewis** (350-351).

Monographs
Albers, Josef

218 **Albers, Josef.** "Art as experience." *Progressive education,* 1935, v. 12, p. 391-393. Not illustrated.

219 ———— "Werklicher Formunterricht." Article in prospectus entitled *Bauhaus,* n.p., n.d.
Also *Création-Abstraction,* 1934, p. 3.

Altman, Natan

220 **Arvatov, B.** *Natan Altman.* Petropolis, 1919. Printed in Berlin.

Archipenko, Alexander

221 **Alexander Archipenko.** Berlin, Verlag des Sturm, 1915. (Sturm Bildbücher). /

222 **Anderson galleries, New York.** *Archipenko; catalogue of exhibition and description of Archipentura.* 1928.

223 **Apollinaire, Guillaume.** *Alexander Archipenko.* Berlin, Verlag des Sturm, 1921. /

224 **Hildebrandt, Hans.** *Aléxandre Archipenko, son oeuvre.* Berlin, Editions Ukrainske Slowo, 1923. In French, also editions in English, German and Ukrainian.*

225 **Kingore gallery, New York.** *The Archipenko exhibition under the auspices of the Société anonyme; introduction and catalogue by Christian Brinton.* 1924.

226 **Lux, Gene.** "Archipenko." *Creative art*, 1932, v. 11, p. 194-202, 227. Bibl.*

227 **Raynal, Maurice.** *A. Archipenko.* Rome, 1923. Editions both in French and Italian. /

228 **Schacht, Roland.** *Alexander Archipenko.* Berlin, Verlag des Sturm, 1923. /

229 **Walden, H.** *Archipenko.* Berlin, 1915. /

230 **Weise, Erich.** *Alexander Archipenko.* Leipzig, Klinkhardt & Biermann, 1923. (Junge Kunst, Bd. 40.) Biog.

Arp, Hans

231 **Arp, Hans.** "Notes from a diary." *Transition*, 1932, no. 21, p. 190-194.

232 "Hans Arp." *Cahiers d'art*, 1931, v. 6, no. 9-10, p. 402-5.

233 **Schiess, Hans.** "Hans Arp." *Abstraction-création*, 1932, v. 1, p. 2.

234 **Torres, Domingo López.** "Hans Arp." *Gaceta de arte*, 1934, no. 24, p. 1.

Also his own writings with **Lissitzky** (37) and **Neitzel** (96). Further: **Huyghe** (83) **Jakovski** (390).

Balla, Giacomo

235 **Galleria del Dipinto, Rome.** [*Exhibition Balla.*] July, 1929. Catalog prefaced by F. T. Marinetti. /

Also **Costantini** (108) **Coquiot** (23) **Huyghe** (83).

Baumeister, Willi

236 **La Galerie d'art contemporain, Paris.** *Willi Baumeister.* Jan. 18 - Feb. 1, n.d. Exhibition catalog.

237 **Galerie von Garvens, Hannover.** *Willy Baumeister.* July 2-Aug. 13, 1922. Exhibition catalog; preface by Karl Konrad Düssel.

238 **Gräff, Werner.** *Willi Baumeister.* Stuttgart, F. Wedekind, 1927. /

239 **Grohmann, Will.** *Willi Baumeister.* Paris, Nouvelle revue française, 1931. (Les peintres français nouveaux, no. 45.) Bibl.

240 **Westerdahl, Eduardo.** *Willi Baumeister. Con un prólogo y un retrato del professor Willi Baumeister.* Tenerife, Ediciones Gaceta de arte, 1934.

241 "Willi Baumeister." *Sélection*, 1931, no. 11, p. 1-60. Bibl. Articles by Will Grohmann and others.

Also **Huyghe** (83)

Belling, Rudolf

See **Fierens** (113)

Boccioni, Umberto

242 **Boccioni, Umberto.** *Opera completa a cura e con prefazione di F. T. Marinetti.* Foligno, Campitelli, 1927. /

243 **Carrà, Carlo.** *Boccioni.* n.p., n.d. /

244 **Galleria centrale d'arte, Milano.** *Grande esposizione Boccioni, pittore e scultore futurista. Catalogo con scritto di Boccioni e prefazione di Marinetti.* Dec. 28, 1916 - Jan. 14, 1917. /

245 **Longhi, R.** *Scultura futurista: Boccioni.* Firenze, La Voce, 1914.

246 **Marinetti, F. T.** *Umberto Boccioni.* 1924. /

Also his own writings (189) **Costantini** (108) **Coquiot** (23) **Huyghe** (83).

Brancusi, Constantin

247 **Adlow, Dorothy.** "Brancusi." *Drawing and design*, Feb., 1927. /

248 **Brancusi, Constantin.** "Réponses de Brancusi sur la taille directe, le poli et la simplicité dans l'art; quelques-uns de ses aphorismes à Irène Codreane." *This quarter*, 1925, v. 1, no. 1, p. 235-237 plus 44 plates.

249 **Brummer gallery, New York.** *Brancusi exhibition.* Nov. 17 - Dec. 15, 1926. Foreword by Paul Morand.

250 **Pound, Ezra.** "Brancusi." *Little review*, 1921, autumn no., p. 3-7.

Also **Fierens** (113) **Joseph** (36).

Braque, Georges

251 **Basel. Kunsthalle.** *Georges Braque.* Apr. 9-May 14, 1933. Exhibition catalog; preface by Carl Einstein.

252 **Horter, Earl.** "Abstract painting, a visit to Braque." *Pennsylvania museum bulletin*, 1934, v. 29, p. 62-64. Not illus.

253 **Bissière.** *Georges Braque.* Paris, L. Rosenberg, 1920. (Maîtres du cubisme.) /

254 **Einstein, Carl.** *Georges Braque.* Paris, Chroniques du jour, 1934. (XXe siècle.)

255 "Georges Braque." *Cahiers d'art*, 1933, v. 8, no. 1-2, p. 1-84.

256 **Isarlov, George.** "Georges Braque." *Orbes*, 1932, no. 3, p. 71-150. Not illus. Dated list of works to 1932.*

257 **Raynal, Maurice.** *Georges Braque.* Rome, Ed. de Valori plastici, 1924. In French.

Also **Huyghe** (83) **Joseph** (36).

Calder, Alexander

258 **Galerie Percier, Paris.** *Alexander Calder. Volumes, vecteurs, densités, dessins, portraits. Exposition.* Apr. 27-May 9, 1931. Catalog; preface by F. Léger.

259 **Jakovski, Anatole.** "Alexandre Calder." *Cahiers d'art*, 1933, v. 8, no. 5-6, p. 244-246.

260 **Sweeney, James Johnson.** "Alexander Calder." *Axis*, 1935, no. 3, p. 19-21.

Also **Benson** (111) **Jakovski** (390) **Joseph** (36).

Carrà, Carlo

261 **Bardi, P. M.** *Carrà e Soffici.* Milano, Belvedere, 1930.

262 **Raimondi, Giuseppe.** *Carlo Carrà.* Bologna, 1918. /

263 **Soffici, Ardengo.** *Carlo Carrà.* Milano, U. Hoepli, 1928. (Arte moderna italiana, no. 11.) Bibl.

Also **Costantini** (108) **Coquiot** (23) **Huyghe** (83).

Chirico, Giorgio de

264 **Chirico, Giorgio de.** *Piccolo trattato di tecnica pittorica.* Milano, 1928. /

265 *Dodici opere di Giorgio Chirico precedute da giudizi critici.* Roma, Ed. di Valori plastici, n.d.

266 **George, Waldemar.** *Chirico, avec des fragments littéraires de l'artiste.* Paris, Ed. des Chroniques du jour, 1928. (Maîtres nouveaux.) *

267 "Giorgio de Chirico." *Sélection*, 1929, no. 8. Articles by Pierre Courthion and others. Bibl.

268 **Ternovetz, Boris.** *Giorgio de Chirico.* Milano, U. Hoepli, 1928. (Arte moderna italiana, no. 10.)

269 **Vitrac, Roger.** *Georges de Chirico.* 6e éd. Paris, Nouvelle revue française, 1927. (Les peintres français nouveaux, no. 29.)

Also **Costantini** (108) **Huyghe** (83) **Joseph** (36).

Delaunay, Robert

270 **Busse, E. V.** "Die Kompositionsmittel bei Robert Delaunay." In *Der blaue Reiter* (137), p. 48-52.

Also *Abstraction-création*, 1932, p. 7, **Huyghe** (83) **Joseph** (36).

Doesberg, Théo van

271 **Dexel.** "Théo van Doesburg." *Das neue Frankfurt*, 1931, v. 5, no. 6, p. 104-106.

272 **Doesburg, Théo van.** "L'évolution de l'architecture moderne en Hollande." *L'architecture vivante*, 1925, v. 3, no. 9, p. 14-20.

273 [Obituary] *Cahiers d'art*, 1931, v. 6, no. 4, p. 228.

274 "Van Doesburg." *de Stijl*, 1932, final no. Articles by Doesburg, A. Elzas, and others; edited by his widow.*

Also his own writings (202-206) **Joseph** (36 [entered under both D and V]).

Domela-Nieuwenhuis, César

275 **Jakovski, Anatole.** "Exposition à la Galerie Pierre." *Cahiers d'art*, 1934, v. 9, no. 5-8, p. 209-210.

276 **Rasch, H. & B.** "César Domela-Nieuwenhuis." In their *Gefesselte Blick*, Stuttgart, Zaugg, n.d., p. 44-47. Issued as a separate.*

Duchamp, Gaston

See **Jacques Villon.**

Duchamp, Marcel

277 **Breton, André.** "Phare de La Mariée." *Minotaure*, 1934, v. 2, p. 45-49.

278 **Duchamp, Marcel.** *La mariée mise à nu par ses célibataires même.* Paris, R. Sélavy, [1934]. Portfolio with 94 reproductions of documents, drawings and photographs.

Also **Huyghe** (83).

Duchamp-Villon, Raymond

279 **Galerie Pierre, Paris.** *Sculptures de Duchamp-Villon.* June 8-27, 1931. Exhibition catalog; preface by André Salmon.

280 **Pach, Walter.** *A sculptor's architecture.* New York, Assoc. of American painters and sculptors, 1913. Not illus.

281 *Raymond Duchamp-Villon, sculpteur, 1876-1918.* Paris, J. Povolozky, 1924. Biography by Walter Pach, 26 illus.*

Also **Joseph** (36 [entered under both D and V]).

Erni, Hans

282 **Jakovski, Anatole.** *Hans Erni, Hans Schiess, Kurt Seligmann, S. H. Taeuber-Arp, Gerard Vulliamy.* Paris, Ed. Abstraction - création, 1934.

Ernst, Max

283 **Lloyd, Peter.** "Max Ernst and surrealism." *Creative art,* 1932, v. 11, p. 214-216.

284 "Max Ernst." *Cahiers d'art,* 1931, v. 6, no. 9-10, p. 415-417.

285 **Read, Herbert.** *The Listener,* 1933, June 7, p. 829. /

286 **Tzara, Tristan.** "Max Ernst et les images reversibles." *Cahiers d'art,* 1934, v. 9, no. 5-8, p. 165-171.

Also **Joseph** (36 [Biog. by R. Vitrac])* **Huyghe** (83).

Exter, Alexandra

287 **Tugenhold, Ia.** *Alexandra Exter.* Berlin, 1922. /

Feininger, Lyonel

288 **Berlin. National-Galerie.** *Lyonel Feininger; Ausstellung.* 1931. Exhibition catalog; preface by Ludwig Thormaehlen.

289 **Hannover. Kestner - Gesellschaft.** *Lyonel Feininger.* Jan. 28-Mar. 6, 1932. Exhibition catalog with biography and quotations from the artist's writings.

290 **Wolfradt, Willi.** *Lyonel Feininger.* Leipzig, Klinkhardt & Biermann, 1924. (Junge Kunst, Bd. 47.)

Also **Huyghe** (83) **Klumpp** (11) **Thieme & Becker** (55).

Fresnaye, Roger de la

291 **Allard, Roger.** *R. de la Fresnaye.* Paris, Nouvelle revue française, 1922. (Les peintres français nouveaux, no. 13.)

292 **Chadourne, Paul & César de Hauke.** *Catalogue complet de l'oeuvre de Roger de la Fresnaye.* In preparation.

293 **Nebelthau.** *Roger de la Fresnaye.* Paris, 1935. /

Also **Huyghe** (83) **Joseph** (36).

Gabo, Nahum

294 **Hannover. Kestner-Gesellschaft.** *Gabo, konstruktive Plastik.* Nov. 6-23, 1930. Exhibition catalog; preface by Bier. Biog.

295 **Kállai, Ernst.** "Der Raumplastiker Gabo." *Das neue Frankfurt,* 1930, v. 4, no. 1, p. 17-19.*

Also **Gabo & Pevsner** (150).

Giacometti, Alberto

296 **Leiris, Michel.** "Alberto Giacometti." *Documents,* 1929, no. 4, p. 209-214.

297 **Zervos, Christian.** "Quelques notes sur les sculptures de Giacometti." *Cahiers d'art,* 1932, v. 7, no. 8-10, p. 337-342.

Gleizes, Albert

See his own writings (159-164), also **Huyghe** (83) **Joseph** (36).

Goncharova, Nathalie

298 **Eganburi, Eli.** *M. Larionov i N. Goncharova.* Moskva, 1913.

299 **Kingore galleries, New York.** *The Goncharova-Larionov exhibition. Introduction and catalogue by Christian Brinton,* 1922.

300 **Parnack, V.** *Goncharova-Larionov; l'art décoratif théâtral moderne.* Paris, La Cible, 1919.

Also **Fülop-Miller** (30) **Huyghe** (83) **Joseph** (36 [Biog. by Serge Chauby-Rousseau]).

Gonzales, José

See Juan Gris.

Gonzales, Julio

301 **Alfonseca, Ricardo Pérez.** *Julio Gonzáles.* Madrid, 1934. /

302 "Exposition à la Galerie Percier." *Cahiers d'art,* 1934, v. 9, no. 5-8, p. 209; *the same,* 1935, v. 10, no. 1-4, p. 32-34.

Gris, Juan

Pseudonym of José Gonzales.

303 **Galerie Alfred Flechtheim, Berlin.** *In memoriam Juan Gris.* Feb., 1930. Exhibition catalog. Biog. Bibl.

304 **Galerie Simon, Paris.** *Exposition Juan Gris.* Mar. 20-Apr. 5, 1923. Preface by M. Raynal.

244

305 **George, Waldemar.** *Juan Gris.* Paris, Nouvelle revue française, 1931. (Les peintres français nouveaux, no. 44.)

306 "Juan Gris." *Cahiers d'art*, 1935, v. 8, no. 5-6, unpaged.

307 [**Kahnweiler, Henry.**] *Juan Gris, von Daniel Henry* [*pseud.*]. Leipzig, Klinkhardt & Biermann, 1929. (Junge Kunst, Bd. 55.)

308 **Raynal, Maurice.** *Juan Gris.* Paris, L'Effort moderne, 1920. (Les maîtres du cubisme.)

309 **Stein, Gertrude.** "The life of Juan Gris; the life and death of Juan Gris." *Transition*, 1927, no. 7, p. 160-162.
Also **Huyghe** (83) **Joseph** (36 [article by M. Gautier]).

Hélion, Jean

310 **Evans, Myfanwy.** "Hélion today; a personal comment." *Axis*, 1934, no. 4, p. 4-9.

311 **Read, Herbert.** "Jean Hélion." *Axis*, 1935, no. 4, p. 3-4.
Also his own writing (9) and *Abstraction-création*, 1932, p. 17, *Cahiers d'art*, 1934, v. 9, no. 5-8, p. 197-200, **Jakovski** (390).

Jeanneret, Charles-Edouard
[Le Corbusier]

312 **Boesiger, E.,** ed. *Le Corbusier und Pierre Jeanneret, ihr gesamtes Werk von 1910-1929.* Zürich, H. Girsberger, 1930. Vol. 2: *Le Corbusier et Pierre Jeanneret, oeuvre complète de 1929-1934.* Zürich, H. Girsberger, 1935.
Also his own writings with **Ozenfant** (88, 168). Further: **Huyghe** (83) **Joseph** (36 [under L]).

Kandinsky, Vasily

313 **Grohmann, Will.** *Kandinsky.* Paris, Cahiers d'art, 1930.

314 **Grohmann, Will & Anatole Jakovski.** *Kandinsky.* Tenerife, Gaceta de arte. In preparation.

315 **Grohmann, Will.** *Wassily Kandinsky.* Leipzig, Klinkhardt & Biermann, 1924. (Junge Kunst, Bd. 42.)

316 *Kandinsky 1901-1913.* Berlin, Verlag des Sturm, [1913]. Including an autobiographical essay entitled "Rükblicke."

317 *V. Kandinsky.* Moskva, Izd. Izobrazitelnogo iskusstva, 1918. /

318 "Wassily Kandinsky." *Sélection*, 1932, no. 14, p. 3-96. Bibl.

319 **Zehder, Hugo.** *Wassily Kandinsky; unter autorisierter Benützung der russissche Selbstbiographie.* Dresden, R. Kaemmer, 1920. (Künstler der Gegenwart.) *
Also his own writings (10, 135-137) and **Huyghe** (83) **Klumpp** (11) **Thieme & Becker** (55).

Klee, Paul

320 **Berne. Kunsthalle.** *Ausstellung Paul Klee.* Feb. 23-Mar. 24, 1935. Exhibition catalog. /

321 **Crevel, René.** *Paul Klee.* 5e éd. Paris, Nouvelle revue française, 1930. (Peintres allemands.)

322 **Galerie neue Kunst Fides, Dresden.** *Katalog der Ausstellung Paul Klee; Aquarelle aus den Jahren 1920-1929.* Feb. 1-Mar., [1929]. Preface by Rudolf Probst.

323 **Grohmann, Will.** *Paul Klee.* Paris, Ed. Cahiers d'art, 1929.

324 **Hausenstein, Wilhelm.** *Kairuan; oder, Eine Geschichte vom Maler Klee.* München, K. Wolff, 1921.

325 **Klee, Paul.** "Schöpferischen Konfession." *Tribune der Kunst und Zeit, eine Schriftensammlung. Herausgegeben von Kasimir Edchmidt.* Berlin, 1920. v. 13, p. 28-40. /

326 **New York. Museum of modern art.** *Paul Klee.* Mar. 13-Apr. 2, 1930. Exhibition catalog; introduction by Alfred H. Barr, Jr. Bibl.

327 *Paul Klee.* Berlin, Verlag des Sturm, 1918. (Sturm Bildbücher III.) /

328 *Paul Klee; Handzeichnungen 1921-1930.* Berlin, Galerie Flechtheim, 1934.

329 **Wedderkop, H. von.** *Paul Klee, mit einer Biographie des Künstlers.* Leipzig, Klinkhardt & Biermann, 1920. (Junge Kunst, Bd. 13.) Biog.

330 **Zahn, Leopold.** *Paul Klee; Leben, Werk, Geist.* Potsdam, G. Kiepenheuer, 1920.*
Also his own writings (138) and **Huyghe** (83) **Klumpp** (11) **Thieme & Becker** (55).

Kupka, Frank

331 **Arnould-Grémilly, F. K.** *Frank Kupka.* Paris, J. Povolozky, 1921. (Coll. Quelques peintres.) /

332 **Kupka, F.** *La création dans l'art plastique.* Prague, Manes. /

333 ———— "Créer." *La Vie des lettres et des arts*, 1922, July. /

334 **Siblik, Emmanuel.** *Frank Kupka.* Prague, Aventinum, 1929. (Musaion no. VIII.)
Also *Abstraction-création*, 1932, p. 23, same, 1933, p. 25, **Huyghe** (83) **Joseph** (36 [article by Georges Turpin]).

la Fresnaye, Roger de

See Fresnaye, Roger de la.

Larionov, Michael

335 **Fry, Roger.** "M. Larionow and the Russian ballet." *Burlington magazine*, 1919, v. 34, p. 112-117.

Also **Eganburi** (298) **Fülop-Miller** (30) **Kingore galleries** (299) **Joseph** (36 [article by Serge Chauby-Rousseau]) **Parnack** (300).

Laurens, Henri

336 **Guéguen, P.** "La conjonction de la réalité sensuelle et de l'abstraction dans l'oeuvre de Henri Laurens." *Cahiers d'art*, 1932, v. 7, no. 1-2, p. 51-56.

337 **Moussinac, L.** "Henri Laurens." *Art et décoration*, 1932, v. 61, p. 141-146.

338 **Zervos, C.** "Les constructions de Laurens." *Cahiers d'art*, 1930, v. 5, no. 4, p. 181-190.*

339 ———— "Henri Laurens." *L'art d'aujourd'hui*, 1924, autumn no., p. 11-16.

Also **Fierens** (113) **Thieme & Becker** (55 [article by W. Grohmann]).

Lebedev, Vladimir

340 **Punin, N. & P. Neradovskij.** *Vladimir Lebedev.* Leningrad, 1928. /

341 *Russian placards, 1917-1922: 1st part, Petersburg office of the Russian telegraph agency ROSTRA.* Petersburg, Petersburg branch of the news of the all-Russian central executive committee, 1923. In French and English.

Also **Thieme & Becker** (55).

Le Corbusier [PSEUD.]

See **Jeanneret, Charles-Edouard.**

Léger, Fernand

342 "Fernand Léger." *Cahiers d'art*, 1933, v. 8, no. 3-4, unpaged. Articles by Christian Zervos and others.

343 "Fernard Léger." *Sélection*, 1929, no. 5.

344 **Galerie Alfred Flechtheim, Berlin.** *Fernand Léger.* Feb. 6-Mar. 2, 1928. Prefaces by A. Flechtheim and F. Léger.

345 **George, Waldemar.** *Fernand Léger.* Paris, Nouvelle revue française, 1929. (Peintres nouveaux.)

346 **Léger, Fernand.** "The new realism; lecture delivered at the Museum of modern art." *Art front*, 1935, no. 8, p. 10.

347 **Moore, George L. K.** "Fernand Léger versus cubism." *Bulletin of the Museum of modern art*, 1935, v. 3, no. 1.

348 **Raynal, Maurice.** *Fernand Léger.* Paris, L'Effort moderne, 1920. (Les maîtres du cubisme.)

349 **Tériade, E.** *Fernand Léger.* Paris, Ed. des Cahiers d'art, 1928. (Les grands peintres d'aujourd'hui, v. 4.)

Also **Huyghe** (83) **Joseph** (36 [Biog. by E. Tériade]) **Thieme & Becker** (55 [Biog. by Will Grohmann]).

Lewis, Wyndham

350 **Lewis, Wyndham.** *Thirty personalities and a self-portrait.* London, D. Harnsworth, 1932.

351 **Rutter, Frank.** *Some contemporary artists.* London, L. Parsons, 1922.

Also **Vorticism** (214-217).

Lipchitz, Jacques

352 **Georges, Waldemar.** *Jacques Lipchitz.* Paris, Ed. Le Triangle, n.d. (Yidn-kinstler-monografies.) In Yiddish.

353 **Guéguen, P.** "Jacques Lipchitz; ou, L'histoire naturelle magique." *Cahiers d'art*, 1932, v. 7, no. 6-7, p. 252-258.

354 **Salmon, André.** "Jacques Lipchitz." *L'art d'aujourd'hui*, 1926, v. 3, no. 10, p. 21-23.

355 **Vitrac, Roger.** *Jacques Lipchitz.* Paris, Nouvelle revue française, 1929. (Les sculpteurs français nouveaux, 7.)

Also **Benson** (111) **Fierens** (113) **Joseph** (36 [Biog. by V. Huidobro]) **Thieme & Becker** (55 [under Lipschitz]).

Lissitzky, El

356 **Kállai, Ernst.** "El Lissitzky." *Cicerone*, 1924, v. 16, p. 1058-1063. Also *Jahrbuch der jungen Kunst*, 1924, p. 304-309.

357 **Lozowick, Louis.** "El Lissitsky." *Transition*, 1929, no. 18, p. 284-286.

Also his own writings (37, 152) **Moholy-Nagy** (42) **Thieme & Becker** (55 [Biog. by D. Aranowitsch]).

Malevich, Kasimir

358 **Kállai, E.** *Kunstblatt*, 1927, v. 11, p. 264-266. /

359 **Malevich, K.** "Nashi problemi." *Izobrazitelnoe iskusstvo*, 1919, no. 1, p. 27-30.

360 ———— "O poezii." *Same*, 1919, no. 1, p. 31-35.

Also his own writings (210-213) and **Thieme & Becker** (55).

Marc, Franz

361 Hancke, Ehrich. "Franz Marc." *Kunst und Künstler*, 1917, v. 15, p. 205-208.

362 Marc, Franz. *Briefe, Aufzeichnungen und Aphorism.* Berlin, P. Cassirer, 1920. 2 v.

363 ———— *Stella peregrina. 18 Faksimile nach Originalen, handkoloriet von Frau Annette von Eckardt, mit Einleitung von Hermann Bahr.* München, 1917. /

Also **Huyghe** (83) **Thieme & Becker** (55 [Biog. by A. Mayer]).

Marcoussis, Louis

364 Cassou, Jean. *Marcoussis.* Paris, Nouvelle revue française, 1930. (Les peintres français nouveaux, no. 42.)

365 Lurcat, Jean. "Louis Marcoussis." *L'art d'aujourd'hui*, 1926, v. 3, no. 11, p. 35-36, pl. XLII-XLV.

366 "Marcoussis." *Sélection*, 1929, no. 7, p. 1-72. Articles by Tristran Tzara and others.*

Also **Huyghe** (83) **Joseph** (36).*

Masson, André

367 "André Masson." *Cahiers du sud*, 1929, Feb. Articles by Jacques Baron, Joë Bousquet and others. /

368 Galerie Simon, Paris. *Exposition André Masson.* Feb. 25-Mar. 8, 1924. Catalog; preface by Georges Limbour.

369 ———— *Exposition André Masson.* Apr. 8-20, 1929. Preface by Georges Limbour. Not illustrated.

370 Pia, Pascal. *André Masson.* Paris, Nouvelle revue française, 1930. (Peintres nouveaux.)

371 Vitrac, R. "André Masson." *Cahiers d'art*, 1930, v. 5, no. 10, p. 525-531.

372 Zervos, C. "A propos des oeuvres récentes d'André Masson." *Cahiers d'art*, 1923, v. 7, no. 6-7, p. 232-242.*

Also **Huyghe** (83).

Miro, Joan

373 Einstein, Carl. "Joan Miró, papiers collés à la Galerie Percier." *Documents*, 1930, v. 2, p. 241-243.

374 Hugnet, G. "Joan Miró; ou, L'enfance de l'art." *Cahiers d'art*, 1931, v. 6, no. 7-8, p. 335-340.

375 "Joan Miró." *Cahiers d'art*, 1934, v. 9, no. 1-4, p. 11-58.*

376 Leiris, Michel. "Joan Miró." *Documents*, 1929, v. 1, no. 5, p. 263-270.

Also **Huyghe** (83) **Jakovski** (390).

Moholy-Nagy, Ladislaus

377 Kállai, Ernst. "Ladislaus Moholy-Nagy." *Jahrbuch der jungen Kunst*, 1924, p. 181-189.

378 Moholy-Nagy, Ladislaus. *6 Constructionen.* Hannover, Ey, 1925. Portfolio.

379 ———— *60 Fotos. Herausgegeben von Franz Roh.* Berlin, Klinkhardt & Biermann, 1930. (Fototek 1.) Text in German, French and English.

Also his own writings (41, 42) and **Huyghe** (83) **Thieme & Becker** (55).

Mondrian, Piet

380 Mondrian, Piet. [Short article.] *Abstraction-création*, 1933, p. 31.

Also **Huebner** (105) **Plasschaert** (106) **Thieme & Becker** (55 [Biog. by W. Grohmann]).

Moore, Henry

381 Leicester galleries, London. *Catalogue of an exhibition of sculpture and drawings by Henry Moore.* April, 1931. Preface by Jacob Epstein. Not illus.

382 Read, Herbert. *Henry Moore, sculptor; an appreciation.* London, A. Zwemmer, 1934.*

Also **Benson** (111) **Fierens** (113) **Read** (60).

Nicholson, Ben

383 Nicholson, Ben. "Aim of painting." *London studio*, 1932, v. 4, p. 333.

384 Read, Herbert. "Ben Nicholson's recent work." *Axis*, 1935, no. 2, p. 14-16.

385 Tschichold, Jan. "On Ben Nicholson's reliefs." *Axis*, 1935, no. 2, p. 16-18.

Also **Read** (60).

Ozenfant, Amédée

386 George, Waldemar. "Ozenfant: from purism to magic realism." *Formes*, 1931, no. 16, p. 104.

387 Guéguen, P. "Réflexions sur l'oeuvre d'Ozenfant." *Cahiers d'art*, 1930, v. 5, no. 10, p. 537-540.

388 Nierendorf, Karl. *Amédée Ozenfant.* Berlin, 1931. /

389 Schneid, O. "Amédée Ozenfant, der Maler des Purismus." *Cicerone*, 1930, v. 22, no. 9, p. 250-254.

Also his own writings (48) and collaborations with **Jeanneret** [**Le Corbusier**] (88, 168). Further: **Joseph** (36 [Biog. by P. Bonifas]) **Thieme & Becker** (55).

Pevsner, Antoine

390 Jakovski, Anatole. *Arp, Calder, Hélion, Miró, Pevsner, Seligmann.* Paris, J. Povolozky, n.d.

Also *Abstraction - création*, 1933, p. 34-35, **Joseph** (36).

Picabia, Francis

391 Breton, André. *Francis Picabia.* Barcelona, 1922. /

392 De la Hire, M. *Francis Picabia.* Paris, Ed. de La Cible, 1930. /

393 Duchamp, Marcel, collection. *Catalogue des tableaux, aquarelles et dessins par Francis Picabia.* Catalog of the auction at the Hotel Drouot, Paris, on Mar. 8, 1926, of Duchamp's 80 Picabias.*

394 "Francis Picabia in his latest moods." *This quarter*, 1927, no. 3, unpaged.

395 Rosenberg, Léonce, art-dealer, Paris. *Exposition Francis Picabia:trente ans de peinture.* Dec. 9-31, 1930. Prefaced by F. Picabia and L. Rosenberg.

Also **Huyghe** (83).

Picasso, Pablo

396 Akseonov, I. A. *Picasso i okrestnosti.* Moskva, Tsentrifuga, 1917.

397 Apollinaire, Guillaume. *Picasso.* Paris, 1905. /

398 Bertram, Anthony. *Pablo Picasso.* New York & London, Studio, 1930. (The world's masters.)

399 Cocteau, Jean. *Picasso.* Paris, Stock, 1923. (Les contemporains.)

400 Dale, Maud. *Modern art: Picasso.* New York, Knopf, 1930.

401 *Dodici opere di Picasso.* Firenze, Libreria della Voce, 1914. (Maestri moderni III.)

402 Galerie Georges Petit, Paris. *Exposition Picasso. Documentation réunie par Charles Vrancken.* June 16-July 30, 1932. Catalog. Bibl.

403 Geiser, Bernhard. *Picasso peintre-graveur; catalogue illustré de l'oeuvre gravé et lithographié, 1899-1931.* Berne, Chez l'auteur, 1933.

404 George, Waldemar. *Pablo Picasso.* Rome, Valori plastici, 1924. (The new artists.)

405 ———— *Picasso.* Paris, Ed. des Quatre-chemins, 1924.

406 ———— *Picasso: dessins.* Paris, Ed. des Quatre-chemins, 1926.

407 Hartford, Conn. Wadsworth atheneum. *Pablo Picasso.* Feb. 6-Mar. 1, 1934. Exhibition catalog. Bibl.

408 "Hommage à Picasso." *Documents*, 1930, v. 2, p. 113-184. Articles by Jacques Baron, Georges Bataille and others.

409 [Horter, Earl.] *Picasso, Matisse, Derain, Modigliani.* Philadelphia, H. C. Perlenberg, 1930.

410 Level, André. *Picasso.* Paris, Crès, 1928.

411 Mahaut, Henri. *Picasso.* G. Crès, 1930.

412 Oliver, Fernande. *Picasso et ses amis.* Paris, Librairie stock, Delmain et Boutelleau, 1933. (Ateliers no. 4.)

413 Ors, Eugenio d'. *Pablo Picasso. Traduction de F. Amunategui.* Paris, Ed. des Chroniques du jour, 1930. (XXe siècle, 5.) Translation: *Pablo Picasso.* Paris, Ed. des Chroniques du jour; New York, E. Weyhe, 1930.

414 "Picasso." *Cahiers d'art*, 1932, v. 7, no. 3-5, p. 85-196.

415 Raphael, Max. *Proudhon, Marx, Picasso: trois études sur la sociologie de l'art.* Paris, Ed. Excelsior, 1933.

416 Raynal, Maurice. *Pablo Picasso.* Paris, L'Effort moderne, n.d. [1921]. (Les maîtres du cubisme.) Translation: *Picasso.* München, Delphin-Verlag, 1921.

417 ———— *Picasso.* Paris, Crès, 1922. Bibl.

418 Reid, Alex., & Lefevre, ltd., London. *Thirty years of Pablo Picasso.* June, 1931. Exhibition catalog.

419 Reverdy, Pierre. *Pablo Picasso.* Paris, Nouvelle revue française, 1924. (Les peintres français nouveaux, 16.) Bibl.

420 Schürer, Oskar. *Picasso.* Leipzig, Klinkhardt & Biermann, 1926. (Junge Kunst, Bd. 49-50.)

421 Solmi, S. *Pablo Picasso der Zeichner.* Zürich, 1933. /

422 Stein, Gertrude. "Pablo Picasso." *Camera work*, 1912, special no., p. 29-30, plus 7 plates.

423 Valentine gallery, New York. *Abstractions of Picasso.* Jan., 1931. Exhibition catalog.

424 Zervos, Christian. *Pablo Picasso. Vol. I, oeuvres de 1895-1906.* Paris, Ed. des Cahiers d'art, 1932. / Translation: *Pablo Picasso. Vol. I, works from 1895 to 1906.* Paris, Ed. des Cahiers d'art; New York, E. Weyhe, 1932.*

425 _____ *Pablo Picasso, oeuvres 1920-1926.* Paris, Ed. des Cahiers d'art, 1926.*

426 _____ *Pablo Picasso.* Milano, 1933. (Arte moderna straniera.)

427 **Zürich. Kunsthaus.** *Picasso.* Sept. 11-Oct. 30, 1932. Exhibition catalog; preface by W. Wartmann.

Also **Huyghe** (83) **Joseph** (36) **Thieme & Becker** (55 [Biog. by W. Grohmann]) **Uhde** (102).

Ray, Man

428 "Man Ray, Paris." *Gebrauchsgraphik,* 1934, v. 11, p. 33-37. Text in German and English.

429 **Ray, Man.** Eight photographic studies. *Transition,* 1929, no. 15, between pp. 26-27. No text.

430 _____ *Photographs, Paris 1920-34.* Hartford, Conn., Publisher James Thrall Soby, 1934.

431 **Ribemont-Dessaignes, G.** *Man Ray.* Paris, Nouvelle revue française, 1924. (Peintres nouveaux.)

Also his own writings (128) **Huyghe** (83) **Joseph** (36).*

Rodchenko, Alexander

Mentioned by **Bush & Zamoshkin** (64) **Lozowick** (68) **Umanskij** (72).

Schlemmer, Oskar

432 **Galerie Alfred Flechtheim.** Berlin. *Oskar Schlemmer.* Jan., 1931. Exhibition catalog; preface by Will Grohmann.

433 **Grohmann, Will.** "Der Maler Oskar Schlemmer." *Das neue Frankfurt,* 1928, v. 2, no. 4, p. 58-66.*

434 **Schmidt, Paul F.** "Oskar Schlemmer." *Jahrbuch der jungen Kunst,* 1921, p. 269-280.

Also **Huyghe** (83).

Schwitters, Kurt

435 *Kurt Schwitters. Einleitung von Otto Nebel.* Berlin, Verlag des Sturm, n.d. (Sturm-Bildbücher IV.) /

436 **Schwitters, Kurt.** "Merzbau." *Abstraction-création,* 1933, p. 41.

_____ "Les merztableaux." *Abstraction-création,* 1932, p. 33.

Severini, Gino

437 **Courthion, Pierre.** *Gino Severini.* Milano, U. Hoepli, 1930. (Arte moderna italiana, no. 17.) Bibl.

438 **Maritain, Jacques.** *Gino Severini.* Paris, Nouvelle revue française, 1930. (Peintres nouveaux, no. 40.)

Also **Coquiot** (23) **Costantini** (108) **Huyghe** (83).

Tatlin, Vladimir Evgrafovich

439 **Punin, N.** *Pamiatnik III internationala.* Peterburg, Izdanie otdela izobrazitelnavo iskusstva, 1920.

440 _____ *Tatlin—protiv kubizma.* Peterburg, Gosudarstvennoe izdatelstvo, 1921.

441 "Vladimir Evgrafovich Tatlin." Reprinted from *Novago jurnala dlia vsekh,* 1915.

Also **Fülop-Miller** (30).

Vantongerloo, Georges

442 **Vantongerloo, Georges.** *L'art et son avenir.* Anvers, De Sikkel; Santpoort, C. A. Mees, 1924.

443 _____ "Préliminaire, axiome, postulat," *Abstraction-création,* 1932, p. 40-41.

Also **Joseph** (36).

Villon, Jacques

Pseudonym of Gaston Duchamp.

444 **Brummer gallery, New York.** *Villon.* Exhibition Mar. 26-Apr. 21, 1928. Preface by Walter Pach. Not illus.

Also *Abstraction-création,* 1932, p. 42; the same, 1933, p. 47-48, **Joseph** (36).*